OTHER BOOKS BY JIM FARFAGLIA

Local History

Pioneers: The Story of Oswego County's Search and Rescue Team
Voices in the Storm: Stories from the Blizzard of '66
In Pursuit of Clouds: The Journey of Oswego's Weatherman Bob Sykes
Of the Earth: Stories from Oswego County's Muck Farms

Poetry

Country Boy
People, Places & Things: The Powerful Nouns of My Life
Reach Out in the Darkness: How Pop Music Saved My Mortal Soul
The Best of Fulton

Nestlé

IN FULTON, NEW YORK

How Sweet It Was

JIM FARFAGLIA

AMERICAN PALATE

Published by American Palate
A Division of The History Press
Charleston, SC
www.historypress.com

Front cover, top: Fulton Nestlé archives.
Front cover, bottom: Aerial view of Fulton Nestlé plant by the Fulton Camera Shop, courtesy of Rick Harvell.
Back cover: Fulton Nestlé archives.

First published 2018

Manufactured in the United States

ISBN 9781467141765

Library of Congress Control Number: 2018948046

Notice: The information in this book is true and complete to the best of our knowledge. It is offered without guarantee on the part of the author or The History Press. The author and The History Press disclaim all liability in connection with the use of this book.

To Fulton Nestlé workers, one and all

CONTENTS

CONTENTS

FOREWORD

My grandfather Louis Michaud and my father, Andrew Michaud, would be so pleased to know that a book is being written about the Nestlé factory in Fulton. They were there at the beginning of the factory's history, arriving from their native Switzerland in 1907 to help start the first Nestlé plant in the United States. My grandfather was thirty-eight years old and already an accomplished Nestlé employee in the Swiss Milk Condensery. My father was only three years old, but it wouldn't be long before he and his brother and sister, Maurice and Germaine, would join their father at the chocolate factory. In time, many of our Michaud family, including me, would work there, and together, we contributed over two hundred years of service toward the company's success.

From the first day my grandfather's family arrived in Fulton, they were welcomed by the city and the factory. Nestlé provided new homes for the four Swiss families who agreed to leave their native land to start the chocolate-making process in America. It was a big sacrifice for them to leave Switzerland and start a new life, but my grandparents and parents never regretted it. They fell in love with America and all it stood for. The opportunities they found in Fulton and at the chocolate factory meant so much to them, and my grandfather and father spent the rest of their lives trying to repay the kindness shown to them.

My father would go on to become one of the senior testers in the Fulton Nestlé lab. He was so accomplished at making the highest quality milk chocolate that he could tell the difference between Nestlé candy bars and its

competitors, even going so far as to be able to identify the precise ingredients the other companies' bars contained. He taught those skills to those who worked under his leadership, assuring that Nestlé's high standards for making chocolate would be passed on generation after generation.

Dad also spent many years helping his adopted hometown of Fulton. He sat on a number of committees and represented the city in the Oswego County legislature. (It was called the Board of Supervisors back when he served.) He also helped people in smaller, but significant ways. If he saw a person who looked sad, Dad would try to cheer him up. He would do anything to put a smile on people's faces, including the time he dressed up as a mailman to hand out holiday cards at the Nestlé Christmas party.

When my father died in July 1970, he had spent the last months of his life working with officials from New York State to secure funding for a new senior care center in Fulton. The facility, Michaud Nursing Home, would bear his name, which was quite an honor for our family. But perhaps just as meaningful was what happened at the funeral home during the calling hours for my dad, when people lined up all the way down Fay Street, nearly reaching the Nestlé factory, to pay their respects. The funeral director said he'd never seen anything like it. But it made sense to our family. My father and grandfather were not only part of the Michaud family but also the Nestlé family and the Fulton family.

—Barbara Michaud Burritt
May 2018

ACKNOWLEDGEMENTS

F irst and foremost, my thanks to the more than one hundred people who sat with me for an interview; sent me stories through Facebook, email or good old-fashioned snail mail; or stopped me at the grocery store to share their memories of working at Fulton's chocolate factory. Their recollections helped me determine the best way to tell my version of Nestlé's grand history in Fulton. There also were individuals and organizations that assisted me beyond memories, and a special thanks goes out to them:

Dick Atkins
Dave Brown
Elinor Cramer
Debbie Curtis-Greeney
The Downtown Writers Center
Bill Fivaz
The Friends of History in Fulton, Sue Lane
Fulton, New York, Mayor's Office
The Fulton Library
Kathy (Putman) Gallagher
Dick Gillespie
Rick Harvell
Daryl Hayden
Douglas Hemphill and Christopher Wood
Suzanne Hutchins

ACKNOWLEDGEMENTS

Mary Jumbelic
Brian Kitney
Mark Lado
Bob MacMartin
Dave Miner
Jo Ann Natoli
Nestlé USA, Molly Dell'Omo
The Onondaga Historical Association
Lynn Siebers Ricketts
Ron Sipling
Donna Terranova Seeber
Bob Thompson
Dan Witmer
Brenda and Dave Wolfersberger

THE SMELL OF CHOCOLATE
IN THE AIR

Ask anyone who lived in Fulton, New York, during the one hundred years Nestlé operated a factory there and they'll surely mention this: the whole city smelled like chocolate. For those who never spent time in Fulton during Nestlé's heyday, a town that smelled as good as a chocolate bar sounds like something out of a Disney movie or a plot point in *Charlie and the Chocolate Factory*. And while you won't find that fragrant fact recorded in history books, those who remember waking up each morning to the smell of Nestlé churning out millions of Crunch Bars and Toll House Morsels know it's true—as true as any memory shared by thousands of people.

I can attest to that truth, not only because I grew up breathing in the sweet smell of chocolate but also because I've spent the last few years researching the Nestlé plant's century-long history in Fulton. Every interview I conducted with those who worked in the factory or lived their whole life under its influence included some reference to that delicious smell. Without fail, each person chose to start their Nestlé story by mentioning the aromatic advantage of living in our city. Even those who knew I'd grown up in Fulton couldn't resist explaining this important detail to me. It's like they needed to say it out loud—as if by uttering those words, we could once again smell chocolate in the air.

Wouldn't we all love to have it back again? Is there any sensory experience that compares to the alluring smell of chocolate? By the time Fulton began producing it, in 1907, the tasty confection already had a

long history of enchanting those who'd sampled it. Our powerful draw to chocolate can be traced back three thousand years, when the cacao tree, producer of cocoa beans, became so important to the Mayans' way of life that it played a prominent role in their mythology. Archaeologists uncovered Mexican drinking vessels dating to shortly after the birth of Christ decorated with symbols praising chocolate, and by the 1600s, it was part of religious celebrations such as the Days of the Dead, which included All Hallow's Eve. Yes, Halloween always was a special holiday in Fulton, when children's trick-or-treat bags were sure to hold plenty of Crunch, Almond and Milk Chocolate Bars.

The smell of chocolate also brings to mind its strong association with love. Jesuit missionary Antonio Colmenero wrote a poem about chocolate's mesmerizing qualities when he first encountered it in South America, more than four hundred years ago:

Twill make old women young and fresh,
create new motions of the flesh,
and cause them to long for you know what,
if they try but a taste of chocolate.

Colmenero brought his wonderment with chocolate back to Europe, and by the mid-1800s, people were offering it to their special someone on a holiday set aside to honor love: Valentine's Day. Scientists eventually figured out why giving chocolate as a sign of one's affection often feels so right. A chemical with an unromantic-sounding name, phenylethylamine, was discovered at very high levels in the brains of happy people, like those in love. Chemists also discovered phenylethylamine in equally large amounts of a certain food: chocolate. With such a long association with matters of the heart, it's understandable how, when chocolate-making came to town, Fultonians would fall in love with its tempting fragrance.

The smell of chocolate made another important contribution to our city during the Nestlé years: its weather-predicting abilities. The people I interviewed for this book not only made sure I knew about Fulton's pleasant aroma, but also mentioned this fact: "When I could smell chocolate," they declared, "I knew it was going to rain."* Strange as that may sound to someone unfamiliar with Fulton, its weather and Nestlé

* It wasn't just rain that the smell of chocolate could predict. It was the same for Central New York's infamous winter weather. People reminded me that, during our coldest months, the stronger the chocolate smell, the bigger the approaching snowstorm.

chocolate, meteorologists confirmed this unique weather tip, explaining the chocolate-rain connection like this:

When storms moved into the Fulton area, the dense, moist air associated with rain hung heavy, keeping the scent of Nestlé's chocolate production close to the ground, closer to our noses. Local weathermen began working the chocolate smell phenomenon into their forecasts. Twelve miles northwest of Fulton is Oswego, for many years the home of weatherman Bob Sykes. Sykes referred to a southern wind coming by way of Fulton as a "Nestlé wind," a sure indicator that rain was on its way.

There's a good reason why we so fondly associate chocolate's smell with our stormy weather. Anyone who has lived in Fulton or the surrounding area knows all too well the unfortunate fact of our cloudy atmospheric conditions. On average, in any given year, we can count on 55 percent of our days being overcast. That's more than half our lives. Maybe that's why we miss the chocolate smell so much. Back when Nestlé was churning out all those candy bars, when we woke up to yet another cloudy day, at least we could count on breathing in that sweetest of all smells.

Like so many others, I miss the breezy hint of chocolate floating through our city, not only for its accurate weather predictions, but also because of how it made me feel. Each person I interviewed had his or her own way of describing the emotion tied to our Nestlé wind, but one lifelong Fultonian spoke for many when she said, "The chocolate smell felt like my hometown was giving me a warm hug."

The reality that our heartfelt association with chocolate was gone for good really hit home when the Nestlé buildings started being torn down. In 2010, seven years after the factory produced its last chocolate bar, the long process of demolishing its entire twenty-four-acre facility began. Certainly, we were all sad those first few mornings in 2003 when the air no longer offered its sweet wakeup call. But like many others, long after those buildings were dark, I held on to the hope that one day I'd drive by to see Nestlé's lights on, hear the candy-making machines kicking into gear and smell the good news that Fulton was back in the chocolate-making business. That dream died when the first wrecking ball came to town.

Though I never worked at Nestlé, nor did any of my family, I found myself getting emotional watching those towering buildings topple. The first structures taken down were in the back of the factory's campus, out of sight from our daily drive-bys. But when the teardown really accelerated in 2016 and you could see the change from a distance, I decided I needed a closer look at what was happening. Driving down Fay Street, where Nestlé's main

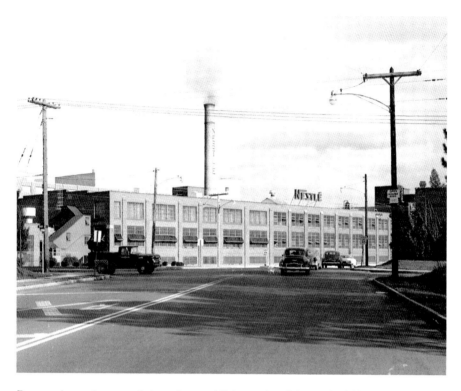

Even on dreary days, people in and around Fulton enjoyed the smell of Nestlé chocolate in the air. *Fulton Nestlé archives.*

entrance was once located, the immensity of the demolition took my breath away. I pulled off to the side of the street, got out of my car and took it all in.

In front of me were dozens of mammoth refuse piles, each composed of a haphazard mix of broken pavement, shredded insulation, twisted rusty metal, collapsed plastic piping, moldy sheetrock and fragments of glass. But most of all, there were bricks—enough bricks to erect the dozens of buildings that once housed our busy chocolate factory.

Those mountains of weathered brick seemed like unrecorded history to me, as if knocking those buildings to the ground had released the memories of all that happened within them. Someone needs to capture these stories before they're gone, I thought. As I stood and considered the end of Nestlé in Fulton, this book was born.

I didn't have to look far to find people willing to share their Nestlé histories with me. On the day I took a visual survey of what remained at the plant, cars were slowly driving by. I noticed that many in the driver's seat sported gray hair, and I was certain some were among the tens of thousands of

people who once worked there. On the other side of Fay Street, a family walked by. An elderly gentleman—a grandfather, perhaps—was holding the hand of a small child. His other hand pointed to the array of debris as he told a story I could not hear but could imagine.

When I finally sat down with some of those gray-haired folks to discuss their Nestlé memories, we started with that chocolate smell. One story in particular, told by Fultonian Larry King, captured my imagination. Larry is the current director of our city's Kiwanis baseball program, with its ball fields just a homerun hit away from the former Nestlé plant site. Larry has lived in Fulton since 1975, back when he was a kid, and he fondly remembers the smell of chocolate in the air. One day last spring, while Nestlé buildings were being demolished, Larry was working on the Kiwanis fields, and "all the sudden, I got this strong strong smell of chocolate in the air," Larry claimed. "It felt like a ghost of the past had come through the city."

Others told me about this phantom chocolate smell near the factory site, and I wasn't sure what to make of it. Chocolate hasn't been produced on those grounds for fifteen years, so it seems unlikely that the familiar smell would still be lingering. On the other hand, as I learned from my interviews, there were manufacturing mishaps at the plant from time to time. Perhaps traces of chocolate seeped into the floors, walls and even the bricks that gave shape to those buildings. When they came down, along with brick, glass and metal, could bits of long-forgotten chocolate be among the rubble, just waiting for the wind to spread their scent across our city?

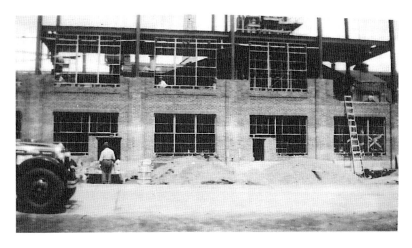

One of the sixty Nestlé buildings constructed during the chocolate factory's century in Fulton, New York. *Fulton Nestlé archives.*

Standing near remnants of the plant on that autumn day in 2016, I couldn't smell any hint of chocolate, but I did get a chill as I looked over those massive piles of bricks. Once, they were the backbone of a one-of-a-kind manufacturing facility: the first Nestlé factory in the United States, and for decades after, the largest chocolate-making plant in all of North America. In more ways than one, during all those years that Nestlé was part of our city, chocolate was as good as gold.

Heading back to my car, thinking about how to write this book, I imagined the time it took for each of Nestlé's demolished buildings to be constructed, laborers laying them brick by brick. Now those bricks have fallen away, and each one represents a trace—a fragrant reminder, if you will—of the chocolate history that took place in our city. The time has come to hear the stories of those who made Nestlé's century in Fulton a success.

1

VISIONARIES

Henri Nestlé, Daniel Peter and the People of Fulton

Fulton was ready. When businessmen from Switzerland's Nestlé Food Company came to the United States in 1898, searching for a site to build their first factory on this side of the Atlantic, the people of Fulton put their best foot forward. Nestlé wasn't in the chocolate-making business yet, but the company had established itself throughout Europe as a leader in the production of infant milk formulas and sweetened condensed milk. Ready to expand their successful business, company officials were looking for a location in America that could match the abundant dairy resources in their Swiss homeland, and New York lawmakers made sure their upstate farms would be in the running. The Nestlé dignitaries were directed to two industrial towns that were soon to merge and become the city of Fulton.

Though it would be four more years before Fulton's official incorporation, local leaders were already planning how the city would take shape. The two towns destined to become one—Fulton on the east side of the Oswego River and Oswego Falls on the west—had made their consolidation plans known to New York State policymakers. When the state's senator Nevada Stranahan had been informed of that fact by prominent Fulton resident George C. Webb, the two men collaborated on an offer to the Swiss gentlemen searching for their new factory's home. Hopeful news travels fast, and soon the possibility of a visit from such special out-of-towners traveled back and forth across the river. People on both sides agreed that a new industry was just what was needed to unite their new city.

Competition for being selected as Nestlé's first U.S. factory was stiff, but the Swiss visitors would find plenty of incentive to choose Fulton. The Nestlé Company had already decided the new factory should be located on the East Coast, where several densely populated cities were already thriving. Boston, Philadelphia, Washington, D.C., and New York City were all a day's travel from upstate New York and Fulton's ability to deliver to those metropolises had already been established. Factories in the two towns regularly used both the Oswego River, which was part of the New York State Canal System, and several railroad companies to distribute their wares. Industry-driven business was so good in the Fulton area that it spurred the growth of smaller support companies, grocery stores, churches and speakeasies. When the two towns merged, their new city was rich with potential.

The local and New York State officials wooing Nestlé's Swiss businessmen had an even more important selling point to offer. The visitors were given a tour of an important industry operating just beyond the two towns' borders: dairy farming. Miles of meadowland in the largely rural Oswego County, where the soon-to-be city of Fulton was located, had long provided sustenance for farmers' grazing cattle. Indeed, when Nestlé officials arrived in upstate New York, the principal occupation in the area was farming, much of it dairy-related. The 1900 New York State Census recorded the county of Oswego as maintaining 6,526 farms with domestic animals, 41,000 of which were listed as "dairy cows two years or older and giving milk." On average, those cows were producing 300,000 gallons of milk a day, an impressive number to Nestlé.

Evidence of a strong dairy industry was everywhere in the Fulton area. In addition to established farms, it wouldn't have been unusual for cows to be seen grazing in the yards of residents within the two town's borders. (One person I interviewed remembered the days when every home in the Fulton area had at least one cow.) Any milk not sold for consumption was sent to local cheese factories; the closest two were located in Granby Center and Bowens Corners. Yes, the Swiss found plenty of milk in Fulton, but it wasn't just abundance they were looking for.

All those farms within horse-drawn carriage distance of the potential factory site were producing milk that was considered among the highest quality in the northeastern United States. By grazing in bountiful meadows, Fulton-area cows gave milk with a high percentage of butterfat, providing the richness Nestlé demanded for its products. After all, the company's success had been built on the milk from cows fed by Swiss mountain

meadows, and the visitors were pleased to see lush farmland reminiscent of their homeland. The company's founder, Henri Nestlé, would have been pleased as well. Long before his company chose Fulton to expand its milk production success, Henri Nestlé had devoted his life to turning the highest quality milk into a lifesaving new product.

HENRI NESTLÉ

Three decades before the Nestlé Company learned of Fulton's abundant milk supply, Henri Nestlé was working day and night in his Vevey, Switzerland home laboratory. Already a successful chemist and pharmacist, Henri was among a handful of medical researchers attempting to find a solution for a health crisis in his homeland and beyond. Throughout Europe, families were being cruelly affected by a high infant mortality rate; in fact, in Switzerland, one in five children died before his or her first birthday. Nestlé, among others, was experimenting with a food product that would one day be advertised as "fresh as milk straight from the cow's udder," a quality largely unavailable in Europe's overcrowded cities.

One might say that Henri Nestlé's conviction to solve this problem for young families flowed through his veins. As the eleventh of fourteen children in a close-knit German family, Henri knew firsthand of the struggles to provide adequate nourishment for loved ones. In his youth, family was all Henri had, and he never forgot it. As a successful businessman, when it came time to create an image to promote his milk production company, Nestlé looked no further than his German surname, which in English means "a small bird's nest." Using the Nestlé family's coat of arms—three baby birds being fed by their mother in a nest—Henri created his company's famous logo. When the lack of sufficient food for young children became a crisis, Henri Nestlé accepted the challenge to overcome it. One night in September 1867, engrossed in his research, a knock on the door intensified that challenge.

It was a colleague of Henri's who'd arrived with some upsetting news. Years later, he remembered their conversation: "[The man told me that] Mrs. Wanner was seriously ill, as was her child, born a month too early. At fifteen days old, he was a sickly infant who refused not only his mother's milk, but all other types of food as well. He was convulsive, and there seemed little hope for him."

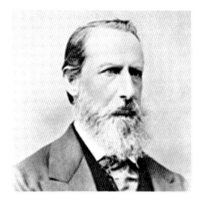

Henri Nestlé, the Swiss-born entrepreneur, founded his famous company after developing a lifesaving milk formula for infants and children. *Google photos.com.*

Already years into his experimentation with milk byproducts, Nestlé had had some success combining cow's milk, grain and sugar to create a balanced substitute for what nursing mothers normally provided. Using this dough mixture and his secret formula (so secret that his company has never revealed it), Nestlé baked it, broke it into pieces, ground it in a stone mill and packed it in tin cans. By the time he heard a knock on his door, Nestlé had marketed his product, calling it Kindermehl, or "Children's Flour." But his formula had never been tried on a young infant. Could Nestlé's creation come to the aid of Mrs. Wanner's gravely ill child? There were no other options. The child was dying.

"After being fed my formula, he began to thrive," Nestlé recounted years later. "After seven months, having eaten nothing but this formula, he has never been ill and is now a tough seven-month-old who can sit up all by himself."

It was a miracle indeed. Mrs. Wanner's baby not only lived but also flourished as any normal child. Word of Nestlé's success passed from hopeful mother to caring doctor to savvy businessman, and by 1868, Nestlé's infant cereal was selling throughout Europe. Demand for the product was also created by women of higher social standards who considered breastfeeding "unfashionable." Henri's one-man operation soon mushroomed into a factory in Vevey and then several others in nearby countries. By 1875, Kindermehl was available in nearly every major country in the world, selling a half million cans a year.*

After his contributions to the health and well-being of children became a resounding success, Henri Nestlé was ready to free himself from the demands

* Henri Nestlé was not the only person marketing a nonperishable milk product in the late 1800s. When Charles Page, a U.S. presidential appointee for Switzerland, saw lush Swiss pastures and abundant milk supplies, he decided a condensed milk factory would make a good business venture for his family. Working with his brother, George, the Pages shipped American-built equipment to a Switzerland factory in 1866. When they learned of Nestlé's success, the brothers offered to buy Henri out but were refused. They brought their company back to America and founded the Anglo-Swiss Condensed Milk Company, which ended up merging with Nestlé in 1905.

of his rapidly expanding business. When buyers came forward with an offer, the sixty-year-old entrepreneur relinquished full ownership of his business, even rejecting the option to retain partial rights as a shareholder. Though Nestlé's new CEOs wisely kept the founder's name for their company, their nutritious product was newly branded Farine Lactée, or "Flour with Milk." Despite his name forever being associated with the food industry, Henri Nestlé never again participated in its worldwide success, choosing to share his considerable wealth with the people of his hometown. Nestlé died in 1890, ten years shy of seeing his life-sustaining infant formula provide a hearty boost for the newborn city of Fulton.

DANIEL PETER

Henri Nestlé made one more important contribution to Fulton commerce, one that would prove even more influential than his milk products. However, our city would have never benefited from this other gift from Nestlé if someone in his own backyard hadn't received it first. Right around the time Nestlé was closing out his successful career, his next-door neighbor, Daniel Peter, was just beginning to experiment with a new food product. Though the food, a chocolate bar, may not have seemed as vital as Nestlé's milk products, young Peter was working as feverishly as his elderly neighbor once had, desperate to figure out how to launch a business that would save his financially strapped family.

Things hadn't always been so tragic for Daniel Peter. Born in a Swiss mountain town in 1836, Daniel's inquisitive mind had made him an outstanding student, so much so that, by age nineteen, he was teaching Latin to his peers when their professor took ill. His drive to succeed continued beyond the classroom, and by his twentieth birthday, Daniel was already operating a candle factory with his brother. Candles were the only available source of artificial light at the time, and the Peter brothers were confident that they were financially set for life. Then, in the late 1850s, kerosene was introduced as a fuel for more modern means of lighting, and within a decade, the candle industry had collapsed. In debt and any hope for success all but extinguished, it would take love to rekindle young Daniel's determination.

The building that housed the Peters' now-obsolete candle factory was owned by François-Louis Cailler, the patriarch of a successful chocolate

candy business. Cailler's daughter, Fanny, caught Daniel's eye, and just as his candle-making business was ending, the two fell in love and married. Without a means to support his bride, Daniel approached his new father-in-law, proposing that he join Cailler's booming business. He was flatly rejected, and perhaps it was his in-law's crass denial that drove him to a new business idea. Instead of joining Cailler's chocolate company, Daniel set out to become its competitor.

The chocolate-making industry had rapidly grown and diversified since it first became a viable business in 1818, when Mr. Cailler adapted a flour stone mill to crush cocoa beans, mixed them with sugar and produced his candy bars. In the early years of Callier's chocolate production, the bars were not considered a confectionary treat but rather a compact source of nutrition for those required to exert great physical effort. They were the energy bars of their day, but they were bitter, and in an attempt to widen their marketability, chocolate makers were tinkering with the recipe. Some added more sugar, which only made the chocolate overly sweet. Daniel Peter had been observing the evolving chocolate industry, and his keen intellect had him pondering a third ingredient that could somehow mellow a candy bar's bitter and sweet qualities. But what ingredient would produce the desired balance?

The explanation of what happened next for Daniel Peter is something I call a legend, since no one alive today or the results of my research can verify that it actually took place. However, since several people I interviewed mentioned the following story and there are discrepancies in various profiles of Daniel Peter's groundbreaking work in the chocolate industry, I am including it for consideration. Here's how the story goes:

Over the fence that separated their properties, next-door neighbors Daniel Peter and Henri Nestlé carried on a conversation about how Peter might break into the chocolate candy market. While discussing what could set his candy bar apart from all others, Nestlé suggested: "What if you added my milk to your chocolate?" Peter liked his neighbor's idea enough to begin experimenting.

Was it really that simple? Was Nestlé's suggestion all it took to inspire Daniel Peter to radically change how most people would thereafter consume chocolate? Some who have written about Peter's innovative chocolate bar claim that he had already been contemplating adding a dairy product to chocolate and was merely discussing the pros and cons of it with his neighbor. No one knows for sure how Daniel Peter took his first step toward creating milk chocolate, but once he was convinced the idea had merit, he became as driven to succeed as Henri Nestlé.

Peter would need that drive once he started running into the many problems of using an ingredient as perishable as fresh milk. It was only years later, after experiencing phenomenal success with his milk chocolate bar, that he was willing to talk about his early experiments and failures:

> *My first tests did not give or produce the milk chocolate as we know it today. Much work took place and after having found the proper mixture of cocoa and milk…my tests, I thought, were successful. I was happy, but a few weeks later, as I examined the contents, an odor of bad cheese or rancid butter came to my nose. I was desperate, but what was I to do?… Being as it was, I did not lose courage, but I continued to work as long as circumstances allowed.*

And persist Daniel Peter did. For the next eight years, he struggled, much like Henri Nestlé had, working to ensure that his milk chocolate bar could sustain a long shelf life. While Nestlé was able to advise his neighbor on how to deal with the perishable fat in milk, Peter had the added challenge of the high fat content in cocoa beans, which makes up about half of a bean's composition. His problems didn't end there. Peter's tests soon revealed that fat does not mix well with liquid, and his special ingredient, milk, is 88 percent water. With each new discovery, Peter's goal seemed to be more unreachable. It would take every one of those eight years of experimentation to figure out his solution.

Milk Chocolate was invented by D. Peter, Vevey, Switzerland.

PETER'S

THE ORIGINAL

SWEET MILK CHOCOLATE

ONE OF THE FAMOUS BRANDS
MANUFACTURED BY THE NESTLÉ COMPANY, INC.

"HIGH AS THE ALPS IN QUALITY"

Daniel Peter's creation, the milk chocolate bar, became hugely popular in the United States once the Fulton Nestlé plant started producing them. *Fulton Nestlé archives.*

HIGH AS THE ALPS IN QUALITY

This logo was used to promote Daniel Peter's original Swiss milk chocolate bars. It was also featured on candy bars manufactured at the Fulton Nestlé factory. *www.peterschocolate.com.*

As a first step, Peter turned a small space of his home into a "drying room," where milk could be evaporated and turned into flake form. Next, he developed a machine that could extract fat from his chocolate mixtures. He tinkered with the process, attempting to remove just the right amount of fat to avoid premature spoilage while retaining enough of its pleasurable taste. At times, the endless trials overwhelmed Peter, but there was one thing he and his taste testers could not deny: after one bite of his milk chocolate bar fresh off the production line, people were proclaiming it a confectionary sensation.

By 1875, Peter had perfected his product, calling it "Gala Peter," using the Greek word for milk, Gala, to distinguish his candy bar from competitors. The chocolate bar began appearing on market shelves in a copper-trimmed wrapper, promoted as "the first milk chocolate" and "the healthiest of all chocolates, very nourishing, very digestible, a little sugar not causing thirst." Included on the wrapper were these words: "High as the Alps in Quality," reflecting Peter's Swiss roots. His chocolate bar pledge sounded a lot like Henri Nestlé's promise to provide life-giving milk products for children, and together those commitments would one day be carried out by thousands of workers at the Nestlé factory in Fulton.

In the January 1916 issue of *International Confectioner*, reporter T.B. McRobert had much praise for Daniel Peter, referring to him as "the inventor of milk chocolate." McRobert had been covering the rising popularity of milk chocolate bars in Europe and noted that "in 1892, when I spent a number of months in Switzerland, not one of the other Swiss chocolate manufacturers—and I visited them all—made it." Fame followed Daniel for the rest of his life, and he earned awards and proclamations for his innovative candy. When he died in 1919, his philanthropic kindness was noted, but his highest praise came as the person who turned the simple chocolate bar into a highly desirable treat.

FULTON WELCOMES NEW OPPORTUNITIES FROM SWITZERLAND

Daniel Peter might best be remembered much like his neighbor and mentor Henri Nestlé. Both men were innovators—ambitious experimenters who would look at a problem and not envision defeat, but the promise of success. As it turns out, with the dawn of a new century, the people of Fulton had a lot in common with Daniel Peter and Henri Nestlé. Here's how the October 1, 1898 issue of the *Oswego Daily Times* reported the community-wide enthusiasm for Nestlé's proposed factory. In its article, "A New Industry Looking for a Manufacturing Site in Fulton; To Be the Only One of Its Kind in America," the exciting news was heralded:

> [Representatives from] *The Nestlé Food Company of England and Switzerland were in town yesterday and this morning to meet a number of businessmen in the town hall in the interest of locating a condensed milk factory. The Honorable N.N. Stranahan and George C. Webb were appointed a committee to look [for] a suitable site which will take up about ten acres. The mill when built will be the only one owned in this country and the reason given for locating on this side of the Atlantic is the scarcity of milk in the old country.*
>
> *Mr. Webb, in the company with the gentlemen, drove through the country yesterday and says there would be no trouble in securing the supply of milk. The company expects, when the milk is running, to ship two [train] carloads of milk a day, use 12,000 gallons of milk per day and employ about 200 men. A capital stock of $150,000 is invested. The meeting adjourned subject to call.*

A February 1899 edition of the *Fulton Patriot* reported on the results from the initial meeting, announcing the news that Fulton had indeed been chosen as the site of the new plant. The article explained how the agreement was reached:

> *Representatives of our citizens and the company met in New York and papers were signed, showing that the Nestlé people had accepted the offer of Fulton businessmen and designated a site for the new structure, the premises of George J. Emeny on South Fourth Street, south of the intersection on Fay Street.*

There are seven and a half acres in the plot selected and Trustee Webb is circulating a subscription paper among our citizens to raise the amount necessary to pay for the same—$2,700.00—and he is meeting with a ready response from the people, who evidently are awakening to the fact that it is a good thing to nail down.

The article concludes by emphasizing that "the people of the village were willing to put up their hard-earned money to purchase a site to assure that the industry would locate here in our area."

Who were the people who raised $2,700—the equivalent of $70,000 today—to purchase land where Nestlé would begin its association with Fulton? Though I was unable to specifically identify those forward-thinking people, I can imagine how quickly their support for the new project spread through the Fulton area. It was no doubt talked about after Sunday church services, while shopping at dry goods stores and during friendly chats with neighbors. Dollar by dollar, the money was collected, sending a strong message to Swiss businessmen that Fultonians believed a Nestlé factory in their city would be as exciting as the beginning of a new century.

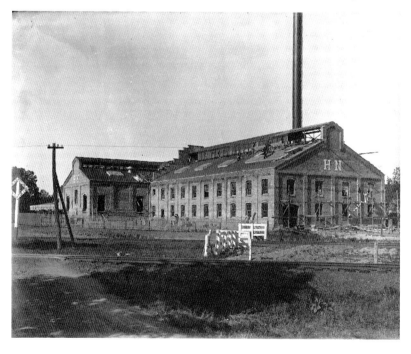

The first Nestlé building in Fulton, 1899. *Fulton Nestlé archives.*

"Construction is set to begin April 1 of 1899," the *Fulton Patriot* article continued. "Upon completion, the first milk condensing factory in the United States would measure 90x300 feet." Yes, Nestlé's first building in Fulton would be no bigger than a football field, just a fraction of what would eventually become its twenty-four-acre factory. But the article announced that it would be supported by "a boiler and engine house, pump house, tin shop, ice houses, and a railroad storage warehouse for the goods awaiting shipment." Then, with the first indication that Fulton was about to become the home of a company which insisted on the highest quality, the article shifted from building specs to business practices: "Farmers would have to be careful in the feeding of their stock to assure that there would be no unfavorable odor to the milk as it came from the farm to the factory." The newspaper report concludes with a sincere thanks to the people who made this deal happen: "On behalf of the people of Fulton, *The Patriot* renders honor to whom honor is due, and together the whole community rejoices over the bright prospects ahead—all the result of genuine American hustle."

Residents of the newly incorporated Fulton, having invested precious dollars in pursuit of an industrial dream, watched as their factory took shape. Some dreamed about being Nestlé's first hires, while dairy farmers awaited the call for their top-quality milk. But no one in Fulton had what it would take to begin milk production: Nestlé's formulas. Those would arrive with the company's highly trained staff who had agreed to leave their native Switzerland for Fulton. Six years later, a team of Daniel Peter's expert chocolatiers would make the journey, ready to share their recipes for "High as the Alps in Quality" chocolate bars. Working together, Henri Nestlé's scientific breakthroughs, Daniel Peter's innovative experimentation and the forward-thinking citizens of Fulton were ready to create our city's century of success.

2

WHEN THE SWISS CAME TO TOWN

The $150,000 Nestlé committed to the Fulton plant would amount to a $3.5 million investment today, a strong sign that the Swiss company intended to have a permanent presence in the United States. Plans for the new factory's first building placed it near the New York, Ontario and Western Railway's passage through town. The structure was even built at an angle to closely border railroad tracks, because, according to a *Fulton Patriot* article, the factory was projected to ship "two to three carloads of the finest brand of condensed milk each day." The article had more good news: "It was anticipated that the plant, when completed, would employ some 250 hands"—50 more than Nestlé's original offer had promised.

The first eighty people hired were charged with preparing for the plant's operation and they had a sizable challenge. They were expected to first learn Swiss milk production procedures and standards and then get machinery up and running to carry out the process. Leading those new employees was a team of Nestlé professionals who arrived in Fulton in 1900, each highly skilled in their area of concentration: Gustave Marquis, who would negotiate the purchase of milk from area farmers; Pierre-Samuel Roussy, in charge of milk processing; and Jules Monnerat, denoted as the chairman in charge of sales. Perhaps most important among this group was the Swiss entrepreneur in possession of Nestlé's secret infant formula: Ernest Fivaz.

The Fivaz name is familiar to those who know their Fulton history. Dr. William Fivaz, son of the Swiss-born Ernest, attended to our city's medical needs for decades. William's son, Bill, keeps the family's history, and when I

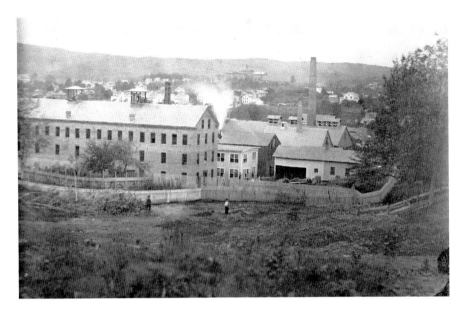

The original Nestlé factory near Vevey, Switzerland, where Ernest Fivaz worked to improve Henri Nestlé's secret infant formula. *Fulton Nestlé archives.*

contacted him with my intent to write this book, he was kind enough to share some of the Fivaz story with me, including how his grandfather first came to Fulton. Bill explained that Ernest was born in Payerne, Switzerland, thirty miles north of the Nestlé headquarters in Vevey. Ernest started working at the factory as a chemist in 1890, and during the next decade, he continued to improve Henri Nestlé's baby food formula. When Fivaz arrived in Fulton with his wife, Adele, in 1900, he brought the latest version of the formula. "It wasn't written down anywhere," Bill noted. "Grandpa had it in his head."

Along with this all-important baby food recipe, Fivaz had also been involved with Nestlé's cheese-making in Switzerland, and as Bill explained, "his 'sniffer' and taste were so acute he could tell to the day when those big two- to three-foot wheels of cheese were made." When Nestlé officials in America learned of the abundance of fresh and high-quality milk available in the Fulton area, they quickly added cheese to their list of products to be made at the new factory.

Not all of Ernest's contributions at the Fulton plant were as highly developed as precise milk formulas. Like all of the original employees at the factory, Ernest carried out any task that needed to be done to assure successful production. "One of his duties," Bill shared, "was to fumigate the factory rooms. Back then, they accomplished this by putting little bowls of

sulfuric acid throughout a room. My grandfather's job was to put a cyanide pellet in every bowl of acid and then quickly exit the room. You can imagine what would have happened if he had tripped or fallen."

In 1924, after the Fulton factory had been successfully operating for two decades, Nestlé determined that Ernest's expertise was needed at its second U.S. milk-processing operation, which was located in Sunbury, Ohio. After his move there, it became Ernest's home and workplace for the remainder of his Nestlé career, totaling fifty-nine years with the company. But that move didn't end the Fivaz family's association with the Fulton plant. Ernest's son, William, had begun working there in 1913, but young Fivaz didn't start out in any privileged position because of his father's prominence at Nestlé. A newspaper article commemorating the Fivaz family's contributions to the Fulton plant noted that William's first jobs were unloading empty milk cans from railroad cars, washing candy-production equipment and helping in the Wrapping Room. It was only later, after William became Dr. Fivaz, that his contributions became more specialized. Bill explained:

> My dad was a general practitioner, and when he finished his medical training in 1931, he returned to Fulton to start his practice in our home. Dad also became the Nestlé Company's physician. We lived just three blocks from the plant, so he could get there in a matter of minutes. He treated things like cuts or broken arms, and on Tuesdays, he did the company's physicals. A few other doctors also helped, but Dad did the majority of them. He worked as Nestlé's physician for fifty-seven years.

The Fivaz association with Nestlé continued for one more generation, this time with young Bill. Born in 1934, the only child of Dr. William and Mildred Fivaz, Bill went through Fulton schools, then completed college and a tour in the navy. By 1959, Bill had received his honorable discharge and started interviewing for a job in sales, and he was eventually hired by the Nestlé headquarters in White Plains, New York. He continued with the company, working in several East Coast locations, until his retirement in 1996.

As I listened to Bill explain his family's commitment to the Nestlé Company, I imagined the great source of pride it must be for the Fivazs. Bill confirmed my hunch when he shared this piece of family history: "I still have Gramp's gold pocket watch that the Nestlé president presented him on his 50th anniversary." I paused a moment to reflect on the Fivaz family's years of service, attempting to total their numbers, but Bill beat me to the punch: "Combined, the three of us had over 150 years with the company."

Bill Fivaz was one of the first interviews I conducted for this book, and the number of years his family devoted to Nestlé was surprising, but I'd soon learn that many Fulton families have long histories of dedicated work to the plant, racking up equally impressive years-of-service totals. I like to think that one of the reasons other families remained loyal to Nestlé was due to the example set by the Fivazs, whose patriarch crossed the ocean not only to help found a new factory but also to establish a new city.

Once Ernest Fivaz, his fellow Swiss entrepreneurs and new hires from Fulton set up the Nestlé plant for milk production, those living in and around the city began waking up to a new sound: horse-drawn carts clinking and clanging their way on gravel streets, carrying forty-quart metal cans filled with fresh raw milk. For dairy farmers, that noise was a ringing of celebratory bells. They were proud to be delivering their product to this new company, one that was carrying out its business practices with principles never before extended to farmers. Prior to Nestlé's arrival in Fulton, dairymen did not have a formal system for negotiating fair compensation for their milk. In fact, the vast majority of dairy farmers were receiving as little as two cents per quart (equivalent to fifty cents today), which only managed to cover about half of their milking and delivery costs.

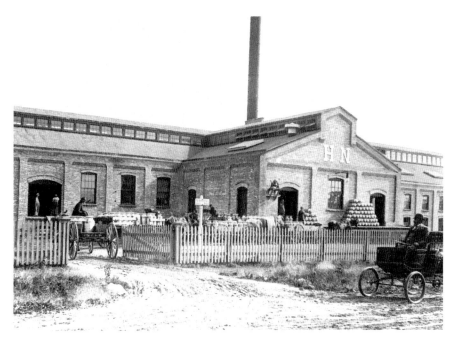

Early 1900s milk delivery to the Fulton Nestlé factory. *Fulton Nestlé archives.*

It would be 1921 before the League Cooperative Association was formed to serve as a milk-selling operation, helping to provide dairy farmers appropriate compensation for their product. But even in the years prior to the association, Nestlé treated dairy farmers as businessmen, and those contracting with the new Fulton factory had official documents regulating their milk deliveries and financial compensation. A review of a 1913 contract revealed Nestlé's commitment to excellence. The contract listed the Nestlé Food Company as the party of the first part and local dairy farmers as the party of the second part. Here's some of what it covered:

> *The party of the second part agrees to sell and deliver to the party of the first part the number of pounds of good, pure milk from _____ to _____.*
> [Contracts were normally binding for six months.] *Regarding the quality of the milk, the following conditions will be exactly observed:*
> *a) The party of the second part will provide necessary cleanliness of the stable, the attendants and utensils.*
> *b) Special care must be taken in milking the cows.*

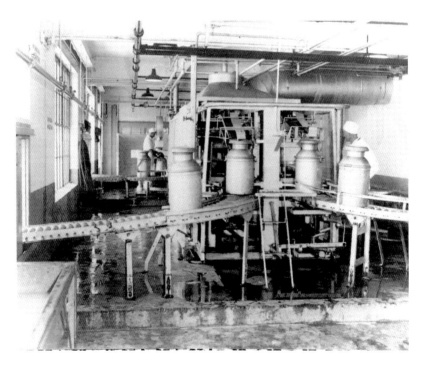

Containers of fresh raw milk from area farmers entering the Fulton Nestlé plant for processing. *Fulton Nestlé archives.*

c) The inside of stables must be whitewashed twice a year.

d) Manure must be removed from stable every day.

e) Cattle must be fed in the best manner according to the resources of the vicinity; no fermented food of any description must be given, with the exception of ensilage [a high-moisture grain byproduct] *from full grown corn, well preserved and free from rot or mold.*

f) The cans necessary for transporting the milk from farm to factory shall be cleaned by the buyer and must be stored at the farm in a clean and dry place and used for no other reason than the care and transporting of the milk.

Dairy farmers who agreed to abide by Nestlé's strict milk standards would receive payment from the company a week or so after a milk delivery. A 1921 paystub, kept among the paperwork by former Nestlé employee Ron Woodward, shows how sales were documented in the early days of the factory. The stub indicates that the farmer provided 3,689 pounds of milk between June 16 and 30, for which he was paid $55.70 (equivalent to nearly $700 today). Also included on the stub was the percent of butterfat in the milk after it was tested (3.6 percent), assuring the factory that its quality met Nestlé standards. Finally, the paystub listed the deduction of $1.20 to cover the monthly rental fee for milk cans used in delivery.

PETER'S CHOCOLATE COMES TO TOWN

With both farmers and factory managers pleased with how Nestlé conducted its business practices, news of the Fulton plant's success spread, not only in and around the city but also across the ocean. Just a few years after the Fulton factory's debut, Nestlé's owners received a request from another Swiss company. In 1904, officials from the inquiring company asked Nestlé if they could make space at their Fulton campus for the manufacture of an additional food product: the milk chocolate candy bar. Peter's Chocolate was anxious to introduce its quality candy bar to the United States, and what better place to produce it than near a milk processing plant? It would take a few years to negotiate the agreement, but much like the company's two founders, Peter's Chocolate and Nestlé Foods were about to become neighbors.

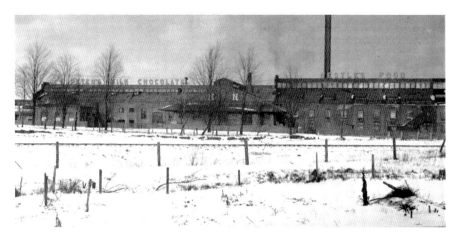

By the end of Nestlé's first decade in the United States, Peter's Chocolate had become its Fulton neighbor. *Fulton Nestlé archives.*

Well before Peter's looked to expand in the United States, its candy bar had become a popular confection in Europe. The descendants of Daniel Peter built on their milk chocolate fame by creating a partnership with another successful company, Kohler & Sons, which had invented a hazelnut chocolate delicacy. The two companies merged as the Peter Kohler Company, and in 1907, management negotiated a deal with Nestlé to begin producing chocolate bars in Fulton. Two years later, a third company, Cailler, founded by Daniel Peter's in-laws and specializing in a thick, creamy confection known as fondant, joined in. The three companies, now known as the Peter Cailler Kohler Swiss Chocolate Company, or PCK, were a good match for Nestlé's proud production standards, introducing their "High as the Alps in Quality" pledge to the city of Fulton.

To make way for this new production at the Fulton plant, Nestlé made the decision to move its condensed milk and cheese operations to the factory in Sunbury, Ohio. Nestlé's remaining milk product, its infant formula, continued on in Fulton until 1924, when it joined the others in Sunbury. At that point, PCK's chocolate production took over the entire Fulton factory and fresh milk became not its main focus, but an important candy bar ingredient. Dairy farmers needn't have worried that their services would no longer be in great demand. America was hungry for milk chocolate bars, and soon Fulton was producing them in extraordinary amounts.

Farmers weren't the only people happy to have an expanding production line at the Nestlé plant. As the call for PCK's chocolate products increased, more workspace was needed. New buildings were erected, turning the once

spacious eight-acre campus into a crowded industrial hub. And the 250 people who were employed during Nestlé's first few years in Fulton soon had company. PCK's production plans meant 600 people would be hired to make all those candy bars.

Another group of professionals from Switzerland guided these new employees in the art of chocolate making. To head up the operation, PCK sent Samuel Grande, who would not only oversee new building construction and installation of special candy-making equipment but also manage the team responsible for setting up production. His handful of skilled chocolatiers were selected for their areas of expertise: Gustave Dentan would be in charge of the treatment of cocoa; his wife, Elsie Dentan, would oversee candy bar wrapping; Louis Michaud, trained as a milk condenser back in his homeland, would be responsible for dairy processing; Ernest (also shown as Emile) Brechon was selected to instruct ingredient mixing; and Louis Ducret would orchestrate candy bar moulding* as well as introduce a step in chocolate making unique to PCK's refining process: conching. Once the preparatory phase had been concluded, Gustave Ansermet arrived from Switzerland, and as manager of the entire PCK operation, he is credited with being the first person to ever manufacture milk chocolate in the United States.

Like Nestlé's talented craftspeople, PCK's expert chocolate makers willingly left the familiarity of their native country and customs to lead this new venture in the United States. Fultonian Kathy Dann, the great-granddaughter of one of the PCK pioneers, Gustave Dentan, helped me understand the complexities of their journey to a new hometown. When she was a child, Kathy's family lived on South First Street, just a few blocks from the site of Nestlé's original buildings. That daily reminder of her heritage motivated Kathy to research her family's history, which led to the uncovering of information about the Dentans' pilgrimage to America. Here's what Kathy learned:

> *My great-grandparents were from Ork, Switzerland, a French-speaking section of that country. Gustave, his wife, Elsie, and their daughter boarded the* LaGascogne, *from France on September 3, 1907. Along with the other Swiss families headed for Fulton were 1,050 immigrants from Hungary, Italy, France, Ireland and Germany. On September 9, they arrived at Ellis Island.*

* PCK and Nestlé referred to the equipment used to form its candy bars as "moulds," the British spelling of "molds."

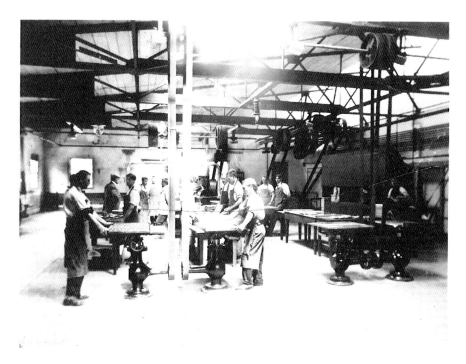

Milk chocolate bars being moulded at the Fulton Peter's factory, 1908. *Fulton Nestlé archives.*

It would be two more days before those travel-weary families got a look at their new hometown. Most of that leg of the journey was by train, but the last few miles, from the Lackawanna station in Fulton to their homes, were rather unconventional. In a horse-drawn carriage normally used as a hearse, the Swiss women and children were transported to their new housing. Since room in the carriage was limited, the men were required to walk behind it, which, according to newspaper accounts of the new arrivals, "greatly upset their wives." It wasn't until they met Adele Fivaz, acclimated to Fulton after calling it home for seven years, did our city's newest residents relax.

The families' outlook improved when they were escorted to their new homes. In an attempt to make those important chocolate makers feel welcome and comfortable, Nestlé had built a row of houses on a nearby side street aptly named Nestlé Avenue. Bill Fivaz recalled that his grandparents lived in one of those homes. "Growing up," Bill said, "I remember their house literally being in the shadow of the plant." Apparently, Nestlé did a good job of constructing them, since Bill was able to add, "It's still standing today."

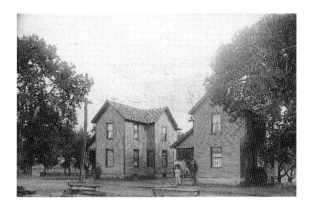

Two of the Fulton homes built for Swiss families who helped start the Nestlé factory. Records indicate that each house cost $900. *Fulton Nestlé archives.*

Dick Atkins, who held a managerial position at the Fulton plant, shared more about those original homes and the care Nestlé took to accommodate its Swiss chocolatiers: "When they built them, they were heated by the boilers in the plant. In fact, their steam lines still can be found under Fay Street. They're no longer working, obviously, but they're still there."

Once those first PCK leaders assumed their chocolate production responsibilities and their families settled into new homes, they gradually adjusted to life in Fulton. In some ways, they found their adopted hometown to be much like what they'd left behind, including upstate New York's colorful autumn foliage and winter's significant snowfall. Once the new immigrants ventured out to shop for groceries and supplies, they met others who'd left their homeland for a better life in America. With such a warm welcome, many of the first PCK workers devoted the rest of their careers to the Fulton plant, never moving from those company-built homes.

Along with their chocolate expertise, the Swiss immigrants also brought traditions from back home to their new workplace. Fultonian Dean Stuber shared this story about his grandfather Frank Benjamin Stuber:

> When my grandfather [started at] *the company in the early 1900s, he worked two jobs. He cooked for either Nestlé officers or in the cafeteria, and he also trained horses for the officers. Grandpa also brought a Swiss custom with him: yodeling. He was a great yodeler, and I remember my grandmother saying that when he worked in his fields on the other side of Lake Neatahwanta, he would stand on a little hill and yodel across the lake. My grandmother would hear him, and by the time he got home, his supper was ready.*

A 1962 *Fulton Patriot* article reflected on the proficiency of the first Swiss workers who brought their chocolate-making talents to America.

Those men and women, the article points out, were so well schooled in the steps to making candy bars that they saw no need for written recipes. Much like those who had started Nestlé's American milk production from memory, the first instructions on how to make chocolate were shared person to person. Precise formulas were entrusted to Fultonians who, in turn, passed them on to those who followed. That word-of-mouth process would continue for generations.

The *Patriot* article also mentions that the families of those first Swiss confectioners—their children, grandchildren and great-grandchildren—continued to carry on the tradition of working at the plant founded by their ancestors. I was fortunate to be able to talk with several of the founders' descendants, hearing stories of entire lives devoted to chocolate making and their adopted hometown of Fulton. When I learned that some of those Nestlé and PCK founders were buried in area cemeteries, I decided to pay a visit to their gravesites. On a muggy summer evening in August 2017, I took a drive to the Mount Adnah Cemetery in Fulton, looking for the Swiss names I'd been researching.

Locating actual PCK- and Nestlé-related headstones was harder than I thought. Though I'd found the section of the cemetery where its caretaker told me I'd find the names I was looking for, I was having trouble reading many of the time-tarnished stones. After several passes, I gave up trying to identify specific burial sites but continued walking between the rows. I was well aware of the fact that the cemetery is just a mile north of where the plant once operated. A breeze blowing from the south and the gathering gray clouds set the familiar stage for a rainstorm. It was the sort of night that, when the factory was in full swing, the aroma of chocolate would have drifted through the air, passing over these very grounds, where Nestlé founders, who willingly shared their candy-making secrets with our city, are laid to rest.

3

FROM COCOA BEAN TO CHOCOLATE BAR

I f you never had a chance to visit Nestlé while it was in operation, it's hard to imagine their process of turning raw materials into millions upon millions of candy bars. Though the aroma of chocolate assured all of Fulton that production was ongoing, most of us have no idea of the precise steps necessary to produce such a delectable smell and taste. Even Nestlé employees themselves rarely knew chocolate from start to finish, since many worked their entire careers in the same department and covered one phase of production. Those who did transfer around the plant would have learned those pieces of the process only for the years they were employed there. Few people ever knew the full one-hundred-year story of how chocolate was made in Fulton.

I was fortunate that our city's historical society gladly shared its collection of Nestlé memorabilia, including several thick scrapbooks filled with newspaper articles about the plant's evolution. In addition, several longtime employees shared company progress reports, records and production notes. From this data, I pieced together a step-by-step overview of Nestlé's chocolate making. This chapter covers how it all took place.

Making candy is a long and involved process, and as I began putting the steps in order, I was already aware that the formulas for those steps had been perfected in Swiss factories 3,800 miles from Fulton. But in order for our city to take their first step in chocolate making, the Nestlé Company had to travel thousands of miles in a different direction, looking for one very important ingredient.

STEP ONE: HARVESTING THE COCOA BEAN

The distinctive taste of chocolate we enjoy when biting into a candy bar can only be derived from the seed of a cacao tree. Though the cacao can be found throughout the tropics, it only reaches its optimal fruit-bearing maturity within ten degrees of the equator. Over its many decades of making chocolate in Fulton, Nestlé brought shiploads of the cacao tree's seeds, known as cocoa beans, from exotic locales such as the Gold Coast of Africa, the Caribbean, Colombia, northern Brazil, Venezuela, the Tropics of Central America and Samoa. There, the natives of those countries handled the first step in chocolate production.

Before cocoa beans traveled to our city, plantation workers used long-handled cacao hooks to reach seedpods from the trees' highest branches. On the edge of growing fields, mammoth piles of pods were collected and then swiftly cracked open with a few machete cuts, each pod releasing twenty to fifty wet, sticky seeds. Workers scooped the seeds out with a wooden spatula, releasing their distinctive scent, thus alerting nearby wildlife to a potential feast. From that point on, while in their motherland, the aromatic seeds were guarded by plantation workers.

For the next ten days, under temperatures approaching triple digits, a fermentation process took place, causing the cacao beans to develop their characteristic flavor. Fermenting also dried the beans, reducing their moisture content from 60 to 5 percent and shrinking each bean's weight to less than two ounces. Once at the Fulton plant, it would take about four hundred of them to create a pound of chocolate.

As the beans neared their scheduled departure date, they were packed in burlap sacks, weighing between 150 and 200 pounds when full. Under tropical sunny skies, thousands of the bags were loaded onto cargo ships and unloaded at U.S. East Coast ports. Early in Fulton's chocolate-making history, cocoa beans entered our country via major ports like Newark, New Jersey, and New York City, but in the early 1960s, a major breakthrough in shipping options brought the beans much closer to their final destination. The Port Authority of Oswego, twelve miles from the Fulton plant, began accepting the tropical cargo.

There was good reason to celebrate Oswego's willingness to work with Nestlé. As the first tropical food product imported through the St. Lawrence Seaway, the bean shipments proved to the rest of the world that Canada and upstate New York had great potential as major North American deep-water port destinations. For Nestlé, the company was pleased to receive

the important chocolate ingredient hundreds of miles closer to its Fulton destination. To express its gratitude, the factory took out an ad in a June 1963 issue of the *Palladium-Times*. It was a thank-you letter of sorts, with Nestlé praising the port authority for its cooperation, signed by "the 1,400 chocolate and cocoa makers of Fulton."

Workers on the Oswego docks waiting to unload the tropical cargo got a firsthand lesson in Nestlé's strict adherence to product quality. Before the cocoa beans were allowed on American soil, random samples were fed into portable laboratory equipment set up on the docks. Testers examined the raw material, looking to make sure beans were of a predetermined size, had a specific moisture content and were properly fermented back in the tropics. Inspectors also selected a few bags to open, searching for any other foreign material that had unknowingly made the trip.

If, and only if, all test results were within acceptable limits, the shipment was approved for delivery to Fulton. Stevedores, who coordinated loading and unloading ships at the port, hired workers to move the mountains of bean-filled bags. Ron Woodward, who would later work at Nestlé, unloaded sacks of cocoa beans when he was a teenager. "You could see that boat rise right up out of the water as the beans were unloaded," Ron explained. "It was hard work; you'd go at it for half an hour and rest for ten minutes. We had to watch out down in those ships because there'd be spiders and snakes from other countries. But they paid $8 or $9 an hour, which was a lot of money for a kid."

Once the bags were unloaded, railroad cars or trucks moved all that heft to the Fulton plant. Passing through the factory's gates, the beans headed to the first of many buildings,* where workers turned that tropical product into America's favorite chocolate treat.

* A general note about Nestlé buildings in Fulton: With the exception of managerial and clerical offices, buildings were large warehouse-type spaces. These were often two or three stories high from floor to ceiling and were filled with unusual-looking equipment, sometimes dozens of the same machine sitting side by side. To the untrained eye, the machines looked like they'd be right at home in a science fiction novel: some rocket-shaped, with tubes connecting them to other machines; others like huge potbellied stoves or gigantic funnels. There were ramps, pulleys and conveyor belts moving in and out of buildings. There were few, if any, windows and rarely any chairs or tables. The people standing next to these monstrous machines looked small in comparison, but they were doing big work.

STEP TWO: THE BEAN ROOM

Initial tests at the docks confirmed that the beans were ready for chocolate production, but after their long journey under extreme weather and travel conditions, they first needed to be cleaned. Nestlé policy required the unclean beans be stored in an area isolated from the rest of the plant, safeguarding against the possibility of foreign contamination infiltrating other buildings and beyond. The factory's storage area was known as the Bean Room, and in Nestlé's later years, its workers wore special protective clothing and footwear. They were not allowed to interact with anyone from the rest of the plant, nor could they enter other buildings before they'd been properly decontaminated.

Brian Kitney, a forty-three-year employee of Nestlé, started his career with the company in the Bean Room, and in 1962, nineteen-year-old Kitney got his first look at what would be his work environment for several years. "The Bean Room was roughly twice the size of a school gymnasium," Brian remembered. "Piles of burlap bags filled with cocoa beans were stacked about ten to twelve feet high. It was our job to build those stacks and keep them neat."

While the sweet smell of chocolate was what those of us outside the plant were enjoying, employees in certain Nestlé departments weren't quite as lucky. Former Bean Room workers described their work environment not with a candy bar smell but more like the pungent odor of raw cocoa. Thousands of burlap bags added the hint of a farm barn to the air. Other senses were also challenged in the Bean Room, which was unheated. "In January, when it was ten below outside," Brian commented, "we used to call it Little Siberia."

In the heat of summer or the chill of winter, Bean Room workers were earning their wage. Dave Wolfersberger, a thirty-two-year Nestlé employee, also started his career in the Bean Room as a teenager, and he described the first step there as "unloading the 150-to-200-pound cocoa beans bags. Those came in on the railroad cars."* Later on, tractor-trailers replaced railroad cars, and Wolfersberger also unloaded those. But no matter if by railway or truck, the workers in Nestlé's Bean Room used the same method to unload them.

* Trains had been a familiar sight in Fulton long before chocolate was being made in the city. By the time Nestlé began operation there, more than thirty passenger and freight trains were powering through on a daily basis. Old timers who worked for those railroad companies recall stopping at Nestlé two or three times a day. The company had commissioned for one of those tracks to sideline directly into the factory, where it split into two so empty railcars waiting to be taken out didn't block full incoming cars.

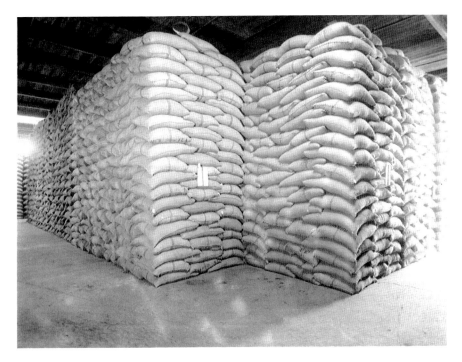

Stacks of cocoa bean bags awaiting their turn to go through the steps of Nestlé chocolate making. *Fulton Nestlé archives.*

"We had hand hooks," Dave explained, "which were basically a piece of wood with a steel hook in them. You held one hook in each hand, grabbed onto a bag and moved them onto pallets. Two of us worked together, one on each side of the bag, with one hook on top and one on the bottom."

The system sounded pretty smooth, and I asked Dave if it was as simple as it seemed. He assured me that unloading those bags took a lot of practice: "We had a system to roll the hooks just right as the bags were lifted and moved to pallets. You learned to get a rhythm with your partner. If you didn't, you could get injured or add extra stress to our bodies because we were expected to move nine hundred of those bags a day."

One longtime Bean Room employee explained that when they hit their nine-hundred-bag mark, their work for the day was done. Especially on the overnight shift, reaching that number as quickly as possible was a strong motivation for Bean Room crews. For the speediest nighttime workers, that could sometimes be achieved by three o'clock in the morning. After taking their scheduled meal break, it wouldn't have been out of the ordinary to see

workers climb to the top of those towering bean bag stacks and make a little nest to catch a nap. And who could have blamed them? They'd earned their keep, having just moved 160,000 pounds of beans.

The pallets of bagged beans were forklifted into the Bean Room, where workers next had to turn them into those towering stacks. That wasn't as simple as hooking the bags into piles. For one thing, as anyone who's tried to stack items that aren't perfectly flat can tell you, after a certain height, those bags could start leaning like a certain tower in Pisa. Brian Kitney remembered a time when the plant manager came through the Bean Room on an inspection. As he walked by, one of those piles started teetering and went over, taking with it anything—or anyone—in its way. Workers panicked that the head of their company had just been buried in beans until they saw his head pop out from the other side, unhurt.

There's another reason why those stacks of beans had to be organized so carefully. Those of us who prefer the taste of one chocolate bar over another may not realize that unique flavor starts with a specific variety of cocoa beans. The half-dozen tropical locations where Nestlé purchased beans had their own growing environments, and those different climates gave each crop of beans a distinctive flavor. Once at the factory, the bean sacks were stacked according to tropical region and variety. One worker recalled twenty-four different types of beans, each claiming their own spot in the Bean Room warehouse.

When the production of chocolate was ready to begin and the request for beans came, retrieving those burlap sacks from the piles was a task for a skilled worker. Here's where those hand hooks again became an essential tool, as Brian Kitney explained: "When we needed to take sacks from a pile, we'd start from the top and work our way down. To do that, we used the hand hooks to climb to the top of those stacks like scaling an ice-covered mountain. We'd toss the required number of bags to the floor and climb back down."

Once the needed sacks were pulled, they were sent on their way by the two workers, their hooks and an old-fashioned two-wheel handcart. The bag-lifting duo would stack one, two and then three bags on the cart and a third worker pushed that heavy load to the next station. Brian explained the math that was involved with this step:

"When a call came for beans to make a new batch of chocolate, the amount needed to be processed was known as 'a shot of beans.' We knew a shot was fifty-one bags, which meant we'd have to load three bags on the handcart seventeen times." (Toward the end of Nestlé's century in Fulton,

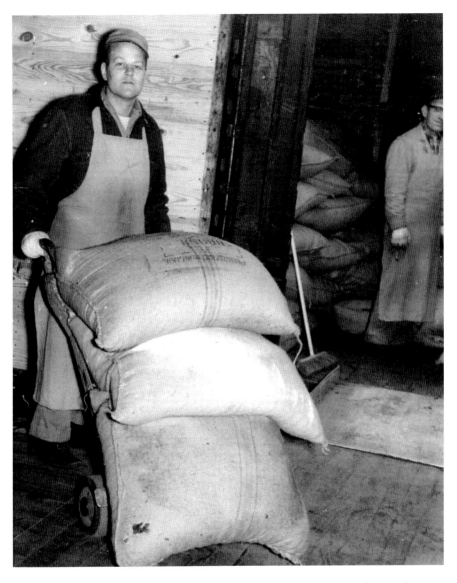

In a typical day in Nestlé's Bean Room, workers moved hundreds of cocoa bean sacks one cartload at a time. *Fulton Nestlé archives.*

the company received beans in two-thousand-pound nylon sacks, with a forklift operator moving the giant bags around the warehouse.)

Whether moved by hand or machine, what happened next to those beans required the attention of a keen-eyed worker. The bags were sent to a hopper where a Nestlé employee stood atop a grate, ready to slice open each sack. A

steady shower of beans fell through the grate's holes, heading for a series of screening steps. Beans too big, which wouldn't roast properly, or too small, which would burn in the process, were removed, along with foreign matter such as stones or twigs—and a few other things you wouldn't normally think of when considering the ingredients for a chocolate bar.

Remember that bean-quality test done on ships in ports, either in New York City or right down the road in Oswego? One of the things testers were looking for was anything that wasn't a bean but somehow ended up on the journey. It turns out that the test was a wise one, and depending on what was found, that bag—or an entire shipment—could be rejected at the port. But as Fulton workers who cut open those bags of cocoa beans for screening will tell you, some things managed to slip through.

"Once you'd cut the bag and dropped it through the grate, you could tell if something else was in there," Brian Kitney assured me. "As the beans were cleaned, any foreign material was removed." Brian and others I interviewed helped me come up with a list of items that had accompanied the beans from the tropics. Pieces of cacao tree roots or branches, snakeskins and stones were to be expected. Spiders were a bit more unusual; workers hoped to find them dead. Luckier employees found jewelry, handmade knives and foreign currency. At the end of the shift, workers could reach below the hopper to a drawer that caught those non-bean items. Nobody wanted sticks and stones, but hand-carved Ivory Coast trinkets were considered collectibles. Some workers had an unusual idea of what was desirable, as Brian pointed out: "Once, somebody found a petrified monkey, so we set it on top of the hopper and that was our mascot for I don't know how long."

There were other run-ins with unusual foreign objects. Don Nihoff, another three-plus-decade Nestlé employee, remembered a frightening experience for a member of the Bean Room's night crew: "The guy who cut the bags open found a small coconut with hair all over it. He turned white as a ghost and was hell bent to get out of there. We had to chase him [a couple city blocks] to McDonald's. The poor guy thought he'd seen a shrunken head and wanted no part of that job."

Generally, the Bean Room workers' shifts were uneventful, so they could focus on the important step of cleaning their raw ingredient. In the plant's early days, the beans were carried in on a conveyor belt over vibrating screens, leaving behind dust and dirt. A blast of air then lifted the beans, while heavier stones, pieces of iron and such were left behind. Later in the plant's history, a rotary magnet reversed the process, snagging metal particles and foreign matter that were heavier than beans. Destoners, which utilized

a high-powered force of air, removed the unwanted material. The cleaned beans were then sent via pipes and a screw-like conveyor system to a nearby building, four floors up, ready for the next step toward becoming chocolate.

STEP THREE: THE ROASTING DEPARTMENT

When people fondly remember the smell of chocolate in Fulton, it was actually the aroma of cocoa beans roasting, not the finished chocolate bars, that brightened a cloudy day. Roasting could only begin after the Production Department staff, who decided what Nestlé products were made and in what amounts, set up the factory's manufacturing schedule. Planners from that department needed to project a week or so ahead of time to make sure the bean varieties needed were available and inventory was adequate. Once those decisions were made, the information was relayed to the Roasting Department, where employees like Wendell Howard, who logged thirty years in Roasting, carried out the production orders.

"To make each formula," Wendell explained, "I'd get a slip of paper from the Production Department saying how much of each type of bean we needed to roast. I weighed the beans on a scale to make sure I was starting with the correct amounts."

For most of its history, the Fulton plant utilized a technique known as "whole bean roasting." Swiss chocolate innovators taught Nestlé workers the value of roasting beans while still in their shells. Doing so, they instructed, allowed the beans' delicate flavors to be enhanced and preserved. In the early days of Fulton's chocolate making, twenty roasters accomplished this important step. Those were common iron drums that rotated over a fire while air was drawn through, carrying away steam and acid vapors. In the 1940s, when Nestlé constructed several buildings to update its Fulton chocolate production, one building was designed to house four large roasters, each twenty-five feet long and capable of handling 3,800 pounds of beans per hour. Temperatures in the new roasters ranged from 100 degrees (known as a low roast) to 135 degrees and higher (a full roast). In their cocoon-like shells, the beans acquired their distinctive chocolate aroma, because cocoa beans, like coffee beans, don't reach their full flavor until properly roasted.

Those operating the roasters kept a keen eye and nose on the process, learning when it was just the right time to move the roasted beans to specially

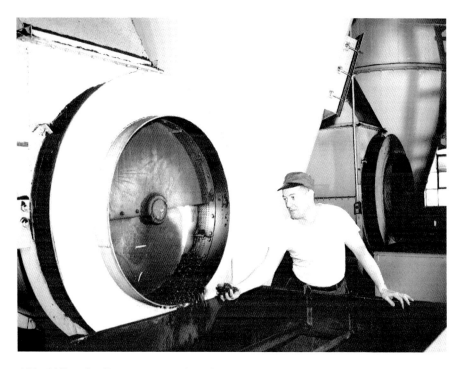

A Nestlé Roasting Department employee inspecting a batch of freshly processed cocoa beans. *Courtesy of Rick Harvell.*

built carts. Fitted with perforated bottoms, the carts connected to a suction system that drew cold air down through them, rapidly cooling the beans to prevent them from overcooking in their own heat. Then it was on to the next phase of the roasting process, where the heart of the cocoa bean would be separated from its protective home.

The rotation of the beans and intense heat as they roasted caused their shells to burst, and Nestlé ingenuity took care of removing them in a process known as "cracking." Initially, the beans were fed into iron rolls that crushed them and then passed over a series of sieves where blasts of air blew the shells away. Workers needed to watch this process closely: too strong a blast might also pick up small particles of the bean's meat; too light a blast would keep inedible shell pieces in the process. Eventually, Nestlé developed a more sophisticated method to separate bean from shell in machines known as "winnowers," doing their job with a series of small hammers that cracked the shells open. Those shells, greatly reduced in weight through the dry roasting process, easily fragmented and were lifted into the air by each winnower's wind machine, nicknamed "The Cyclone."

Once separated from their beans, you might think those shell fragments were headed for the dump, but that wasn't the case for Nestlé. During peak production times, with ten of those winnowers each cleaning between 1,200 and 1,900 pounds of beans per hour, massive amounts of bean shells accumulated. As we'll see over and over again in Nestlé's chocolate-making process, the company's goal was to find a purpose for every ingredient and byproduct. Having dutifully fulfilled their role of delivering cocoa beans over thousands of miles, the shells still had something to offer.

After being ground into particles, the shells were packaged and sold as an excellent source of organic material. One-hundred-pound bags could be purchased for as little as fifty cents, and employees filled their trunks, using the crushed shells to enrich trees, shrubs and flowers around their homes. That unique type of compost came with an added bonus: after a light rain, gardens mulched with Nestlé bean shells smelled just like chocolate.

STEP FOUR: THE LIQUOR AND PRESS DEPARTMENT

Once cocoa bean shells were removed, the bean's meat, known as "nib," was ready to enter the next phase of chocolate production. Nibs are the thumbnail-sized heart of the cocoa bean, and they are packed with flavor—not that we want to bite into one. In fact, sinking our teeth into a nib isn't really an option, since at this stage of chocolate making, they're hard as a kernel of uncooked popcorn. More importantly, though, without the sweet and mellow additions of sugar and milk, nibs are downright bitter.

Awaiting their introduction to those other vital ingredients, nibs were sent to a holding area where they were stored according to variety. When Nestlé put in new buildings for chocolate production, one was constructed to house two rows of thirty-six metal nib bins, each seventy-five feet long and two stories high. The bottom of those bins was on the building's third floor, where workers retrieved the specific varieties of nibs needed. A large cart suspended from a rail on a spring not only served as a vehicle to transfer the nibs but also as a scale.

If instructions were to make a batch of Semi-Sweet Chocolate Morsels, for example, workers knew to put so many pounds of one type of nib, slide the cart down to another bin, load the prescribed amount and so forth. Those who scooped out nibs got quite a nosefull when they opened a bin's sliding

Nestlé workers measured out nibs and sent them to the next chocolate-making step. *Fulton Nestlé archives.*

door, the intense chocolate smell comparable to the aroma of opening a fresh can of coffee beans.

As might be expected, the next step toward chocolate production involved breaking down the nibs, reducing them to substantially smaller particles and releasing their powerful flavor. The first goal was to turn the thumb-sized nib into minute pieces the thickness of a single strand of hair. To accomplish this, workers moved full carts of nibs to an opening in the floor and poured them into a grinder below. Using techniques originally developed by flour mills to break down wheat kernels, Nestlé's updated machinery ground the nibs into the desired consistency. In the Fulton plant, a roomful of those grinding mills was almost continually in action.

Depending on the chocolate variety being produced, nibs went through as many as twenty different millings, which created lots of friction and resulted in plenty of heat. Temperatures in the machines sometimes approached five hundred degrees, which is a number we associate with baking a pizza or roasting a chicken but not making a chocolate bar. With so many machines

grinding away, Liquor and Press became a hot house, regularly reaching temperatures of one hundred degrees. It was something workers could appreciate in winter but dreaded in the summer.

Employees sweating through all that friction and heat eventually turned the nibs from a solid to a liquid known as chocolate liquor. Much like its alcohol-infused namesake, chocolate liquor packed a powerful punch. When those flavorful cocoa beans were broken down to their liquid essence, the distinctive smell of chocolate was present in a highly concentrated form. Bill Fivaz, whose family spent decades associated with the chocolate plant, remembered meeting people in the city of Fulton who worked those grinding machines: "You always knew who they were because the smell of chocolate permeated their clothes. They'd walk by and you'd say, 'Oh, you work in Liquor and Press!'"

Yes, the smell resulting from that stage of chocolate making was strong, but you wouldn't have wanted to take a sip of that liquor. Instead of fighting with the rock-hard nib to get a taste, sipping the highly concentrated cocoa liquid was a lot like drinking over-brewed coffee. More had to be done to

Nestlé employees endured oppressive temperatures from the heat generated in the Liquor and Press Department. *Fulton Nestlé archives.*

create a product people would not only enjoy, but crave. Before that could be achieved, though, the chocolatey liquid had to undergo the press phase of Liquor and Press.

Much like the intense grinding that turned the solid nibs into liquid, 5,000 to 7,500 pounds of pressure per square inch was applied to the liquor. If you're curious what that kind of compression is capable of, it's about the same amount required to crush concrete into dust. With such tremendous pressure, two byproducts of the liquor were squeezed out: the fat of the cocoa bean, also known as cocoa butter, and a dry solid called cocoa cake, or "kibble." Separately, those byproducts would travel further down the chocolate-making line to create a myriad of Nestlé products.

Cocoa butter, which was originally thought to be the only valuable part of chocolate liquor, makes up about half of its volume. After being separated from kibble, the butter was allowed to cool and form into bricks and then was set aside. It would be added back into chocolate bar recipes in varying degrees—the more of cocoa butter's fat, the higher quality chocolate bar. But before the butter could be reintroduced to the production line, it had an important step to go through. In its raw form, workers were quick to tell me, cocoa butter had a putrid smell and acidic taste.

To remedy its unpleasant qualities, cocoa butter was sent to an appropriately named room called the Deodorizer. Rita Norton joined Nestlé in the 1970s, and when she started working in Liquor and Press, she was just in time to see how the company replaced its older deodorizing equipment with upgraded models. Rita described the difference between the two:

> *The first deodorizer I worked on was an antique. It was huge—the size of a small house and it looked like a UFO. The new deodorizer was wonderful; much more efficient. In both cases, though, the cocoa butter was heated with a low temperature to avoid burning and then put through a series of filters to extract contaminants and cleanse the flavor. The byproducts they drew off of the butter were terrible—they smelled so bad and couldn't be used for anything, so they went to the landfill.*

Once purified, cocoa butter could be added to chocolate recipes, but any extra of the supply had a second, unrelated use. Over the years, cocoa butter has also become an important ingredient in healthcare products. In fact, in the Fulton plant's early history, the company which oversaw the sale of Peter's Chocolate also sold health products under the brand name Ponds. That branch of operation turned cocoa butter into hand creams and lotions,

so Nestlé workers learned about the butter's healing potential. Many brought a sample home, and it was reported to work miracles on the stretch marks of women who had recently given birth. But users had to be careful. Chunks of cocoa butter sitting in a refrigerator might look a lot like white chocolate, but it sure didn't taste like it.

Nestlé originally didn't know what to do with the other half of the pressing process, the dry and compacted kibble. (One worker described it to me as looking like "chunks of broken concrete.") Without any apparent value to Nestlé, kibble was originally thought to be another waste product headed for the landfill until researchers started running experiments with it. They found that despite the intense pressure applied to chocolate liquor, the kibble byproduct managed to retain some of the cocoa bean flavor and a trace of cocoa butter. Tests showed that when kibble was ground into a fine powder, it became a key ingredient for a new market Nestlé was trying to break into: beverages. Through years of trial and error, researchers eventually perfected the kibble-based drink and turned it into one of Nestlé's most popular products, Nestlé Quik. Later in the book, we'll discuss its flavorful history.

STEP FIVE: THE CONDENSERY AND SUGAR SILOS

Whether it was Nestlé's thriving milk factory, beginning in 1902, or Peter's Chocolate production arriving five years later, the demand for a steady milk supply kept Central New York dairy farmers in business for decades. First delivering in horse-drawn wagons, then horseless carriages and, finally, full-sized trucks, farmers made sure their product made it to the Fulton factory. In the 1930s, Ivan Parsons, who grew up on a farm just outside Fulton, worked with his father on a milk route, and he described their association with Nestlé:

> Dad drove a 1937 International 1½-ton truck, which we used to pick up cans full of milk from local farmers and deliver them to the Nestlé plant. The cans were numbered so we knew which ones went to which farmer. There was a roller conveyor outside the plant which we put the full cans of milk on and pushed them along inside the plant. The milk was dumped, the cans were washed with hot water and came out another conveyor. We loaded them back on the truck and delivered them to the farmer for the next day.

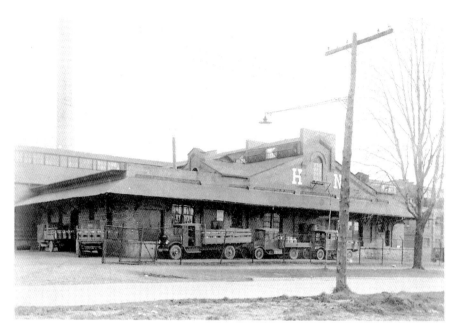

Milk deliveries to the Nestlé plant in the 1920s. *Fulton Nestlé archives.*

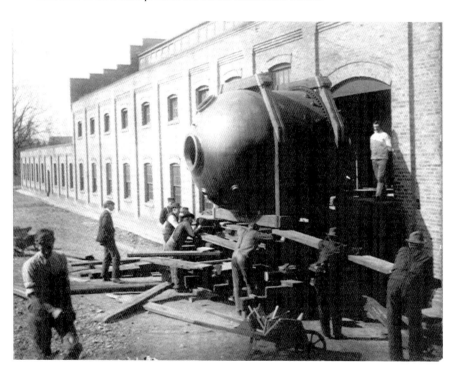

Installing one of Nestlé's first milk evaporators. *Fulton Nestlé archives.*

Decades after the Parsons family's daily delivery route, milk arrived at the plant on refrigerated trucks carrying three-thousand-gallon holding tanks, and those working in the building known as the Condensery would receive eight to fifteen of them a day. Though the Fulton plant always depended on local dairies, as the factory's demand for milk grew and high-speed transportation greatly reduced travel time, it began accepting product from as far away as Pennsylvania. But no matter where the milk was from or the era of the plant's history, Nestlé's inspectors were the first to meet each delivery.

In the early years, *sniffers*, as those inspectors were called, relied on their noses to detect undesirable odors associated with a bad batch of milk. More sophisticated methods followed, including a portable laboratory that greeted trucks pulling up to the Condensery. Once the milk had been approved and the truck's contents had been drained into an agitating storage tank, further testing took place. Inspectors standing alongside early versions of those tanks looked like small children, but as holding tank designs modernized, workers looked almost Lilliputian compared to the Condensery's new thirty-thousand-gallon silo. Along with agitators and temperature gauges, skilled operators still relied on their senses, observing the milk through a window on the tank, keeping an eye out for anything problematic.

Once the milk was deemed free of any impurities, it left the test area to be boiled down in large vats, known as evaporators, where its water content was removed, leaving a granular solid. Combined with chocolate liquor, the milk byproduct became the second ingredient for Nestlé confectionary products. While both were vital components of future candy bars, the third ingredient, sugar, topped them in at least one category: volume. Since sugar makes up more than half a candy bar's bulk, the Fulton factory needed lots of it. And true to Nestlé's unique production standards, how sugar became part of the process is a story in itself.

After traveling great distances from plantations in Cuba and Puerto Rico, granulated sugar arrived at the plant packed loose on railroad cars.* (In later years, it was delivered via trucks, packed in extra-large paper sacks.) The cars entered the plant and pulled up to an outdoor platform with a sunken holding tank below it. There, a Nestlé employee would open a door on the bottom of the car, allowing the sugar to flow into the tank. Vince Cardinal worked for several New York railroad companies, and he recalled the special technique used to unload those deliveries:

* Most of the sugar delivered to Nestlé was used in its granulated form, but some was fed into grinders for further processing. That sugar, now in a powdered form, was used to make beverage products in the Nestlé Quik or Nestea Departments.

"We'd rattle the cars back and forth to loosen any sugar stuck to the sides," Vince explained. Apparently, not all the sugar was dislodged because Vince remembered hearing about people sneaking into the Fulton plant and opening the empty cars' bottom doors, searching for any sugar left behind. "If there was, they'd collect it in a pan or a bag, but Nestlé never said a word about it," he noted. "Nor did the railroad cops, whose job it was to keep people from breaking into boxcars on the rail system. For some reason, they overlooked those people getting their sugar from the cars."

The massive deliveries of sugar that ended up at Nestlé provided workers with an unusual sensory experience. Those emptying sugar cars told me about the sweet smell in the unloading area, likening it to what you'd find when opening a package of Kool-Aid mix or taking the top off a canister of sugar. As delicious as that sounds in the comfort of our kitchens, it wasn't quite so pleasant when handling sugar by the ton. With all that unloading, sugar dust was always in the air, and once workers broke a sweat, they'd wind up with a syrupy, tacky coating from head to toe.

Sugar was such an important part of Nestlé chocolate that it had its own specially designed storage facility. After railcars dumped sugar into the underground holding tanks, it was then conveyed to silos. Though from a distance they resembled the tall structures found on farms, Nestlé's twin sugar silos were constructed of thick concrete and lined inside with oak wood, which helped control their interior moisture content. (When water and sugar come in contact it turns into a solid, which anyone who's left a bag of sugar open on a humid day can tell you.) Those silos were big: each had a capacity of 1.8 million pounds of this important ingredient. According to my calculations, that's enough sugar to sweeten 78 million cups of coffee.

I'd heard a lot about the sugar silos, and because they were left standing long after most of the Nestlé plant had been demolished, I got to view them in their grandeur. What an impressive sight they were, rising nearly sixty feet, with their twin circular structures built in the heart of the factory's campus. But seeing them from a distance wasn't anything like working alongside them, according to those who oversaw the sugar's transfer from underground storage tank to silo. To get to the top of the silos, Nestlé devised a chain-pull delivery system; it moved a series of buckets that scooped sugar from the storage tank and headed skyward. As the buckets rounded the highest part of the chain-pull, they would tip and dump the sugar into an opening at the top of the silo.

Because of their placement in the center of Nestlé's campus, the sugar silos were in proximity to the other two main components of the plant's candy production: milk and chocolate liquor. The three ingredients were

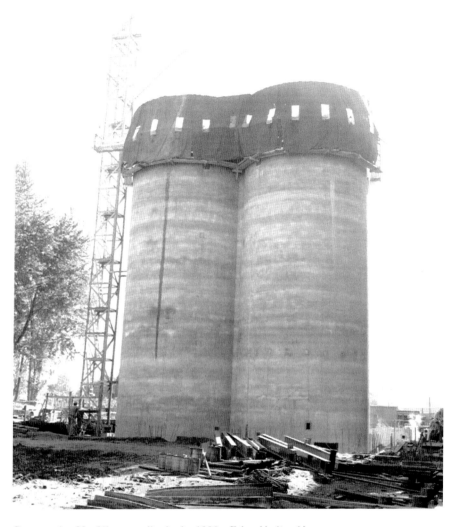

Constructing Nestlé's sugar silos in the 1950s. *Fulton Nestlé archives.*

mixed in a nearby building. At one point in Nestlé history, six large mixing units operated much like the machine Henri Nestlé invented to process his dried milk infant formula. Advancing Henri's concepts, the Nestlé factory's mixing units blended sugar, milk and liquor into a unified consistency and then dried it. This final product was known as *flake*, though workers told me that didn't really describe its consistency, which they likened to a powdered cake mix. Misleading name aside, the flake was stored in bins, inching closer to becoming milk chocolate.

STEP SIX: THE REFINING DEPARTMENT

Few people ever witnessed what took place inside the Refining Department, where flake was combined with other ingredients to create Nestlé's many candy products. The popular public tours offered at the factory skipped that step of the process due to safety concerns and uncomfortable work conditions, such as high heat and humidity. But had the tours stopped at Refining, visitors would have seen employees mixing flake with ingredients the formulas called for in vats so large that they needed stepladders to do their work. Those toiling at the mammoth vats described the churning mass as a sand-like mud with a gritty texture. Yes, they acknowledged, the mix smelled good, but it still had a long way to go to look or feel anything like its intended final product. To achieve that, the "mud" was fed into machines with two elongated rollers[*] fit snuggly together, methodically working the product. The specially made rollers were temperature-controlled to keep the mixture from overheating as the clumpy mass squeezed through them, its particles breaking down and its flavors intermingling.

Among the ingredients being added at this point was the byproduct from an earlier step: cocoa butter. Now deodorized and clarified, the butter was reintroduced to provide the full-bodied satisfaction people expect from a candy bar. Rita Norton, who worked the deodorizing step of the process, also added the cocoa butter, now in forty-pound blocks, back into the mixture. "We had to lift those blocks from pallets," Rita explained, "then push them down a chute into the vats." Those assigned to Refining were getting a workout on the job. They were required to move five pallets of cocoa butter blocks a shift, and Rita remembers about forty blocks stacked on each pallet.

Rita and others who worked in Refining mentioned the heat being generated there, challenging the Roasting Department as the hottest spot in the plant. During summers, temperatures would register three digits, but for Rita, who had endured the horrid smells of cocoa butter back in its raw state, this was a more pleasant workstation for the senses. She remembered Refining's pleasing aroma as the chocolate mixture came together and that muddy paste slowly turning smooth. One more step lay ahead before the chocolate mass could be considered suitable for a candy bar, and it was a step that arguably no one has ever done better than Nestlé.

[*] When Nestlé modernized its refiners, it increased the number of rollers to five.

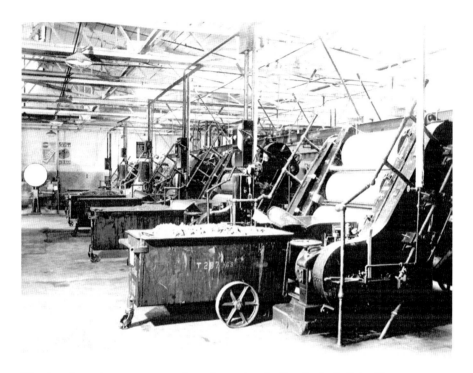

The chocolate mixtures were sent through a series of rollers in the Refining Department. *Fulton Nestlé archives.*

STEP SEVEN: THE CONCHE DEPARTMENT

If the goal of the Refining Department was to unite the mixture's flavors and textures, the goal of the Conche Department was to further work that mix, turning it from smooth into what might be called silk. It was an additional step in chocolate making that Daniel Peter had learned from his Swiss predecessors, a step that might never have been considered if one of those early chocolatiers hadn't discovered it by mistake.

It was Peter's father-in-law, François-Louis Cailler, who, in 1818, first marketed a candy bar made with a "crushing machine." The machine's two grinding stones achieved what Cailler had been aiming for by breaking down ingredients into minute pieces. Cailler began selling his crushing machine, and in 1879, Rudolphe Lindt, another Swiss candy maker, accidentally advanced the art of chocolate refining when he left his machine running overnight. Thinking he'd over-processed the chocolate, Lindt was surprised to find that, with extended friction, heat and time, its flavor more fully developed.

By the time Nestlé was setting up operations in Fulton, Cailler's machine, now known as a *conche*, was considered an integral part of the company's chocolate-making process. Named for the conche's spiral shape, which resembled a conch snail shell, the machines were as big as they were important. Each weighed a hefty eight thousand pounds and had four "pots," or compartments, together mixing over one thousand pounds of chocolate. Gone were Cailler's grinding stones, replaced with a motor-driven arm-like apparatus that moved back and forth, agitating the chocolate mixture. In principle, you might say conches operated much like an oversized eggbeater, but according to those who oversaw them, they were a work of art.

Conches were in high demand at Nestlé's first U.S. factory, but production managers didn't have to look far to purchase them. A machine foundry in Syracuse, New York, agreed to mass-produce the important equipment. And mass-produce they did. In the early history of the Fulton plant, over four hundred Syracuse conches, as they became known, were in operation. In 1987, when Fulton and the plant were preparing for the first Chocolate Fest, a citywide celebration honoring Nestlé products, thirty-five-year employee Jim Lamie told reporters about his job in the Conche Department: "Each of us workers was responsible for loading 14 conche machines. To do that, we shoveled [chocolate mixture] from carts in 25-pound scoops. The 90 degree heat created by the agitator liquefied the dry paste, and when that had been accomplished, we were also responsible for 'dipping' each machine."

Other conche workers elaborated on what Lamie meant by dipping. Here's Fultonian Ron Woodward, who started working in the Conche Department at seventeen years old: "When the chocolate had been thoroughly mixed and was ready to be removed from the conche, as its arm moved past, you took a dipper, scooped out some of the finished chocolate, and poured it into a big cart. You learned to get a rhythm going along with that arm so you wouldn't get hit by it."

Certainly, today's OSHA regulations would frown on people performing this part of conching, since they were dipping into a hot mixture while machine parts were in motion. Even without OSHA standards, Nestlé knew that people needed proper training, so first-time conchers were instructed to job shadow longtime employees. Newbies were not only observing the proper way to dip but also the impressive physical condition of those seasoned men, whose strong torsos and bulky arms made them look like bodybuilders. Mike Malash, another longtime Nestlé employee who put in years at the Conche Department, reflected on the men whom he trained under and worked with:

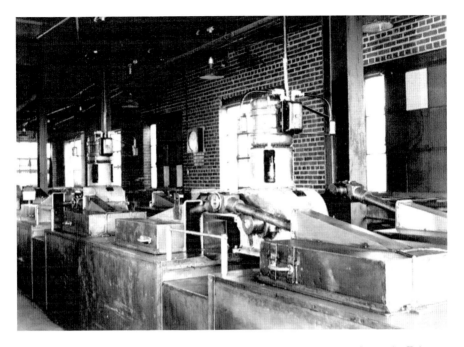

Some of the four hundred Syracuse conche machines that were in operation at the Fulton Nestlé plant. *Fulton Nestlé archives.*

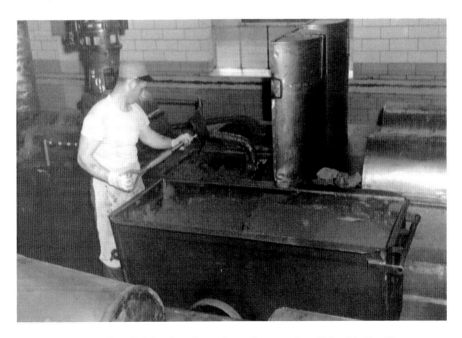

Nestlé workers carefully fed the chocolate mixture into conches. *Fulton Nestlé archives.*

Most of the guys in the Conche Department were farmers. They worked long hours at home and then came in to do a shift at Nestlé. When I first started learning how to work the conches, I watched the incredible effort those guys put into their job. One time, I thought a guy had died because he was just standing at the machine, frozen. But after a minute or two, he'd start again. I realized he was so exhausted that in between swipes he'd close his eyes and take a quick nap.

Malash offered another example of a conche man's brute power:

I was pulling a steel cart full of morsels that weighed about 750 kilograms [1,650 pounds]. I was supposed to take the cart up the elevator to dump in a storage tank and was having a hard time moving it. Along came this guy from the conches who saw me struggling. Picking up the tank with one arm, he said, "This what you want done, boy?"

The muscles powering the Conche Department also worked under the intense heat prevalent in many Nestlé departments. Even though conches were jacketed with cold-water wraps to control the chocolate's temperature and fans and vents were installed to remove oppressive heat, the area was always humid. And since most of the plant's history occurred before air conditioning was commonplace, working the conches meant working up a sweat.

Having well-developed muscles wasn't the only valuable attribute of a conche worker. Along with their strength, those working in that department had to develop an intuitive understanding of their machines. It was for their own safety, since, as Jim Lamie explained, there wasn't a lot of downtime to think about how to operate a conche: "[They] were never turned off during production hours. That was three shifts a day, around the clock. And during peak production times that meant seven days a week. Depending on the type of chocolate being produced, each batch was conched between 24 and 96 hours."

Today, researchers are still trying to figure out why the precise timing of the conche process influences the chocolate flavor and texture in such a pleasurable way. Through trial and error, the pioneers of chocolate making learned that their product could be overworked. Like over-kneaded bread loses its ability to fully rise, over-agitation of a chocolate mixture can lead to a flavorless end product. Conches at Nestlé were operated by workers who knew what "too long" meant, again relying on their senses to gauge a

batch's conditions. A concher with a good nose was able to determine when the chocolate had reached its optimal point, some describing its aroma as the "best smell in the world."

A lot of a conche worker's finesse became unnecessary when, in 1973, Nestlé announced it would replace the Syracuse conche with the "B" conche, so named not because it was the second version of the machine but because its processing compartment looked like our alphabet's second letter.* As often the case with industrial modernization, B conches were substantially larger than the original Syracuse version, each capable of processing over six thousand pounds of chocolate. Replacing the Syracuse conche's agitating arms, B's paddles created a shearing action to further develop the chocolate mixture.

B conches eliminated another task performed by that department's workers. Instead of shoveling the finished product out of conches, piping moved chocolate from the Bs to "Jumbo" storage tanks. You can probably guess why those tanks were so named. Holding 20,000 to 100,000 pounds of product, the various tanks were equipped to keep all that chocolate properly agitated and temperature-controlled as it waited to be sent to the next step. At this stage, laboratory testers evaluated the mixture in the Jumbos, and if any final adjustments were needed, they were done there. One important modification Nestlé workers made in Jumbos was something known as tempering.

Tempering involved a procedure most of us aren't aware of, but it greatly affects what we come to expect when we unwrap our favorite candy bar. Over its years of developing high-quality products, Nestlé researchers observed how temperature affects chocolate as it moves from its heated, pliable consistency to a cooler, moulded solid. Should the chocolate cool too quickly, cocoa butter will separate from the other ingredients, causing the candy bar to lose its silky sheen and "break out" in white blotches. This unfortunate mishap is known as blooming and was to be avoided at all costs.

There's a lot of science behind why blooming occurs and how tempering can prevent it, but Bob MacMartin, a Division Manager at the plant, helped me understand it without using any confusing scientific jargon:

> *If you randomly filled a room from top to bottom with chairs and knocked down a wall, the chairs would fall. But if you took those chairs and*

* A third type of conche was used near the end of Nestlé's time in Fulton. "Thouet" conches relied on computer-controlled technology to operate the machines and were used alongside B conches.

stacked them up, one on top of the other, so the legs interlocked, and then knocked down a wall, the chairs wouldn't go anywhere. What tempering does is take the chocolate molecules and make them attach to each other, as if they were stacked chairs. Tempering gives chocolate structure and stability. It also creates a chocolate bar's snap, gives it a nice gloss and prevents it from melting too quickly. Those are qualities you want in a good chocolate bar.

Tempering is achieved by adjusting the chocolate mixture's temperature, which should vary only a few degrees up or down at this critical point. Among the jobs Nestlé employee Bob Fravor performed was tempering, and he described how his years of training made sure the temperature was right where it needed to be:

There were gauges on top of the Jumbo tanks that indicated the chocolate's temperature, and if needed, I could apply cold or hot water to the tank so the chocolate remained at the correct temperature. But you couldn't always go by the gauges. I learned by one of the older guys who taught me to temper by feel. You felt the tank, and over the years, I got to know what it should feel like.

Yes, the variance of only a few degrees would determine if chocolate that had traveled all that way would end up as a Nestlé product. Another reason why a batch of chocolate might not finish its run on the production line was the company's strict adherence to cleanliness standards. Any chocolate that came in contact with an object or surface not approved for food production would be automatically rejected. Chocolate that spilled on the floor, overflowed on machinery or came in contact with ingredients not approved for that formula was taken off the line.

The rejected chocolate ended up being put through an expeller. Dennis Collins, who worked as an expeller machine operator, explained the department's goal:

[We were to] separate the cocoa butter, which could be purified and reused in non-food products. The machines had something called a "choke," which squeezed cocoa butter out of the chocolate. Once the butter was separated, it and the unusable solids were put into burlap bags marked "Not to be used for human consumption." Nestlé sold that extracted cocoa butter to cosmetic companies, and the rest went to the dump.

As I prepared to write about the final phase of Nestlé's chocolate production, I thought back on what I'd learned about the intricacies of each progressive step. Workers in every department had to be on the lookout for signs of a good, or not so good, batch of chocolate. I remember something several Nestlé employees pointed out to me concerning candy bar production at the Fulton plant: making chocolate, they assured me, was not only a science but also an art.

STEP EIGHT: MOULDING, WRAPPING AND PACKAGING

With ingredients superbly mixed and taste and texture properly mellowed, it was time for chocolate to be shaped into one of Nestlé's famous products, and for more than half of its history in Fulton, Building 30 was where that happened. In 1950, with the plant's expansion rapidly filling the main campus, Building 30 was constructed on the opposite side of Fay Street, separated from other production departments. A "sky bridge" connected the two sides, and traveling across the one-hundred-foot walkway as cars passed below was a Building 30 employee's only way to and from work. On their daily walk, workers had company. The chocolate mixture ready for moulding was also sent across the bridge, either in storage vats or overhead pipes.

Like all structures in the Fulton plant, Building 30 relied on one of nature's most fundamental forces to help Nestlé produce chocolate: gravity. With so many different ingredients and mixtures needing to be moved from point to point, factory engineers learned to work with, and not against, the laws of nature. Gravity was the cheapest energy source, and as one employee told me, unlike machinery, it never broke down. Building 30's four floors* were designed to efficiently use "what goes up, must come down" to their advantage.

Whether the chocolate ready for moulding had been walked over the sky bridge or piped through, it ended up in one of eight Jumbo storage tanks on Building 30's third floor. (Additional ingredients, such as chopped nuts or crisped rice, were also stored in Jumbos.) John Borek, who worked in Building 30 his entire forty-year career, was often assigned to clean the storage tanks out. "He had to scrape the inside of Jumbos and they were

* Building 30's first three floors were part of the original structure; a fourth floor, primarily used for storage, was added in the 1960s.

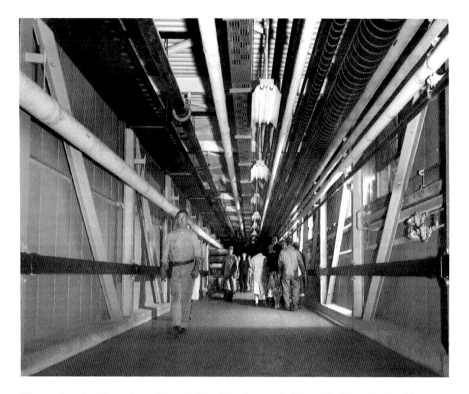

The overhead walkway from the main Nestlé's plant to Building 30. *Fulton Nestlé archives.*

big," his daughter Denise explained. "Even my dad, who was 5'11", had to stand on something to reach in."

Along with those mammoth tanks, the third floor also housed three specialty production lines, such as the "rabbit line," which produced chocolate Easter bunnies. Once the designated run of a specialty product had been completed, the moulds used to create them were replaced for the next item to be made. Saturday was designated as mould-changing day so new production could begin Monday morning.

It was on Building 30's second floor where, day after day, week after week, most of Nestlé's popular candies were moulded. During the factory's busiest years, it took nine production lines to keep up with demand, and some of those lines were dedicated to continuously manufacturing the same product. From the third-floor Jumbos, gravity dropped chocolate into several four-hundred-to-six-hundred-pound temperature-controlled kettles, and then it was on to the moulding lines. Moulds ranged in size from miniature (something that could be held in two hands) to king-size (which required a conveyor belt to move them).

Original Nestlé moulds, made from solid steel, are considered collectible treasures, and during our interview, Dave Wolfersberger, who spent many years in Building 30, showed me one he'd found at a garage sale. It was a smaller mould, with dimensions about the size of a sheet of writing paper, but when he placed it in my hands, I had to be sure I had a good grip on it. I ran my fingers across the uniform rows of depressions, each with the Nestlé logo at the bottom. When Dave explained that steel moulds were eventually replaced by plastic versions, I understood why people would consider the originals collectible. I could feel their importance to Nestlé history in my hands.

The moulds were custom built to fit specially designed Swiss machines, and workers assured me that watching them operate was fascinating. Chocolate flowed out of a depositor from above, squirting just the right amount into the moulds. Then a "shaker" jiggled them, settling the chocolate as moulds rode a conveyor belt through long cooling tunnels, some measuring 150 feet. Gravity sent the hardened bars, still in their moulds, down to the first floor, where another shaking mechanism separated bars from moulds. The moulds were shipped back upstairs for the next run and the bars headed off for wrapping.

Unlike other Nestlé departments that could be unbearably hot or have repulsive smells, the sensory challenge in Building 30 was auditory. All those metal moulds shaking and clanging significantly raised the decibel level. In addition, while the Refining, Conche and Roasting Departments endured intense heat, the temperature in the Moulding Department registered on the cool side to prevent chocolate from remelting. However loud or cold it was, though, one sensory experience made working in Moulding worthwhile. Here's how Dave Wolfersberger described it: "If you've never had a candy bar that's two minutes old, fresh off the Moulding line…well, there's nothing like it. It's so much richer and creamier, and the flavors jump out at you."

Any bars that didn't meet Nestlé's high-quality mark, whether from cracking, air bubbles or incorrect moulding, were rejected by the workers at this point of the production line. Those pieces of chocolate were sent back, remelted and then added to the process in small percentages. As one Nestlé employee commented: "They were given a second try at being first rate!"

Nestlé ingenuity and hardworking employees made the wrapping of candy bars a sight to see. Through most of its years in Fulton, the company's famous logo appeared on wrappers mass-produced at the city's Morrill Press, a printing and label company.* Morrill Press's involvement

* In the factory's early years, bars were double-wrapped. Glassine, an inner white paper, protected the candy, with the brand label placed around it.

with that step of the Nestlé chocolate process is an example of the many local businesses that benefited from the large-scale chocolate industry in Fulton. It was also a bonus for Nestlé—if the facility ran short of a certain wrapper or needed to make a change on the label's information, Morrill Press was just a few city blocks away.

Once wrapped, the bars would be packaged in various amounts: a 120-count case for bigger business accounts, a 36-count carton for supermarkets or a 24-count box that could be displayed at a corner grocery store or movie theater. For many years, those boxes and cartons had to be hand-packed, and that task was largely carried out by women.

The rationale for a primarily female wrapping crew was explained to me by several longtime Nestlé workers. They noted that most jobs at the factory, at least until equal employment laws were enacted, were designated as either for men or for women. For decades, wrapping candy bars was considered women's work, and I got to hear stories from some in that role. Roxanne Hollenbeck, who had just graduated from high school when she was hired by Nestlé in 1974, shared her Wrapping Department memories:

> There were nine lines running in the Wrapping Room, and I trained on line four, where Crunch Bars were packaged. At first glance, they seemed to be coming down a conveyor belt at warp speed. There were two women at each of the eight stations, four on each side of this four-foot-wide belt. They stood at the belt, pulling a row of nine bars off the belt onto a stainless steel shelf in front of them. Sliding the bars onto another conveyor belt, the women fed them into a wrapping machine.
>
> At the other end of the wrapping machine, another woman sat at a table grabbing eight wrapped bars at a time between her first and middle finger, and another eight between her middle finger and pinky. With her other hand she grabbed a carton, opened it and slipped the bars into it. Each carton was filled with thirty-six bars, and after filling four of them, she slid them to the edge of her stainless steel worktable. A machine operator stacked the cartons on a large cart, which was sent to a poly-wrapping station.

Roxanne thought it all looked pretty easy as she watched on her first day of work. In fact, she thought it looked like fun. Then it was her turn to try. Roxanne explained:

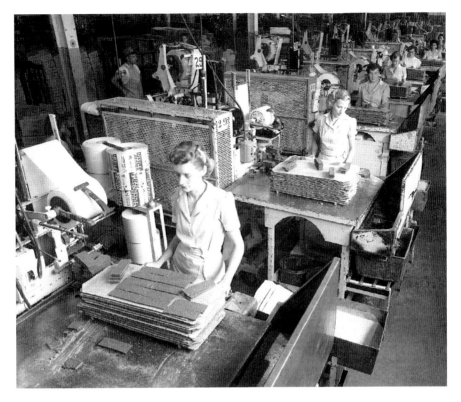

Women on the Wrapping Department line in the 1940s. *Fulton Nestlé archives.*

If you've ever seen the TV show with Lucille Ball and those candies on a conveyor belt, you'd be laughing at my attempt to do what those other women did so easily. If you pressed too hard when pulling those eight bars off the line, the bars would flip onto one another and you would have an accordion-style pile of literal crunch in front of you. After that first hour trying, I believed I'd be soon fired. Fortunately, the woman training me was very patient.

Over the years, how chocolate bars were wrapped and packaged at the Fulton plant went through some major changes. Production records from the 1920s indicate over two hundred women were employed in wrapping. By the plant's final years, most of those jobs had been eliminated, with automation and cost-saving cuts the primary reasons for this. Another factor strongly influencing the changes that were enacted was the wrappers' health. Those who worked in that department or whose mother, wife or

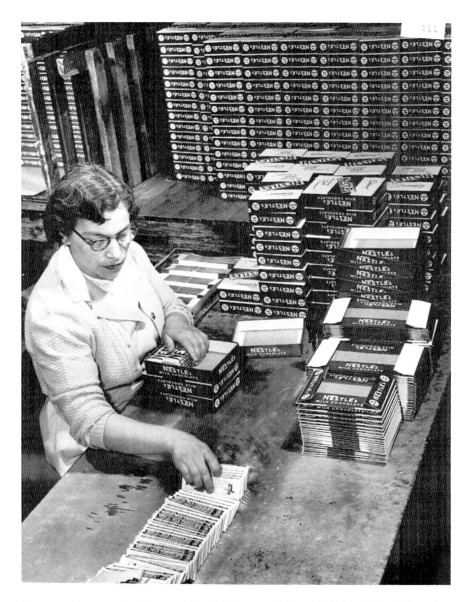

Success on the wrapping line meant learning how to quickly and efficiently handle lots of candy bars. *Fulton Nestlé archives.*

sister did, told me about the ailments associated with wrapping. Women came home after a shift with their hands cramped up, frozen in position as if they were still grabbing those candy bars in groups of eight. Some developed hip problems after years of the repetitive pivot moving from

the line to workspace. Sometimes pains eventually eased; other times, they continued. As industrial health standards improved, repetitive-motion jobs were reevaluated and often eliminated.

MAKING MORSELS

While much of the Fulton plant's output focused on candy bars, there was another Nestlé food that racked up impressive production numbers. This taste treat wasn't enjoyed as soon as customers laid down a coin at their neighborhood stores; it was carried home in shopping bags, along with other ingredients, headed for the kitchen. I'm talking about Nestlé's Toll House Morsels, the tiny, flavor-packed baking ingredient that became a go-to item for mothers of active families. We'll find out about how Toll House Morsels were invented later in this book, but once they were, the demand for them kept the Fulton factory busy. At times, production of the morsels accounted for 30 percent of the plant's workload. For many years, morsels took over a couple floors of a building, where the machinery that Nestlé engineers had designed turned huge vats of chocolate into millions of tiny morsels. Here's how those machines operated:

Toll House Morsel lines were extra-wide stainless-steel conveyor belts, wide enough to accommodate eighty morsels in each row. The belt moved through a long, enclosed tunnel as a depositor from a trough above shot dots of hot liquid chocolate. The rows of eighty moved fast enough to turn out twenty-five thousand morsels a minute. Yes, enough morsels were made *every sixty seconds* to bake nearly four hundred dozen cookies—as long as bakers didn't nibble on a handful while mixing up a batch.

I've always thought of Toll House Morsels as being triangle shaped, but their appearance is really a bit more special, as Dick Atkins explained. As the Fulton plant's supply chain manager, Dick had to pay attention to details like the morsel's unique shape:

> *They weren't perfect triangles; they had a little tail on them. Our machinery was set to operate in just such a way that when the chocolate was deposited and the depositor rose back up, it left a little tail that curled over. That was our standard. At the end of the line, if the morsels didn't have their tails they were put into a tank, remelted and given a second try.*

Fultonian Jo Ann Butler remembered seeing morsels being made on a factory tour. Her recollections aren't as technical as Dick's, but they offer another perspective of the unique process: "We watched the big machines drop down little plops on the conveyor belt. It would lay the blob and then add a little bounce to put the curl on top of the morsels." Butler goes on to describe where those specifically shaped candies headed next. "They went through a refrigerated section where the temperature dramatically changed as you walked through it. After the morsels had cooled, they were sent to a good-sized hopper."

Several people imaginatively described the end of the morsel line, some likening it to a rain shower, while others called it "a rainbow of chocolate flowing from line to hopper." Wendell Howard remembered a coworker definitively naming it "the most beautiful sight they'd ever seen." But perhaps the most important memory of morsel making was something a number of people noted. Here's how Jo Ann Butler put it: "As we walked by the hopper, they'd let us reach in and grab a handful of morsels."

Morsels that managed to avoid being eaten were sent on for packaging, but first they were screened to remove oversized chunks and then shipped in cooled bins to the building's fourth floor. From there, the morsels were "poured down" to the second floor, where Toll House packaging machines

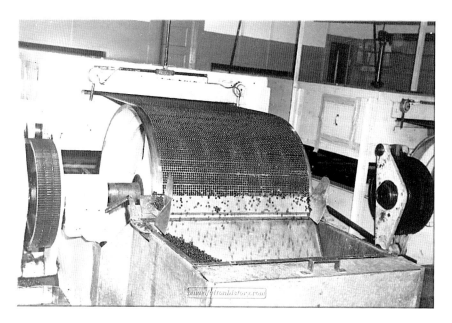

Watching Nestlé morsels come off the line was a real treat. *Fultonhistory.com.*

pumped out continuous sheets of pre-labeled plastic bags (made at Fulton's Morrill Press). The morsels were packed, weighed and sealed and, depending on the era of Nestlé's Fulton history, then boxed by hand or machine. Carton after carton was shipped to grocery stores around the country, where store clerks had to hustle to keep shelves stocked, ready for customers who came looking for "a baker's best friend."

TEN-POUND BARS

Along with renowned chocolate products like Nestlé Crunch and Toll House Morsels, there was also a lesser known, but important confectionary product made inside those Nestlé buildings. Some of the chocolate we smelled as it was being made ended up wrapped in labels other than Nestlé brands. In fact, at various times during the Fulton plant's history, up to 25 percent of its chocolate ended up on the production lines of Nestlé's competitors. That's right, high-end candy products from Russell Stover to Fanny Farmer were made with chocolate from the Fulton factory, sold to the other companies as ten-pound bars.

Those ten-pound mega-bars were part of Nestlé's Industrial Chocolate division, produced at the Fulton plant on three moulding lines: one for milk chocolate, one for dark chocolate and one for white chocolate. Formulas for those oversized bars were developed specifically for each brand-name customer.* The extra-large bars were either bagged or boxed in 50- or 1,500-pound portions and sent to the Fulton plant's warehouse. Delivery dates could often be delayed for months, per a company's instruction. Longtime employee Vern Bickford, who spent many years working in the warehouse, explained: "Russell Stover used to specify that they wanted their candy aged before we shipped it to them. We would store it for a year and only then would they accept it. Aging somehow changed the flavor to Stover's liking."

Those ten-pound bars were occasionally available for purchase by Nestlé employees. Once in their home kitchens, imaginative bakers broke off sections to create one-of-a-kind chocolate treats. Of course, breaking off a piece of that two-inch-thick chocolate slab wasn't easy; some people

* Sometimes, companies ordering the ten-pound bars made unusual requests. The white coating bars might be ordered with a green tint added to them—perhaps for Christmas or St. Patrick's Day. One man who took a Nestlé tour as a child remembered being confused when he spotted a large vat of green chocolate.

needed a chisel and hammer to break through. Ten-pound bars were popular beyond kitchens. Nestlé employee Shirley Jensen Hanley has a favorite oversized bar story: "Mary Sperati was our neighbor for many years. She also worked at Nestlé and occasionally purchased those huge bars. Sometimes, she'd give them to my husband who worked at the Lyons, New York, schools. He'd raffle off those ten-pound bars at the school's fundraising events."

The group-sized bars were certainly a favorite throughout Central New York, but they also found their way around the world—for example, the Philippines. Nestlé employee Robert Fravor's wife, Zeny, was born in the Philippines, and when she would go home to visit her family, she'd have him purchase several of the big bars to pack in her suitcases. Once Zeny was back in her childhood home, sections of a bar would be passed around, as she enjoyed time with her reunited family, munching on a chocolate treat made 8,500 miles away.

Some ten-pound bars found their way to dessert lovers' favorite restaurants, diners or ice cream parlors. If you remember watching your waitress pour

Workers on the Coating Line produced ten-pound candy bars. *Fulton Nestlé archives.*

syrup on an ice cream sundae, there's a good chance you have Fulton's chocolate factory to thank for that delicious finishing touch. Once eating establishments had remelted those bricks of candy, they provided one more delicious ending to Nestlé's chocolate-making story.

4

IT WAS A CITY WITHIN OUR CITY

From 2010 through 2017, as the teardown of the Nestlé plant took place, those of us who'd never worked there got our first good look at its entire twenty-four-acre facility. For decades, most of us only saw the outsides of a few tall buildings along the main thoroughfare, but once demolition began, the factory's immensity became quite apparent. What a contrast my perception of Nestlé was compared to those who had worked there, many who referred to it as a small, but busy city. As I conducted interviews, learning about the flow of production from building to building, I'd often get confused. Which structure stored cocoa beans? Where did the Syracuse conches endlessly churn batches of chocolate? How did workers ever manage to follow the trail of a Nestlé candy bar?

It turns out I wasn't alone in my confusion. Many former employees described their amazement when they entered the Nestlé campus on their first day of work. Jim Schreck, who was employed seventeen years in the company's Accounting Department, described his initial impression of the full factory as "overpowering, because the operation was so big." As Jim and many others confessed, just learning your way around the campus was a challenge in itself. Part of the "blame" for the confusion was due to Nestlé products' rapid rise in popularity. No one knew, when the company began its century in Fulton, how enthusiastically Americans would embrace its candy bars, morsels and Quik, and as demand grew, buildings were added to meet the factory's production goals.

For much of Nestlé's Fulton history, new structures were added without a comprehensive campus plan and were named without following a consistent pattern. Buildings were known by their number, and initially, those numbers made sense. The first building at the plant was known as Building 1. But as time went on, a new structure might have been named for the year construction was completed: Building 55 was built in 1955. Things got more confusing when some numbers were skipped and others were randomly assigned. Because of this, a new Nestlé employee needed time and a little luck to find their way around the campus, as Brian Kitney explained:

> *You had to learn the language of the plant. Someone might say, "I'll meet you in Building 32.'" You'd think you needed to find Building 32, but there wasn't one. What they meant was "I'll meet you in Building 30 on the second floor." 30–2. The language was the building number followed by the floor. But somebody new wouldn't know that—you had to learn it by trial and error.*

It was one of Nestlé's division managers, Bob MacMartin, who helped me understand the plant's layout when he showed up for his interview with several aerial-view photographs of the factory. Bob knew I'd need to see them because, like Brian Kitney, he had also struggled to figure out Nestlé's campus. Before working at the Fulton plant, Bob began his manufacturing career in a more modern facility, and he explained the difference between the two factories' designs:

> [At my first job], *raw pieces of steel would come in the back door, a machine would take them off the truck, and they'd go through several steps. The finished product was boxed and then headed out a door at the other end of the building. It was all in one straight line and that factory's buildings were all on one story. It also had columns that were numbered 1 and so on, and then from A to Z, for the width of the building. Someone would say, "So and so wants to see you in Building 3, A-4" and you'd know exactly where you were going.*

Bob's concept of a factory's layout was turned upside down when he began work at the Nestlé plant:

> *On my interview for the job, the person giving me a tour walked us up and down ramps and such. I wasn't really paying attention to where we were*

going, but when we got there this person seemed to have taken me through effortlessly. I figured, How tough can it be? It's one big building.

Actually, it wasn't one continuous building that Bob had walked though. His tour guide had moved him in and out of several buildings connected by enclosed walkways, and once he started working on his own, Bob had trouble finding his way around the plant. Knowing he had to overcome his navigational challenges, he came up with a plan:

I used the cafeteria as a starting point. It was easy to get to from my office, and there were signs throughout the plant that pointed the way to the cafeteria, making it easy if I got disoriented. Beginning from there, I could go up or down, left or right. To start, I took a right, which was where the original building was located. That had lots of little rooms, set up for the smaller volume of product the factory put out in its earliest years. I headed down a flight of stairs, and all the sudden I was in the Rice Department. I backtracked up the stairs, went to the end of the hallway, and came to Westreco [where the factory conducted research and product testing]. *I turned and continued down the hall, tried another stairway and I was in Cookie Mix. I asked someone what that department was and was told Nestlé didn't make Mix any longer, but they still called it that.*

All that information was tough for Bob to develop into a factory travel plan, but he found that his senses could help him remember room and department names: "The Strawberry Quik Department had its sweet strawberry smell and the Almond Department, where they'd wash and roast the nuts, had an amazing smell." Bob thought he'd figured out that part of the factory until someone told him he needed to attend a meeting in the Almond Department. He retraced his steps (and senses) through the many departments to reach his destination. "I went around the corner," Bob explained, "and walked right into a brick wall. Since the last time I'd been there, a flight of stairs that were no longer needed had been removed! The maintenance staff was constantly changing things to upgrade those older buildings."

Next, Bob began mastering the Nestlé factory to the left of the cafeteria, where he ran into some different challenges:

Immediately, I went up this ramp and the only place I could go was to the right. I then went down a ramp, which seemed strange. There I heard a loud noise, which was coming from mixing machines—I was in the

Refining Department. Around the corner from there was Iced Tea Mix. I went another 100 feet and I'm in Liquor and Press. If I had kept walking, I would have been in the Condensery. I hadn't gone 200 yards and I'd been in four different departments. It just didn't seem right.

Finally, things started making sense when Bob explored what happened when he changed to a different floor. Starting again at the cafeteria, he headed up a flight of stairs and walked first to the left or then the right, where he saw the same departments he'd just been in on the floor below. That's when a light bulb went off and Bob began to understand the plant's path of chocolate-making:

[I realized that] *they processed the milk in the Condensery, which ended up as flake. Bean processing took place in Building 58, right next to the Condensery, because they needed the flake as a component to mix with the liquor and cocoa butter. Then raw sugar was added from the nearby silos. All those ingredients had to meet in one place, the Refining Department, so Nestlé developed the plant with those steps taking place near each other on several floors.*

Nestlé multistory buildings could be a challenge to navigate for new employees. *Fulton Nestlé archives.*

Finally, it made sense to Bob. Unlike the one-floor horizontal setup he was used to at his previous job, he was now working with Nestlé's vertical chocolate-making process.

Bob's aerial map helped me further understand what he'd learned. In the center of the map is the heart of chocolate making: the Condensery, Bean Processing, Mixing, Refining and Conching. Surrounding those buildings were departments that supported chocolate production: Crisped Rice, Almonds and Special Products; the Warehouse where candy was stored and shipped; and the Research, Accounting and Management offices that oversaw production. Off on its own, across Fay Street, Building 30 handled moulding and wrapping. Viewed from above, the city that was Nestlé began to make sense.

It's true that a factory built today would never be designed like Nestlé's layout, but as Bob pointed out, those who orchestrated the plant's expansion had to work with what they had. Despite its misgivings, he also noted, Nestlé was an efficient plant:

> *When Fulton competed with other Nestlé factories for production—who got to make which product and how much of it—our plant could move massive amounts of material. It was really hard to compete with us from a cost perspective. In fact, people from other plants came to Fulton to learn how we operated. And not just from our researchers and product developers, but also from our mechanics and line operators. Together, our workers figured how to do it.*

While I was aware that the Nestlé plant had greatly expanded over the years, I didn't fully understand its progression until Bob showed me a second aerial map, which had buildings labeled by their year of construction. By combining the map's information with newspaper articles and company documents, I was able to summarize the plant's growth from a turn-of-the-century handful of buildings to its ultimate sprawling city. Here's a decade-by-decade overview of the expanding Fulton factory. (See Appendix B for a map of the expansion.)

1900–1910. When the factory was founded, a single brick building handled the company's milk manufacturing. By 1907, Peter's Chocolate had started production, both in that original building and a few additional structures.

1910–1920. In its second decade, Nestlé added six new buildings, including the Ice Plant, Boiler House and Laboratory, as well as maintenance and administrative offices.

1920–1930. During this slow-growth period following World War I, Nestlé added a new Bean Delivery Room and a refurbished Boiler House to its campus.

1930–1940. A large receiving area and several other production buildings completed the factory's presence along the city's main street. A Pump House and a Coal Dump were also added* and a four-story Warehouse and Distribution Center was established on the northeast corner of the plant.

1940–1950. This decade, which included the World War II era, was a time of great expansion for Nestlé, including a new Cocoa Processing Department

* The Coal Dump became a flour shed in the 1940s when boilers were converted to oil-fired.

and expanded Chocolate Refining Area. A newspaper article reported that the expansion was due to increasing demands for Nestlé and Peter's products, noting that the plant had been operating three shifts six days a week. Also during this decade, a storage area was set aside for retention of important materials and records, such as product reports, payroll statistics, samples of candy labels and containers and newspaper clippings. It would continue to collect the factory's history until the plant closed.

1950–1960. Round-the-clock production continued, as did new construction, including Building 30; a new Condensery, which required the purchase of property adjacent to the plant and relocation of seven neighborhood homes; a new Bean Receiving Area; a new boiler; the towering sugar silos; and one new coal silo. Fulton's chocolate plant crossed the half-century mark with 800,000 square feet of floor space on twelve acres of land. At the beginning of this decade, Fulton was one of sixteen Nestlé chocolate plants throughout the world and still the only one in the United States. A newspaper reporter emphasized Fulton's important standing with the company, stating that its factory produced more chocolate than all other Nestlé companies combined.

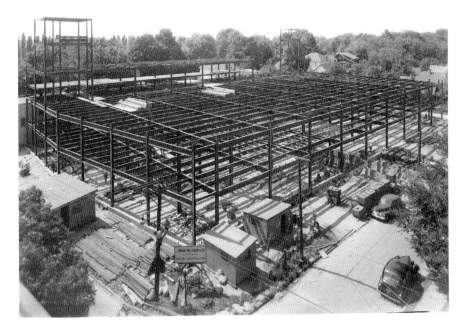

Building 30 under construction, 1950. *Fulton Nestlé archives.*

1960–1970. After such rapid growth and expansion, the plant slowed down its building construction, adding just a new Bean Unloading Area.

1970–1980. This decade also saw a single new building, but it was a major one: a 134,000-square-foot warehouse. This addition proved necessary when 24/7 production resulted in Nestlé running out of storage room, requiring the plant to contract with cities like Oswego and Syracuse for additional space. Nestlé Corporate literature describes the new warehouse, constructed in 1972, as "one of only three building projects" undertaken by Nestlé that year throughout the world. It was "ultra-modern, fully air-conditioned and humidity controlled. Using railroad [tracks] which entered the warehouse, seven freight cars could be shunted in for loading and unloading." With a nod to our region's brutal winters, the announcement noted that "to prevent possible snow tie-ups, heating coils[*] were constructed under the concrete-surfaced truck staging area."

1980–1990. Fulton Nestlé reached its peak of sixty buildings, now housing over one million square feet of floor space. Throughout the decade, manufacturing of some Nestlé products was shifted to its other plants, resulting in an employment reduction in Fulton. However, production remained strong.

1990–2000. To take care of its power needs, in 1991, Nestlé constructed a Coastal Cogeneration power plant. One final building project remained for Nestlé's Fulton plant, and it was touted as its crowning glory. With some buildings and equipment dating back to the early 1900s, Nestlé Corporate officials knew they needed to make some decisions to keep their Fulton plant competitive in the chocolate industry. After conducting feasibility studies, a decision was made to demolish some of the oldest buildings and modernize how Fulton produced, wrapped and prepared confections for delivery. Construction took place from 1992 until 1995, when this major building initiative was named Building 95. A local newspaper reported on what this $50 million addition meant for the plant: "[The] new 85,000-square-foot building…allows for the consolidation of moulded confections production from 10 lines (ranging up to 40 to 45 years old), to two new reconfigured lines. This project, in combination with the recent demolition of older buildings, also allows for significant improvement in material flow through the facility."

[*] Heated walking and driving surfaces at Nestlé were exciting news for Fulton in 1972. People today still talk about how amazing it was to use the plant's heated sidewalks. Imagine arriving at work after one of Central New York's two- or three-foot snowstorms to see the Nestlé sidewalks effortlessly melting all that snow.

Dave O'Bryan, a twenty-year employee at the plant by the time Building 95 was in its planning phase, was closely involved with the development of its super-efficient machinery. Prior to 95's construction, O'Bryan had worked in foreman and supervisory roles at Nestlé, and he was part of the Fulton team sent to Switzerland, where similar equipment had already been successfully operating. There he studied the Swiss setup to determine how to best approach the new building's equipment design. Dave explained:

> *Building 95's production line was the second largest line of its kind in the world. The company with the largest line was already operating somewhere in Europe, but in the United States, we were starting from scratch. The Swiss company assembled the equipment to do a test run for us, then disassembled and shipped it to Fulton. Workers here were going to need some sort of guidance to install the equipment since there was nothing else like it in the U.S. So, while observing it up and running in Switzerland, I videotaped it. Back home, we developed and wrote our own manuals for its operation.*

After thirty years with the Fulton plant, much of it in managerial positions, Dave Miner was selected to oversee Building 95's startup. After he worked

Building 95's ultra-modern candy-making production, in 1995. *Fulton Nestlé archives.*

with the contractors who designed the building, then watched it being constructed, Dave trained workers on its innovative new process. Here's how he explained Building 95's integration into the existing plant: "Chocolate mixtures were still made in other buildings and then piped over to 95, where bars were moulded and fed into an automated wrapping department. You still had operators, but machines did the work."

Nestlé employee Bob Fravor had worked in the plant both prior to and after Building 95 began operation and he described what it was like to see 95's innovative setup after years of working with older factory equipment: "Those new machines were amazing. It was all automated, but I still needed to monitor the machine by watching the process through a window on the equipment. The machine wrapped quickly, too: over 100 bars a minute for the regular size and 200 a minute for the 1.5 ounce bars."

As Nestlé closed out its ninetieth year of operation in Fulton, and as the whole world neared the closing of one century and beginning of a new millennium, the first milk chocolate manufacturer in the United States continued to lead all others in how to efficiently produce a high-quality candy bar.

MANAGING THE NESTLÉ FACTORY

Now that I had an understanding of the step-by-step process for making chocolate and a good overview of the plant's physical layout, I turned my attention to another important factor of Nestlé's Fulton success: the management of the factory's sixty buildings, where over 1,500 employees produced a variety of chocolate bars and other confections. Most employees I talked with were able to explain their department's responsibilities, but to get a feel for the entire plant's management strategy I turned to Dick Atkins. With half of his nearly forty-year tenure at Nestlé spent as the supply chain manager, Dick was in charge of big-picture concerns such as scheduling, warehousing, trucking and purchasing. We started our conversation with his explanation of the Fulton factory's employee structure:

> At the top were the plant manager, assistant plant manager and a superintendent. In the 1990s, the assistant plant manager was eliminated, and three shift superintendents were added, one for days, one for evenings and one for nights. During the day shift, when those in charge of most

departments normally work, shift superintendents could get help on making decisions. But in the evening and overnight, they were on their own. Superintendents were in charge of the whole plant, which might mean responding to a bomb threat, fire, injury or death.

Next in Nestlé's chain of command were the division managers, who each oversaw one of the four plant areas:

- Condensery, Refining, Liquor and Press, and Work-In-Process (which covered products that still needed additional ingredients or adjustments before becoming a finished product)
- Morsels, Beverages, and Special Products (such as a new line or promotion)
- Coatings and Building 30 (where candy bars, rabbit line, miniatures, filled bars and some chocolate works-in-progress were produced)
- Supply Chain (which didn't produce specific products, but provided total support for the other divisions' needs)

Dick's overview of the plant's hierarchy noted the staffing under each division manager: general foremen, shift foremen and the workers. The plant also had Personnel, Accounting, Quality Assurance, Research, Engineering and Maintenance Departments. I asked Dick to explain his duties as a supply chain manager:

Nestlé Corporate's Marketing Department would set annual and monthly sales projections, which I broke down to weekly production goals for the Fulton plant. We determined which lines were going to run and how often. Take morsels, for example. Autumn is always a busy baking season, so all summer long the plant worked to get warehouses full. Management would watch the supply as the season opened up, and if a promotion or coupon was going on, sales might spike, so we'd increase our production. But changes in our weekly schedule could occur. Sometimes a machine might go down and we'd have to reschedule work shifts or move people around to where they were needed. Because of those last-minute changes, we'd start each day with a planning meeting and determine what needed to be done.

Dick's responsibility meant he also had to keep in mind *how long* it took the different Nestlé products to be manufactured, and he offered an example that proved Fulton didn't skimp on their production time:

We had a product called Superfine Chocolate and, to start, the beans needed to roast for ten hours, then it took another ten hours to grind the beans into liquor, and ten more to run it through refining. From there it spent ninety-six hours in a Syracuse Conche, twenty-four in a Jumbo vat for final fat adjustment, and then eight hours to mould it into ten-pound blocks.

My quick calculation added up to a nearly seven-day process for just one special Nestlé chocolate. Since I knew Nestlé was home to many candies, confections and other foods (I could name about a dozen from memory), I was curious exactly how many were made at the Fulton plant. I wasn't prepared for Dick's answer. "Three hundred," he stated. Three *hundred?* Nestlé had created *three hundred* different food items in Fulton?* I had trouble even imagining that many different products until Dick explained how he and his team kept track of them all: "Every Nestlé product had an SKU, a Sales Keeping Unit, so we were able to keep track of the number of items. For instance, each different type of Toll House Morsels, which came in various flavors and sizes, had their own SKU. Our 12-ounce Morsels' SKU was 2158."

I noted the ease with which Dick recited that code number, after more than a decade since Morsels last rolled off Fulton production lines. I didn't quiz him on other SKUs, but my guess is that by working so closely with all those products, Dick's brain still has a lot of numbers logged in.

I thought I'd heard all the amazing numbers associated with Nestlé products and production until Dick offered one more: "On average, when it was in full production, the Fulton plant was producing 320 million pounds of product a year. That averaged out to about a million pounds a day."

Though I'd never been involved with a production process as grand as Nestlé and had no idea what a million pounds of product coming off conveyor belts looked like, I still wanted to find some way to visualize this million-pounds-a-day phenomenon. To do so, I turned to my calculator.

Let's say on a given day in Nestlé's Fulton history, the plant was to have focused on just three products: its renowned Semi-Sweet Morsels, packed in 12-ounce bags; its thirst-quenching Nestlé Quik, filling 16-ounce containers; and its wildly popular Crunch Bars, in its bestselling 4.4-ounce serving size. Let's also say that production would be split evenly between the three products, each responsible for one-third of a day's million pounds. Here's what I came up with:

* Today the worldwide count of Nestlé products is 8,500.

Chocolate was produced at the Fulton Nestlé factory in extraordinary amounts. *Fulton Nestlé archives.*

Fulton Nestlé employees were hard at work, producing nearly 450,000 bags of Morsels, about 333,000 cans of Nestlé Quik and a whopping 1.3 million of those scrumptious Crunch Bars. And that, I had to remind myself, was just one day on the job at Nestlé. Suddenly, the chocolate aroma that once reached every corner of our city was not only a poignant memory but also a source of enormous pride.

Of course, my math exercise only covered the numerical aspects of Nestlé products. There were myriad other managerial concerns, such as what it took to move chocolate around the plant. Sometimes product was moved in storage tanks; other times it was sent via six-to-eight-inch pipes that traveled the plant's campus like rivers. This web of chocolate "streams" could flow within buildings, from one building to another, and even across a street on the overhead walkway to Building 30. They weren't run-of-the-mill pipes, though. They were special double-walled versions that assured chocolate would maintain its desired temperature and peak quality on route.

Other equipment used to move ingredients were the expected elevators and conveyor belts, but Nestlé also relied on something many workers called tunnels. Bob MacMartin clarified their purpose:

> *There were two overhead bridges that went from the Condensery to Building 70. One was for people to travel through and the other was for a conveyor that brought chocolate through the plant. That bridge was built at an angle because the plant's buildings, which were constructed at different times, didn't always end up with the same floor elevations.* [Floor elevations were determined by the size of equipment to be installed on each floor.] *If someone was walking on one of those bridges, they walked at an angle, but they weren't meant to be pedestrian walkways. They were for conveying materials and supplies, for maintenance access to unplug jam-ups and for inspections and such.*

Overhead passages, sometimes referred to as Nestlé tunnels, moved chocolate (and sometimes people) from building to building. *Fulton Nestlé archives.*

There were even a few underground tunnel-like passageways between some buildings. Dave Wolfersberger told me he'd encountered them when he worked in maintenance: "They were put in to connect wires and piping between buildings, and they were just big enough for a person to crouch over and go through. It was kind of eerie to be underground the Nestlé plant."

Not all methods of moving product were as intricately designed as elevators, conveyor belts and bridges. There also were low-tech systems to make deliveries, including a three-wheel bicycle used in the plant's warehouse. The bike was a convenient method of travel for those who needed to make their way across the warehouse's 125,000 square feet, a distance of more than two football fields. Not only did it save time, but it also saved an employee's back if they were hauling a few heavy boxes, and their feet, since they were walking on concrete.

When the buildings were being torn down, I drove around the three sides of the campus open to traffic, attempting to estimate the total circumference of the plant. I measured about four thousand feet, somewhat less than a mile. But many employees traveled much greater distances as they zigzagged from building to building, some covering four or five miles in a single workday. Often they were moving more than their own body weight. Dennis Collins remembered pushing a container of cocoa butter between two buildings: "It was at least a mile walk and I was pushing a tank of about two thousand pounds." I'll bet Dennis and many other workers never had to hit the gym to stay in shape.

DESIGNING AND ACCOUNTING FOR NESTLÉ PRODUCTION

Some departments at Nestlé weren't directly involved with making chocolate, but they still played an important role in the process. The Engineering Department helped the factory maintain good production flow by overseeing the entire plant layout, evaluating refurbished or new chocolate-making equipment and advising operators on safe work practices. As the company added new buildings to the Fulton campus, engineers redesigned the plant's flow of production. Brian Kitney, who'd studied mechanical drafting while in school, explained his work in Nestlé's Engineering Department, where he was involved with plant design:

To change a department's layout, I would tour that floor and take measurements and such to figure out how it was all going to be laid out. When Nestlé wanted to expand its Beverage Department to include products like Strawberry Quik, they decided to build four-story towers that went atop an existing building. We designers started with information the engineers had given us, such as the size of each piece of equipment. From there, I built the towers on paper. Then, some construction was contracted out to steel workers and the rest done in-house.

Brian was also involved with changes made to Nestlé factory machinery. Here's how he helped the company address an upgrade it wanted to make in the Moulding Department:

For many years, we'd used what were called "automoulds." As an experiment, we took one of them out and replaced it with a high-speed Jensen machine designed to mould 1,050 bars a minute. The company we bought the Jensen from sent a technician to supervise the installation. When the new machine turned out to be successful, we decided to replace another automould, but this time I designed a way to copy a Jensen, so we could do it ourselves.

Other Nestlé departments were even further removed from chocolate making, such as the Accounting Department, which was responsible for the company's financial matters: payroll, accounts payable and purchasing. About a dozen people worked in that department, and from 1986 until the plant closed in 2003, Jim Schreck was one of them. Though Jim ended up heading the Accounts Payable division, he was first hired as an accountant, which included making sure dairy farmers got paid. Jim explained:

The largest invoices we received were for raw materials bought in bulk. It wasn't unusual for us to have invoices for fresh milk from the Dairylea Coop that were in the hundreds of thousands of dollars. By the time I started working at Nestlé, everyone who sold milk to the plant had to be a member of the Dairylea Coop. The milk still came from individual farms from all over Central New York, but it came to our plant through the Coop. It made it a lot easier for the farmer. He produced the milk but didn't have to worry about all the paperwork for payment.

There *were* times when Jim's world of finances met the world of chocolate making. After his promotion to cost accountant, he spent more time in

factory departments, which, he said, "helped me better understand how Nestlé operated." One of Jim's responsibilities that took him into factory departments was a monthly inventory. "To properly do an inventory, you have to have a controlled environment, which was tough at Nestlé because the plant was almost always operating. To remedy that, inventories were typically done on a Saturday or Sunday, when lines weren't running."

MAINTAINING A TWENTY-FOUR-ACRE CHOCOLATE FACTORY

As industrial work modernized, companies found ways to handle production with fewer employees, and Nestlé was no exception. For example, when chocolate bars were moulded and packaged in Building 30, about four hundred people per shift were needed. After Building 95 took over, however, forty people handled its rapid production lines. However, there was one department at Nestlé that wasn't eliminated or had its crew size reduced: Maintenance. Here's how Dave O'Bryan, who was involved with the installation of equipment in Building 95, explained changes for the streamlined operation:

> [When 95 went in], *the need for maintenance increased a little because everything was so high tech. In the old days, the foreman of a department would have the tools he needed to make sure his machines were up and running. But when things got so automated and maintenance got so specific, only certain people were able to do those jobs correctly.*

Old Nestlé or new Nestlé, maintenance workers at the Fulton factory were involved in every step of chocolate making. They performed duties you'd find in any factory—repairing or replacing malfunctioning machinery, routine cleaning and upkeep both inside and outside the plant.* But there were maintenance needs specific to the food industry, some that applied only to the making of chocolate. Because addressing those needs was critical to the factory's successful operation, in the 1960s, Nestlé decided to formalize its Maintenance Department standards. John

* Upstate New York winters kept maintenance workers busy plowing. Snowstorms were a good way to put in some overtime, former maintenance workers assured me.

MacLean, who worked at the Fulton plant for forty-seven years, was involved with this transition.

When John became part of the first official training program for Nestlé maintenance staff, in 1966, he had already put in thirteen years at the plant, and here's how he compared Nestlé's original handling of maintenance with its newer method:

> *Before the changes, people who did maintenance were just off the street and not formally trained. Many of them had been working for the company all their life and were ready to retire. Nestlé wanted to professionalize the Maintenance Department, and they offered everyone in the plant the opportunity to qualify for it. About one hundred of us took the two- or three-day written test; thirty of us passed.*

John and his classmates were enrolled in the two-year, eight-thousand-hour training program. For year one, the trainees continued working their regular eight-hour shifts and then headed to Nestlé's conference room to receive instruction from a Syracuse University professor and an engineer. The second year, as John explained, "was in the maintenance shop, learning on the job: the ins and outs of fabrication, welding, triangulation and how to fix machinery."

Dave Wolfersberger was another Nestlé employee who transitioned from work on the production line to maintenance. His fifteen years at the plant prior to joining the special maintenance training served him well. "Because I had already worked in production, I knew to ask the people on the line what problems they were having. They knew their machines and that helped me fix them much faster."

Dave mentioned another example of how closely maintenance crewmembers worked with other Nestlé departments:

> *There were times that engineers gave us blueprints for a new machine we needed to set up. Sometimes it didn't work according to the prints, so the engineers would say, "Make it work." Since the machine came in pieces, we'd figure out a way to put it together, like a puzzle. After we got it running, the engineers took a picture of how we'd put it together and then redid the blueprints.*

As I spoke with lifelong Nestlé maintenance workers, I was impressed with the unique skills they developed on the job. I was already aware how

Fulton Nestlé's first Maintenance Training class. Plant manager Jim Gillis is center, front row. John MacLean is far left, front row. *Courtesy of John MacLean.*

Nestlé employees used their sense of smell to successfully monitor the chocolate-making process, but those in maintenance also fine-tuned their audio sensibilities. With some production departments housing up to sixty machines driven by one-hundred-horsepower motors, workplaces often approached intolerable noise levels. (Earplugs did not become standard safety gear until later in the plant's history.) But 38-year employee Mike Malash assured me that the din from those machines "became background noise and I could identify a new sound, such as one of our machines not working properly."

Division manager Bob MacMartin observed another example of how maintenance and line workers shrewdly used their senses:

> *I was having a conversation with one of the workers, and at one point he excused himself, walked to the control room, adjusted something and came back to continue our conversation. I was curious what he had done. "I had to make an adjustment because the product was running high moisture," the worker explained. "That would have been a quality defect if it continued."*

"You had your back to the machines and were talking to me," I said. "How did you know that?" It turns out that the floor we were standing on had made some sort of vibration that the worker recognized, so he went in to check on the equipment and made the adjustment. He could feel the difference in his feet.

While Nestlé maintenance responsibilities covered all aspects of the factory's production, nothing could be more important to a food-processing plant than cleanliness. Properly sanitizing hundreds of machines and miles of piping was a regular part of the job and often the first thing new workers learned. When Dave O'Bryan was in college, he worked summers at the plant. "Saturday's third shift was set aside for cleaning, and my job was to wash the inside of Jumbo tanks," Dave explained. "I'd put on overalls and a hairnet, take a brush and a bucket of citric acid and water, and scrub."

With seventy of those tanks to keep clean, lots of workers spent time in them, including Dave Miner, who remembered the physical challenge of just getting inside one: "There was a hole at the top of those tanks that you'd climb into; it was almost like climbing into a submarine." Once workers made it inside, it would be a while before they saw the rest of the world again. "It might take the whole eight-hour shift to clean just one," Dave added, ending his firsthand story of tank cleaning with this cautionary reminder: "The Jumbos included a steel agitating arm that did the mixing. You wanted to make sure the machine was locked out and that nobody could start it before you got in."

Keeping equipment clean was an important job for a factory that often used the same production lines and holding tanks to make different candy varieties. As Dave O'Bryan noted, "If the next product stored in the tank was a drastic change from what had just been made, say from a dark coating to a white or lighter coating, we had to make sure we got the tank completely clean, so specks of one color didn't end up in the other."

There were other reasons Nestlé wanted to make sure one batch of candy didn't mix with the next. For decades, the Fulton plant produced chocolate for Jewish holidays, and those of that faith follow strict kosher dietary guidelines. This meant the candy made for them at Nestlé had to be specifically manufactured, as Dick Atkins explained:

Twice a year, during Passover production, two of our coating lines would be running; one for Barton's Chocolate, which was the kosher product, and the other for our regular chocolate. We had to be very careful not to mix

them, and it took about a week to set up because it required so much prep. Everything the chocolate touched had to be hand-washed, cleaned and dried. In addition, we had to be careful there was no soap that contained lanolin in the restrooms, because lanolin was an animal product and not kosher. During the entire run, a rabbi would stand watch over the production, inspecting to ensure their high standards were maintained.

Specific cleaning procedures weren't always due to religious formalities; sometimes they were instituted to address a growing health concern, such as when peanut allergies began to be associated with illness in the early 1990s. Peanuts were used in a number of Nestlé products, and once reports of severe allergic reactions were linked to the legume, the company addressed the concern. Dick Atkins explained the changes Nestlé made:

We ran peanuts just like cocoa beans: grinding them, making a liquor, etc. When we were going to start a peanut run, say for peanut butter morsels, we had to suspend the making of cocoa so the two wouldn't mix. When the run was done, we'd have to wash everything in each department for every step of the process: Refining, Jumbos, Morsel machinery, the lines, and the bins that held the Morsels.

POWERING THE NESTLÉ FACTORY

As can be expected in a facility as large as the Fulton plant, substantial amounts of energy were needed to keep the chocolate-making process running. Depending on the step, machinery and candy mixtures had to be either heated or cooled. And while gravity helped move production, it couldn't always be counted on for future chocolate bars to get from point A to B. Power was needed, and during Nestlé's early history, it was generated in the factory's Boiler House, where coal-fired furnaces produced steam that was shipped throughout the plant. Those first furnaces, much larger than found in a family home, were adequate at first. But soon, Nestlé would outgrow them.

In 1924, it was determined that an upgrade was necessary to accommodate the expanding plant, and those original furnaces were replaced with a three-story-high structure housing three one-thousand-horsepower boilers, still fueled by coal. In the 1960s, Thomas Heaphy

worked in the upgraded Boiler House, and he described each of those furnaces as "big as a room." Railways delivered the coal Thomas and others fed into furnaces, coming into the plant much as did sugar, with railcars stopping over a grate and pouring their contents onto an elevator. From there, coal was taken to the Boiler House's loft and deposited in bins, where it fed the fire as needed. "We still had work to do when we weren't adding coal to furnaces," Thomas explained. "There were all those ashes to pull out from beneath the coal bins."

Shoveling coal and ash became a thing of the past when furnaces started to be fueled by oil. They, in turn, were replaced in the early 1990s by a new energy source constructed on the Nestlé site. It was called the Fulton Cogeneration Associates Power Plant, and it was a shrewd financial investment for the factory, as Dick Atkins explained: "The Power Plant had a new gas-fired operation generating steam and electricity. The turbines that made power also produced a byproduct that heated the plant. Any excess electricity was sold on the market."

I was shocked to see the costs associated with Nestlé's energy needs. One estimate I found concerning the power required during the plant's heyday compared it to the energy needs of fifteen thousand households, more homes than could be found in Fulton. Prior to the Cogeneration Plant's cost-saving system, the factory purchased its power from Niagara Mohawk (Ni Mo), the Upstate New York energy company. To provide this massive amount of electricity, the plant was given a direct connection to Ni Mo's high voltage distribution line, which passed through Fulton on its way from Clay to Oswego. Nestlé employee Ron Woodward remembered seeing one of the factory's monthly utility bills. It totaled nearly $1 million.

To address the need for cooler temperatures during chocolate's moulding and wrapping steps, Nestlé first turned to nature. One unique job early in the plant's history took place in the Ice House, where blocks of frozen river and lake water were stored and sent to appropriate departments as needed. As refrigeration methods modernized, chemical coolants such as liquid hydrogen, ammonia and chlorofluorocarbon were introduced. Those were powerful and potentially dangerous, requiring trained workers to handle that phase of production, and as regulations for food and worker safety were enacted, some of those chemicals were eliminated.

Cooling wasn't only needed for chocolate making's final stage. For instance, to counteract the heat generated by refiners and conches, water drawn from the nearby Oswego River was piped into the plant to cool machinery and then returned. (The city's wells also provided some of this supply.) This

step sounds simple, but it was by no means a minor aspect of the plant's operation. As the river water entered, moved through the plant and returned to its source, it traveled at a rate of two thousand gallons per minute—that's enough water to fill forty Fulton bathtubs every sixty seconds.

While water collected from factory restrooms and hand-washing could simply be sent to the city's wastewater treatment system, water directly involved with the chocolate-making process sometimes picked up food-related contaminants along the way and required a cleaning before returning to its source. In the earliest years of the plant, as was the case for all factories in operation at the time, proper elimination of contaminated water was not well understood. But by the late 1960s, laws regulated how wastewater entered natural streams, rivers and lakes, and Nestlé's research staff and engineers addressed this important matter by developing a system known as dissolved air floatation technology. Here's how it worked:

The Fulton plant's water treatment system utilized a three-thousand-gallon well that exposed wastewater to a neutralization system, returning it to its neutral pH. A tiny probe monitored the water, and when needed, pumps added sodium hydroxide or sulfuric acid to achieve the neutral pH. The treated water then went to a mixing tank where a small amount of flocculent, a chemical that attracts loose particles, was added. Droplets of the oily residue from chocolate production clumped to the flocculent and rose to the surface. This "sludge" was skimmed off and sent to local dumps, and the water was sent on to the city's treatment system.

Ron Woodward, who spent years running Nestlé's waste-treatment system, shared some impressive numbers concerning its capabilities:

The permits issued by the City of Fulton allowed Nestlé to discharge up to 250,000 gallons of water and 1,080 pounds of solids a day. In addition, we had other restrictions, including something called Biological Oxygen Demand, or BOD, which are food particles that could create an oxygen demand when water reentered the river, threatening fish and other aquatic life. Metals in the water were another problem. We had a small lab where daily samples and measuring could be done.

Ron had taken some college courses to learn the science behind water-treatment methods, but I'm pretty sure there's one colorful aspect of his Nestlé job he wouldn't have learned about in class. As Ron covered the steps of the process, he pointed out that there would sometimes be more than chocolate solids removed from the wastewater. "You'd also find crisped

rice or Quik drink solids," he explained. I tried to imagine what that three-thousand-gallon well looked like on Strawberry Quik days, when wastewater leaving the Fulton plant would be running a pretty pink.

PARKING LOT CHALLENGES

There *is* one element of Nestlé's buildings and maintenance work that we Fultonians got a good look at, since it was found outside the factory's fence. In fact, those who were neighbors to the plant often found themselves face-to-face with overcrowded parking lots. When the company's workforce reached 1,700, management had to figure out how to accommodate all their vehicles. Adding new lots and staggering the start and end times for each shift helped, but parking places remained at a premium. While the problem continued from time to time during Nestlé's heyday, at least the company found a way to have a little fun amid all the hassle. Dave Miner, whose job as supervisor of the factory's Service Department included handling parking issues, explained:

> In the 1980s, Nestlé bought Ingamells, a small mom-and-pop store near the plant that had been closed for years. We tore it down and made a parking lot with thirty spaces, labeled one through thirty. Those spaces were designated for the thirty employees who had worked the longest at the plant. When one of them retired, the next person with the longest tenure moved up.

Among the many good reasons for Nestlé workers to put in their years at the Fulton factory, becoming eligible for a prime parking spot was certainly one of them.

5

GUARDIANS OF
NESTLÉ'S SECRET RECIPES

Anyone with a sweet tooth knows how chocolate can turn a troublesome day into something sunnier. Though I count myself among those who've often enjoyed a satisfying candy bar, I've never considered myself a connoisseur, able to decipher what makes one brand of chocolate taste better than another. Nestlé workers knew, though, and I loved hearing how one bite of the freshest chocolate possible—right off the production line—was all those workers needed to tell if it had the qualities of a good candy bar: its *appearance*, which should be rich in color, with a smooth, glossy surface; its crisp *snap* when broken; its creamy *mouthfeel* on the palate; and of course, its *taste*, which should be rich, sweet and chocolatey. That's a lot to expect from a piece of candy, but Fulton Nestlé workers wouldn't have had it any other way.

Thirty-seven-year employee Vern Bickford made this suggestion of how to tell the difference between a Nestlé bar and one from its biggest competitor, Hershey's, the company often referred to by Fultonians as "the H word": "Buy a Nestlé bar, take a bite and let it set on your tongue for a while. Then get that taste out of your mouth and take a bite of a Hershey bar. There's a difference. In my opinion, Hershey's is grainier and not as chocolatey. Nestlé has more chocolate and is smoother." Fulton resident and historian Jerry Hogan Kasperek put it another way: "I never did like that other kind of chocolate in its ugly brown wrapper. The candy is too dark and bitter for me, not creamy at all, not like real milk chocolate, either!"

When that milk-infused chocolate was first invented in Switzerland, Daniel Peter and his company's leaders made sure that its distinguishing qualities would be carried on through precise production recipes. As the first keepers of Peter's secret formulas, those men and women became true chocolatiers: experts in their craft who would not settle for less. With each new Peter's factory, chocolate professionals passed on guarded secrets of their high-quality standards, eventually establishing teams of skilled chocolate makers at each factory, including their first one in the United States. Those experts were known as the Quality Control Team.

One team member who would lead hundreds of Fultonians in the art of chocolate making was Christian (Chris) Klaiss, a senior confectioner for Nestlé. Born in 1927 in Switzerland, Klaiss began his lifelong devotion to making chocolate when, at age sixteen, he was hired by a small confections shop. According to an interview Klaiss gave to Fulton's *Valley News* in 1987, his early training in candy making landed him a job with Nestlé in 1953. The company was recruiting people to work at its overseas plants, and Klaiss had the opportunity to fine tune his skills in places like England, Africa, West Germany and, in 1969, Fulton. The *Syracuse Herald-American* also interviewed Klaiss, and the article describes his demonstration of the precise art of making a Crunch Bar:

> *Klaiss sweeps a glob of chocolate back and forth on a tempering table cooled to around 70 degrees. He mixes and stirs, his metal spatulas clanging in perfect rhythm: boom, bum-bum, boom, bum-bum. His movements are as calculated as an artist's brush strokes,* [as he] *pours the chocolate into a mixing bowl along with a measured amount of rice. "Eventually, the texture will flatten and the chocolate will lose its shine," Klaiss explained in a thick Swiss-German accent. "Too much mixing and the chocolate will end up crumbly; too little mixing and the texture will feel like rubber."*

By the time newspaper readers learned about Klaiss's meticulous methods, he had racked up thirty-four years as a confectioner, earning his spot on Fulton's Quality Control Team. Nestlé management stated that they relied on Klaiss's expertise to develop plans for new products. "They have an idea for a chocolate," he explained, "and I find a way to make it with a good shelf life and good eating quality."

Among Klaiss's contributions to Nestlé's success, primarily carried out in Fulton, included the development of the O'Henry, Chunky, Alpine and $100,000 Bars. He also became the perfect spokesperson for the company,

Nestlé's chocolatier Chris Klaiss and friend posing in front of his creation of the world's largest Toll House morsel. *Fultonhistory.com.*

his Swiss expressions reflecting Nestlé's original home. When a local television program wanted to report on the Fulton factory's colorful history, Klaiss fit the bill. He even used his skilled hands to sculpt the world's largest Toll House Morsel for Fulton's Chocolate Fest, where young and old alike marveled at his many culinary accomplishments.

Klaiss served as a mentor for the next generation of Quality Control Team members, passing on the science and art of Nestlé formulas. As chocolate-making equipment modernized and raw material availability fluctuated, different cocoa bean blends were developed, new roasting and refining methods were trial-tested and formulas were modified. A November 1964 issue of *Candy Industry and Confectioners Journal* notes the innovative success of Fulton's Control Team, pointing out that the plant was home to "a staff of 55 in Quality Control…[and] these staff comprise the biggest group performing technical work encountered in any confectionary plant in the industry."

By 1972, Fulton's QC Team was providing their services for all three Nestlé chocolate plants in the United States: Burlington, Wisconsin; Salinas, California; and Fulton. Along with the technical and research-driven work those men and women were performing, one job sounded like fun. Its official title—organoleptic analyst—didn't mean much to me until I learned its common name: taste tester. In the book *The Chocolate Chronicles*, which covers modern candy bar and confection manufacturing, two of Fulton's Quality Control taste testers are profiled. The author made a wise choice by interviewing Fultonians Harold Kenyon and Phil Williams, who had a combined sixty-three years of chocolate-tasting experience. That's a lot of sampling Nestlé's prize products, and here's how the two men handled their savory task:

Taste testing isn't as easy as biting into a piece of candy and giving a thumbs up or thumbs down. Kenyon and Williams were expected to analyze the chocolate's flavor, odor, mouthfeel, appearance and texture. Their job

also required the men to be familiar with Nestlé's various candies in order to compare them to new products being tested. When sampling, they used a knife to carve off a piece of chocolate about the size of a pea, rolling it around their mouth to gather sensory impressions. Soda crackers or water were available to clear their palates before taking the next sample. In a day's work, the men each consumed an average of one and a half pounds of chocolate, but they never worried about gaining weight. The four or five miles they walked each day to test samples in different departments burned up all those calories.

Though Kenyon and Williams had jobs that most of us would hunger for, not everyone can be a professional taste tester. Some people just like chocolate too much and can't distinguish a run-of-the-mill bar from a superior one. But others, like Colleen O'Brien, find out they have a talent in distinguishing good from great. When Colleen was hired by Nestlé as a junior lab technician, her workplace was right across the hall from Quality Control, and she recalled often being recruited to help with taste tests:

If an existing product was being modified, I would often find three bars of chocolate left on my desk to do a taste test called a blind triangle. Two of the chocolate bars were identical and one was different. Maybe the cocoa butter content had been tweaked or a new type of a raw material was being tested. My job, along with other testers, was to pick out the different one. If few people chose the different bar, then the change to the product could be made. If all three bars tasted the same or the wrong one was chosen, the chocolate bar would be left as it was, instead of becoming "new and improved."

Another lucky laboratory worker who counted taste testing among his duties was Angelo Caltabiano. Angelo started at Nestlé in 1973, joining the company straight out of college and training under Roy Miller, who he described as "an icon of the Quality Control Department." Here's how Angelo described a typical workday: "We evaluated the finished product before it went to the customer. You'd get the morsels, chocolate bars and such to check before they went out the door. Every morning, you'd be tasting, and that was wonderful."

Of course, working in Quality Control wasn't always as enjoyable as sampling chocolate. There were other, more somber aspects of Angelo's job, like testing the water that came into the plant to make sure it was sanitary or placing candy samples on a Petri dish to see if it would grow mold, which helped researchers determine a product's shelf life. Some tests took Angelo

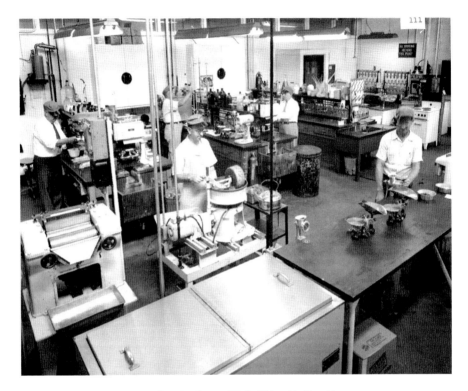

Nestlé product testing in the Quality Control Lab. *Fulton Nestlé archives.*

to the Wrapping Department, where he made sure bars were packaged with a good seal. "All those tests were labeled and numbered as to the day and time they were inspected," Angelo explained. "If there was a problem later on, we could go back to our tests and investigate how it might have happened. We'd hold samples for a certain amount of time, sometimes six months or a year."

Another rather unpleasant aspect of Angelo's job involved customer complaints:

> *From time to time, our corporate office received letters that said something was wrong with our chocolate; it was crumbled, or too sweet. Sometimes people said they found glass in their chocolate bar, but that turned out to be just sugar. Still, you had to be sure. We would look into it, write our test results into a report and then send it to the Quality Control Manager. He'd check with us if he had questions. If not, a secretary typed up our response and sent it back to Corporate, who followed up with the customer.*

Though largely stationed at the plant's main laboratory, Angelo described four satellite labs, "where we checked products right from the lines. The hourly samples were taken from Jumbo vats with a long-handled ladle-like device, and we tested for things like the chocolate's viscosity, which is its thickness." Angelo described his viscosity test instrument, which rapidly spun the sample until its dial revealed a certain number. Using those test results, he figured out if the chocolate needed to be thicker or thinner: "To make it thinner, you added cocoa butter or lecithin. If it was too thin, thick unadjusted chocolate stock could be added. Line workers would make the adjustments, and an hour later, we'd go back and retest."

When we buy a candy bar or a package of Toll House Morsels, we take for granted that we're getting the amount of product stated on the label, and another one of Angelo's jobs made sure this was true. Because of his strong background in mathematics, Angelo was also one of the plant's Weight Control Statisticians, making sure the stated amount was indeed delivered by randomly checking bars and packages coming off the line. If he found that weights were running low, "we could program the packing machines to aim a little higher than the target weight. We'd tried to be as close as possible, though; if we aimed too high, we were giving away product and that's not profitable."

Angelo's tenure at Nestlé took place during a major change in how the company handled its chocolate recipes. In 1984, corporate officials decided it was time for those secret formulas to be documented. The radical shift in policy came when corporate managers realized that many longtime keepers of the formula were nearing retirement. Those loyal Nestlé employees who knew recipes by heart might have jotted them down on a scrap of paper or an old candy bar label, and Angelo's task was to take the hastily written notes and create an official text. It wasn't always easy.

"Some of the pages had browned from being so old," Angelo said. "You could see how those formulas had changed and been reformatted over the years." After attending a Cornell University computer workshop, Angelo began the process of putting the formulas into spreadsheets, marking the beginning of Nestlé's reliance on computers to store data. Security was upgraded at Westreco. "To protect formulas as confidential documents," Angelo explained, "full formula books were kept in a safe file. Partial formulas were distributed as needed in each separate chocolate-processing department."

Getting an updated formula approved was not as simple as writing down a recipe's new steps. A formula wasn't considered up to Nestlé standards

until it had received three approvals, and those also were part of Angelo's responsibility: "I'd turn in a revised formula and my supervisor would sign off on it. Then the plant manager approved it, and finally, corporate offices signed off. Only then could it be put into production, and in those days, it might take two weeks to get all those approvals." I asked Angelo why the company couldn't have just used a fax machine, which would have made communication back and forth instantaneous. He acknowledged it would have speeded things up but then reminded me why Nestlé wouldn't have wanted to transfer such information over phone lines: their formulas were confidential.

HOW FULTON DEVELOPED NEW NESTLÉ PRODUCTS

The steps to making changes within the Nestlé Corporation were even more involved when the company wanted to greenlight a brand-new product. Approval to do so wasn't needed from Nestlé's USA offices alone, as Dick Atkins explained:

> *The quality standard of each new product had to also be approved by company owners in Vevey, Switzerland. This was an involved and expensive process, but Nestlé was committed to it. I remember one of our vice presidents saying "If it was easy to do, everybody would be doing it." Not everybody was making the gold standard of Nestlé products.*

New candies and confections were being added to Nestlé's product line all the time, and the people developing formulas were a bit like medical researchers credited with discovering lifesaving cures and treatments. Like their medical counterparts, Nestlé researchers worked tirelessly to create unique products that were, in culinary terms, "just what the doctor ordered." Corporate-level managers acknowledged this important aspect of new product development by opening an independent department within the Nestlé hierarchy. When it was created, in the 1960s, it was known as Technical Services. By 1980, people were calling it Westreco.

Dick Atkins explained how Westreco became a vital component to Nestlé's expanding food product line:

Westreco technicians studied new products in development at the Fulton plant. *Courtesy of Lynn Ricketts.*

> *Since Nestlé was involved with so many different aspects of the food industry, there were different research departments. The Fulton Westreco, which stood for Western Research Company, was charged with improving chocolate production for Nestlé factories in the entire western hemisphere.* Most of the other United States chocolate companies didn't have their own research division, so our competitors would sometimes ask for assistance from the Fulton Westreco staff.*

Dick also mentioned that the work going on in Westreco was so confidential that access in and out of its offices was limited to certain Nestlé employees. The few allowed right of entry were issued a special code to unlock Westreco's door. Dick was one of those with the code, but only because he supervised factory cleaners and occasionally had to inspect their work. "It was a secret place," Dick noted. "You couldn't find out what was going on in there."

* Along with Westreco, Nestlé had other food development divisions with similar sounding names. Northreco and Eastreco covered other parts of the company's worldwide corporation.

JOE ALLERTON

When a new Nestlé chocolate treat showed up on grocery store shelves, it most likely got its start under a Westreco microscope. Peering into the miniature world of chocolate development were great thinkers like Joe Allerton. Just shy of ninety-eight years old when I interviewed him, Allerton spent twenty years in Fulton's Westreco Department. My review of his work résumé made it clear why the Nestlé Company was so anxious to bring Joe to the Fulton research team. One of his first jobs, long before he arrived in Fulton, was vastly different from the study of chocolate, but it proved his incredible potential.

In the 1940s, while he was working toward his PhD in engineering from the University of Michigan, college administrators noted Joe's brilliance in that field of study. When the United States was looking for engineers to research methods of combating Hitler's advances during World War II, the college recommended Joe. Little did Allerton know that he would become part of a group on a top-secret mission to help the Allies win the war. They were known as the Manhattan Project.

From 1941 to 1942, and again from 1944 to 1945, Joe served as one of the project's chemical engineers, assisting in the design, construction and operation of laboratory and plant equipment used for defense research. Allerton family friend Mary Ellen Ross remembered how Joe's wife, Muriel, explained his reaction when he realized he had been involved with a project so classified that those working on it had no idea of its ultimate goal: the creation of an atomic bomb. "After they dropped the bomb," Mary Ellen said, "Joe came home and said to Muriel, 'That must have been what I was working on.'"

Joe shifted from wartime chemical research to the food industry, first working with the National Dairy Council and the General Foods Corporation and then at Nestlé's White Plains corporate offices. The Allertons moved to Fulton in 1963 when Joe began working for Technical Services/Westreco. He held managerial positions in the department until he retired in 1984. "When I worked for Nestlé," Joe explained, "we looked at thousands of candy types, and I headed up the research of those different options."

Research wasn't limited to test tubes and microscopes. Some was carried out beyond Fulton Westreco's private offices, conducted with nonscientific folks like Joe's daughter, Martha, and her friends. "He would bring home three different types of candy bars," Martha remembered, "and ask us, 'Which do you like best?'" Joe knew exactly what he was doing, once telling a newspaper reporter that "one of my jobs was to take the ideal conditions

which were developed in a sterile laboratory and move them to the practical part of producing chocolate in the factory."

Inside or outside his workspace, it became clear that Joe was deeply committed to the science of a good candy bar. Mary Ellen Ross, who was not only an Allerton family friend but also Joe's coworker in Nestlé's research library, often observed his extreme dedication. Here's how she described Joe at work: "He was like an absent-minded professor. If you asked him a question, he'd stare off for a few minutes and then give a brilliant answer. I think it was because he was so focused on whatever he was working on. When someone interrupted him, it took him a minute to switch his brain to a conversation."

I saw some of that same contemplation during my interview with Joe. Sometimes, after a period of deep thought, he'd answer my question. Other times, after more than thirty years away from his Nestlé work, he couldn't reach back for an answer. But our interview came to life when I noticed a small blue box sitting on an end table in Joe's living room. Its label read "The Manufacture of Chocolate by Nestlé." When I asked Joe what it was, he tenderly picked up the box, held it in front of him and, after a long pause, admitted he couldn't remember its purpose. Then he opened the box, offering me a look inside.

Nestled in the box were contents divided into sections labeled 1 through 6, with each section holding a different ingredient: cacao beans, nibs, chocolate liquor, cocoa butter, cocoa powder and semi-sweet chocolate morsels. The box's inside cover provided details about each section: where the foreign-looking cacao beans came from, how nibs were roasted, why cocoa butter had to be extracted and so forth. Sitting in Joe's hands was a miniature version of the Nestlé chocolate-making process.

After my meeting with Joe, I checked with a few other longtime management and research employees, who told me that the small blue box performed a big job for Nestlé promotion. "It would have been used by our salesmen to describe our process to potential clients," Dick Atkins explained. Bob MacMartin added, "It also would have been used for displays set up away from the plant, so people who couldn't see the art of making chocolate firsthand could learn about the process."

Before Joe set the box back on the end table, he took a moment to look it over. I could see him pondering its contents, trying to recall the purpose it had served him and the Nestlé Company, his brilliant mind reaching back into his history with the Fulton factory, back when he turned laboratory tests into Nestlé's High as the Alps quality.

BART SIEBERS

While researching information about the company's many successful products, I decided to google "Nestlé patents" and after some digging, I found my way to this:

> *United States Patent 3,307,953 "Viscous Chocolate Flavoring Composition and Process of Making Same." Filed June 21, 1965 by Barton Heard Siebers, Fulton, N.Y.*

Additional information about this patent explained that "the invention relates in particular to a chocolate flavoring composition for foodstuffs which is simple and convenient to use, and to the method of its preparation." No brand name was included, but a name I did recognize was the person who filed the patent: Bart Siebers. Joe Allerton had mentioned Bart, noting their work together at Westreco to develop new Nestlé products. But I had no idea Bart had been involved with the success of the company's premier beverage: Nestlé Quik.

Curious to find out more, I recalled that I'd gone to high school with Lynn Siebers, and when I contacted her, she confirmed that Bart was her father. She kindly offered some information about his work at Nestlé, and I found Bart's résumé as impressive as Joe Allerton's. A Long Island native, Bart worked his way through the Boy Scouts, eventually becoming an Eagle Scout. In 1932, he enrolled as an aeronautical engineer at New York University, but with the Great Depression's stronghold on the country, Bart felt compelled to quit school and financially contribute to his family's well-being.

Through his volunteer work with the Scouts, Bart met the head of the laboratory for Ben Loose-Wiles Biscuit Company (later known as Sunshine Biscuits), who offered him a position. His new boss made sure Bart returned to college, where he earned a degree in chemical engineering. Siebers put that degree to work during World War II as a member of the U.S. Navy, and following his honorable discharge, he joined Lamont, Corliss & Company, applying his chemistry knowhow to chocolate research. When that company was purchased by Nestlé in 1949, Bart was transferred to Fulton's Westreco division, where he spent the rest of his career.

At one point while with Westreco, Bart traveled to Nestlé's International Headquarters in Vevey, Switzerland, to learn the process of manufacturing candy from the company's early chocolatiers. In 1969, he became a technical specialist in the bulk division, eventually earning the title "Manager of

Customer Services and Bulk Chocolate Products." Through those many experiences, Bart achieved a long list of accomplishments for Nestlé, including:

- a method of "cooking" sweetened condensed milk for use in chocolate
- milk and vanilla compound coatings
- the determination of the extent of vitamin and mineral fortification of chocolate beverages
- morsel products: chocolate, butterscotch, spice
- a Cookie Mix product
- a new liquid baking chocolate product called Choc-O-Bake
- perfecting chocolate and fruit-flavored beverage powders

I mentioned this last item, "perfecting chocolate beverage powders," to his daughter, Lynn, assuming it meant that Bart had invented Nestlé Quik. (I'd already read several newspaper articles identifying him as the brains behind Quik.) But both Lynn and her sister Kim are quick to correct people, explaining that their father was one of many who were involved with the long process of figuring out how to turn cocoa powder into a thirst-quenching beverage. Lynn also described her father as a private man, though among the Nestlé archives I reviewed are reports of Bart publicly representing the Westreco Department. One unusual example of this was found in the July/August 1978 issue of the Nestlé Company's magazine, *Nestlé News*. Bart had been invited to be a guest on *The Magic Toy Shop*, a popular television show for Upstate New York baby boomers. He, along with other workers and a few of their children, were part of a *Toy Shop* segment called "Central New York Makes It." The episode is a journey through the Fulton chocolate plant, and it features Bart as a tour guide.

Siebers worked thirty-five years for Nestlé, and in 1977, he achieved a career highlight: the Stroud Jordan Award, a national honor given to someone who "exemplifies vision and devotion for candy technology." The annual presentation "is the highest award that can be received by one who serves the candy industry in a manufacturing and technical capacity." Paperwork accompanying the award noted that "Siebers is one of the most technically qualified people in the Nestlé organization, which is known worldwide for its excellence in the field of chocolate and chocolate products."

In 1981, Bart and his wife, Joyse, left Fulton for Hilton Head, South Carolina, where he continued his dedication to fine chocolate making, this time focusing on its retail potential. The couple opened a store, the Chocolate

Plantation, delighting customers with their freshly made chocolates. The Siebers co-managed the store until Bart's death in 1988.

I found one more example of Bart Siebers's interest in developing chocolate to its fullest potential. Throughout his career, Bart studied chocolate's nutritional value, even after people became more health conscious and began thinking of candy bars as nothing but a snack. Bart never wavered from his belief that there could be a place for chocolate in a person's diet. In a 1981 article, he wrote, "I think chocolate is too often classified as a 'junk food' or a 'sweet.' I think milk chocolate, when compared to other snack foods, really can stand pretty well above them. For one thing, it has milk [and] it has 20 times more protein and 50 times more calcium than peaches and other canned fruits." Bart acknowledged chocolate's high caloric count, but pointed out how "calories turn into energy and people need calories to survive."

Bart's conviction to the idea of chocolate being an important part of a healthy person's diet really "took off" for one important American institution: the NASA space program. Westreco was helping chocolate manufacturing companies develop new products as well as the U.S. government. Part of Bart's work for Nestlé was the study of what he called fortified nutritional candies, or "space cubes," little shots of the energy he knew chocolate could provide astronauts. Who would have thought that, in the Fulton Westreco laboratory, dedicated researchers like Bart Siebers were discovering ways to send Nestlé chocolate into the cosmos?

A CHOCOLATE LIBRARY

After decades of research in the Technical Services/Westreco Department, a sizable collection of new product formulas and related information had accumulated. The hundreds of technicians, lab specialists and engineers who'd generated the facts and figures and who were committed to studying the latest food science advancements wanted to organize all that data. In 1970, the factory that was a city unto itself added an important dimension to its thriving community: a library. Phoenix resident Joyce Cook, with her newly earned degree in library science, became the first person Nestlé hired to set up and develop its new research library.

"It wasn't a lending library," Joyce explained.

It was for those researching new products and safety measures. Those men—they were all men at the time—were food and lab technicians, and I had to know what they were working on so I could order periodicals that would help them. When magazines came in, I would make a note for certain technicians: "Look at this particular page." We also purchased books on the chocolate and candy-making industry that we would see profiled in trade magazines and journals.

Joyce left the position in 1978 and was replaced by Fultonian Mary Ellen Ross, who'd previously worked in her city's school libraries. By the time Mary Ellen was in Nestlé's library position, her research duties went beyond chocolate and candy since the company had diversified its product lines. Researchers were coming to her with a wide range of questions, looking for answers. "I wished I'd taken more chemistry in school!" Mary Ellen commented. "But I was fortunate that Nestlé had other research departments, like their library in Chicago, and if I needed, I could call the librarian there to help me find answers."

Nestlé librarians like Mary Ellen and Joyce sometimes worked with as many as fifty Westreco staff. A team of that size is an example of the company's commitment to high quality standards while developing an ever-growing array of popular food products. Westreco is credited with masterminding hundreds of confectionary treats, often blending the three basic ingredients—cocoa beans, milk and sugar—with a few others to cook up enticing new candy recipes. Each new product has its own creation story, and what follows are profiles of a few of them, including one that, though not conceived in a research lab, still belongs in the history of Nestlé's greatest achievements.

TOLL HOUSE MORSELS

When Ruth Graves Wakefield invented the Toll House chocolate chip cookie, she wasn't the first person to use chocolate in baking. Soon after chocolate bars became a popular candy, people began breaking them up to stir into cookie batters. But Wakefield found a unique way to incorporate chocolate in a cookie recipe while working in the kitchen of her Massachusetts lodge, the Toll House Inn, so named because people traveling on a nearby road were required to pay a toll. Ruth's home-cooked meals and special desserts

were already a point of destination for tourists when she introduced a new chocolate-infused cookie in 1938.

There are two stories of how Ruth invented her chocolate chip cookie recipe, with the most popular version giving credit to a missing ingredient. The story goes that on a busy day preparing meals for the inn's guests, Ruth was following her recipe for chocolate-flavored Butter Drop Dough cookies, which called for melted squares of baking chocolate to add a dark color and distinctive flavor to the mix. When Ruth realized she was out of baker's chocolate, she substituted broken pieces of Nestlé's semi-sweet chocolate bars, expecting them to melt and blend into the dough as baker's chocolate did. Though that didn't happen, her guests loved biting into the cookie's solid bits of chocolate.

Wakefield's version of her chocolate chip cookie's debut, however, gives full credit to her imagination. "We had been serving a thin butterscotch nut cookie with ice cream," she was quoted as saying. "Everybody seemed to love it, but I was trying to give them something different." Replacing butterscotch and nuts with diced Nestlé Semi-Sweet Bars, she called her creation "Toll House Crunch Cookies." They became extremely popular when the recipe was published in a Boston newspaper. Soon, Nestlé noticed a spike in Semi-Sweet Chocolate Bar sales and learned of Wakefield's recipe. To take advantage of the new baking craze, Nestlé altered the production of the bar, first moulding it with notches, making it easier to break apart, and then including a special "chopper" in the bar's wrapping for cutting it to bite-sized pieces. Then the company came up with an even better idea of how bakers could use their chocolate.

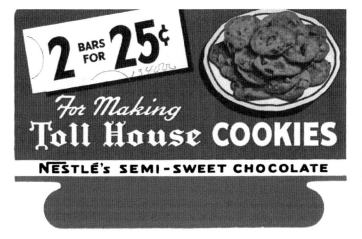

Nestlé's semi-sweet chocolate in bar form, before the creation of its famous morsels. *Fulton Nestlé archives.*

In 1939, Nestlé introduced its semi-sweet chocolate packaged in tiny pieces, first calling them "nibbles" and later trademarking their teardrop-shaped baking ingredient as "morsels." Nestlé and Wakefield came up with an agreement on how they could both benefit from the increased chocolate chip sales. Nestlé would be allowed to print the Toll House Cookie recipe on every package of morsels, and Wakefield was promised a lifetime supply of them. Ruth might not have been financially rewarded for her popular recipe, but she should have been proud of what it did for 1930s and '40s America. Food historians have suggested that her simple cookie was the perfect antidote to the Great Depression. Rich and poor alike could afford one, making it possible for everyone to brighten a challenging day with something sweet and comforting.

Along with Nestlé's traditional Toll House Cookie recipe, the company started diversifying its popular morsels. In the 1970s, children began enjoying their afterschool or dinner treats made with refrigerated chocolate chip cookie dough. Soon, chocolate chip cookies, baked and ready to eat, began popping up in famous brands like Amos and Mrs. Fields. Along came the Chipwich ice cream sandwich, and finally, in 1984, people had their first taste of Ben & Jerry's Chocolate Chip Cookie Dough ice cream. By 1991, Cookie Dough had become its top seller.

Today, more than a dozen varieties of the morsel are available, with many of its new variations originally created and manufactured in Fulton. Some are popular in their own right, such as butterscotch and mint, and for those who believe small is beautiful, we can purchase a bag of mini-morsels. True to the nature of Westreco research technicians, Nestlé kept experimenting with new versions of the popular product. The January-February 1974 issue of *Nestlé News* notes that William Bell, Nestlé marketing group manager, challenged the technicians in Fulton's lab to develop a coconut morsel. Pointing to research that showed $35 million a year was spent on shredded and flaked coconut, the Fulton lab worked on a formula with just the right taste, texture, toasted coconut flavor and baking performance—the only one of its kind on the market.

Ruth Wakefield died in 1977, and seven years later, her Toll House Inn burned to the ground. It would seem that, in this new millennium, the world has forgotten her. But today there are thousands of foods that contain chocolate chips—most importantly, her simple handheld dessert. Wouldn't Ruth be pleased to know that eighty years after she decided to add pieces of Nestlé Semi-Sweet Chocolate to a recipe, her creation is still the most popular cookie in America?

THE CRUNCH BAR

The year 1938 was monumental for the Nestlé Company. The same year Ruth Wakefield introduced chocolate chip cookies to the world, America's first milk chocolate factory began producing what is perhaps its most famous candy, the Crunch Bar. The history of that bar also begins with a legend.

I learned one version of the Crunch Bar's origins from Yvonne Mace, whose great-uncle was Maurice P. Michaud, a member of the Swiss Michauds who helped introduce chocolate making to the Fulton factory. Yvonne told me this story, which her family has passed down through the generations: "Maurice used to take chocolate home from the factory to make a special treat. He'd warm up chunks of chocolate, add Rice Krispies, let it harden and then share them with his family. One day, Maurice brought his treat to work and everyone from line workers to plant managers wanted the recipe!"

My research on Nestlé's history could not verify the Michaud story, but it certainly rings true to what I'd heard many times about Fulton plant employees contributing ideas to improve a product or its production. But a chocolate bar with rice? I can't imagine a blander food being mixed with the exciting taste of chocolate. It turns out that Nestlé had a perfectly logical reason to experiment with the chocolate-rice combo, and it all came down to dollars and cents.

Prior to the Crunch Bar, candy bar fillings were often made with heartier ingredients, such as nuts or caramel. Although their rich flavors were popular with customers, those extra ingredients were expensive, driving up production costs. By using economical rice, Nestlé not only continued to expand its product line, but it could also manufacture some of them at a lesser cost. It was a candy bar company's version of a win-win solution.

Of course, the ingredient that made the bar so unique wasn't just traditionally cooked rice. It was a crisped version, and at first, the Fulton plant relied on other companies to provide it. However, Nestlé's main rice provider, Van Brode, began having trouble keeping up with the chocolate company's supply needs, even after supplementing delivery orders with Kellogg's Rice Krispies. Nestlé Corporate considered several options to meet production demands, and in 1981, management made the decision to begin crisping rice at the Fulton plant. Dave O'Bryan, a Nestlé plant supervisor, was involved with the startup of its Crisped Rice Department, but he'd been aware of Nestlé's desire to process rice in-house well before the 1980s.

"Back in the '60s, when I was in college and working summers at Nestlé, the Technical Services Department was already doing trials on cooking rice

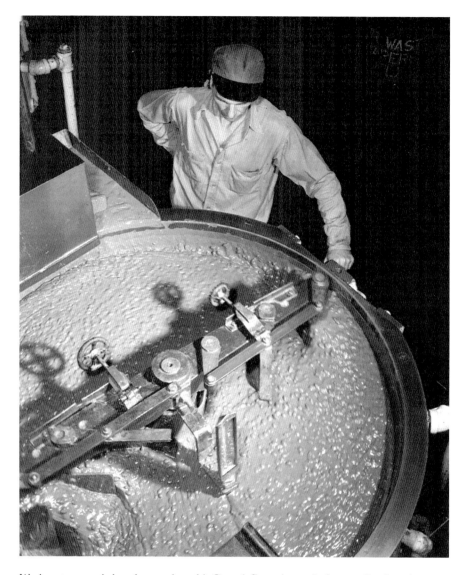

Workers tempered chocolate, such as this Crunch Bar mixture, before sending it to the Moulding Department. *Fulton Nestlé archives.*

and crisping it," Dave noted. "They were working on a two-step process of cooking rice with steam and then drying it to a crispy texture. It was a lot of trial and error, and many times it didn't work. The rice came out a mess."

By 1972, Dave was a full-time Nestlé employee, and those crisp rice-development trials were still going on. He was involved with the tests and described how they were carried out:

Technical Services had made a miniature rice-cooking factory, a small prototype of what the plant ended up building. We went through each phase of the operation, and the line workers who ran the equipment were key to that process, advising us on what their machines needed. Along with producing a good product, we were also trying to shorten the cooking time because Nestlé's goal was to produce a thousand pounds of crisped rice per hour. By the end of our two years of tests, we were able to triple that production goal.

Soon, uncooked rice began arriving at the Fulton plant in one-ton "super sacks." It was then put through a syrup-processing phase and cooked under vacuum until it burst, much like popcorn. Fulton's rice-preparation method became so efficient that the factory became responsible for providing rice to all other Nestlé plants. For many years, no matter where in the world people bit into a Crunch Bar, its crisped rice snap came from the Fulton factory.

Like the chocolate chip, Crunch Bar's success has spawned dozens of different varieties. Over the years, Nestlé launched versions of the bar to commemorate noteworthy events, such as the Bicentennial Crunch Bar, wrapped in its red, white and blue label in 1976, the 200th anniversary of our nation's birth. Today you can find Nestlé's Crunch White (first introduced and manufactured at the Fulton plant in 1997), Buncha Crunch, Crunch with Caramel and Crunch with Peanuts. It's also become popular in ice cream novelties.

Once the Crunch Bar proved to be successful, it got a run for its money from other candy companies. Shortly after the Crunch Bar was introduced, Hersheys came out with its Krackel Bar. It was never much of a competition, though. For decades, Nestlé's Crunch not only outsold Hershey's version, it also was the most popular candy bar. You'll still find it ranked on Top Ten lists of all-time favorite chocolate bars.

NESTLÉ QUIK

Though Nestlé's Quik didn't become the drink of choice for American children until the late 1950s, its history goes back to the Fulton plant's earliest years. When Peter's Chocolate started production at the factory, their researchers were trying to find some use for the cocoa bean's kibble,

the granular byproduct after cocoa butter was pressed out of chocolate liquor. On paper, mixing kibble with an already plentiful ingredient at the plant, milk, seemed like a winning idea, but it took years to figure out how to effectively do so. What eventually became Quik actually went through hundreds of versions. Some trials were test-marketed, given names like EverReady, a powdered chocolate that turned heated milk into hot cocoa. Its success began in the 1920s, and it was primarily marketed as an adult drink, found at high-class soda shops, cafeterias and restaurants. But kids at home wanted to drink a chocolate treat, too, and they wanted to do so with a glass of cold milk.

Westreco researchers, including Joe Allerton and Bart Siebers, were involved with the years of tests to satisfy children's cocoa beverage request. Joe explained their struggles toward perfecting Quik in layman's terms: "The basic problem was that if you took sugar and cocoa and tried to mix them with cold milk, it just sat there." Bart elaborated on what stood in the way of Quik's eventual success: "It was a very fine powder and relatively high in fat. It's not wettable, but if you do get it wet, it crumbles."

To make matters worse, shelf-life tests showed that when thirsty children dipped a spoon into a months-old canister of the mix, they found a hardened mass. Researchers went back to the laboratory, finally figuring out that by infusing steam into the process, the mix's consistency easily dissolved and remained granular, even after sitting on a shelf for months. Thanks to the persistence of researchers like Siebers and Allerton, today kids around the world can turn a couple scoops of Quik into a real treat… real quick.

Once Quik had been perfected, three processing lines were needed to meet the demand for it: two for the regular version and one for Strawberry Quik, which was one of the few products made at the Fulton factory that didn't contain a trace of chocolate. Production took place in the factory's Quik Tower. Constructed in 1955 with materials made by the Fulton Sheet Metal Company, the one-and-a-half-story-high addition was placed on top of Building 57's fourth floor, and other than a few workers who used catwalks to clean the interior of the towers, no one ever ventured into them. There wouldn't have been a lot of extra room, anyway. Up to eighteen thousand pounds of the mix was made *every hour*—enough Quik to sweeten a million glasses of milk.

I've done my share of scooping Nestlé Quik out of its traditional tin and cardboard canister and enjoyed learning how the Fulton factory packed them. That happened at the Cocoa Fill and Pack Department,

Before the product known as Nestlé's Quik, Fulton researchers trial-tested several varieties of a beverage mix that could be successfully added to milk. *Fulton Nestlé archives.*

where Vern Bickford put in fifteen of his thirty-seven years with Nestlé. "The empty containers to be filled with Quik came in on a conveyor belt, were tipped upside down and given a puff of air to make sure they had no debris," Vern explained. "Once righted, the cans swung around a machine with a hopper up top and a series of premeasured tubes. The cans would stop, get filled and weighed. If a can was light, the machine kicked it off the line and its cocoa went back into the mix for another try. Once full, the cans went to the capper, where those metal tops were tapped on."

Working in Cocoa Fill and Pack came with some unusual challenges. Once those machines filling canisters of Quik had been running awhile,

they generated enough heat for operators to work up a sweat. As a young man, Fultonian Bob Green spent time in several Nestlé departments, including some humid summer nights in Fill and Pack. "By morning, I'd be perspiring," Bob explained. "With the chocolate dust sticking to me, I'd walk out of the factory looking like a candy bar."

Workers had a similar problem in another Nestlé department, where Nestea Iced Tea was made. Tea leaves and sugar were its main ingredients, and they were brought to the Beverage Department in one-thousand-pound deliveries. When mixed together, tea and sugar dust permeated the air. Arriving home after their shift, that department's workers removed their hairnets and got rained on by tea powder. Once in the shower, they'd watch something most of us have never seen: water that looked just like a fresh glass of Nestea pouring down the drain.

FARFEL AND OTHER NESTLÉ MASCOTS

In 1948, the name Nestlé Quik was first test marketed, and the descriptive name stuck. Its fame in the world of children's treats was partially due to aggressive marketing campaigns that Nestlé launched for Quik. The most successful was a series of commercials featuring a ventriloquist named Jimmy Nelson whose dummy, Farfel, a stuffed dog, would finish the TV ads by singing "N-E-S-T-L-E-S, Nestlé's makes the very best…chocolate." Those raised on 1950s and '60s TV can still sing the song, slowly stretching out Farfel's last word, just as he did.

It was kids' devotion to Chocolate Quik that convinced Corporate Nestlé to offer the drink mix in a very different flavor: strawberry. Introduced in 1960, it only took a few years before Farfel and the gang had some serious competition from the Strawberry Quik Bunny, who, in 1973, had its own rock and roll–influenced jingle: "You can't drink it slow if it's Quik!" Nestlé didn't stop there. In 1981, Nesquik, as it was now called, appeared on store shelves in a syrup form. A Nesquik cereal, comparable to Cocoa Puffs, was introduced in 1999. It was made using whole grains, which Nestlé hoped would appeal to health-conscious consumers. The company tried a similar tactic with its most popular Quik product, its chocolate drink mix, by reducing its sugar content. I've never tried it. Why would I? Who wants a drink of Nestlé Quik without its rush of sugar turning a plain old glass of milk into something special?

My parents weren't the only ones who got their children to drink milk by adding sweet-flavored Quik. Here's a letter to the editor found in the January/February 1972 *Nestlé News:*[*]

> *When my son, Billy, was born in 1960, he hated milk. The nurses in the hospital had to squeeze his cheeks together to get* [the bottle's] *nipple between his lips. As soon as he got a taste of milk, he'd cry and push the nipple out of his mouth with his tongue. When I brought him home, it was the same thing. He just refused milk. I became quite frustrated and irritable with him, because he was fussy and losing weight. The doctor put him on all sorts of special formulas, none of which worked.*
>
> *One day, when Billy was six weeks old, I took him to the grocery store with me and happened to spy Nestlé's Strawberry Quik on the shelf. An idea struck me. I thought, "Nothing the doctor suggested has worked, and I've got to try something." I bought your product and some homogenized milk, went home, filled and heated the bottle and gave it to my son. It was like a miracle; he loved it! For the first time since his birth, he emptied the bottle. He drank Quik until he was two years old, and now he and my two daughters have graduated to Chocolate Quik.*

Apparently, Strawberry Quik has been a savior of sorts for young mothers not only after but also *before* they give birth. Fultonian Sarah Fay had this comment about the Nestlé product and her first pregnancy: "I couldn't get enough strawberry milk. I would buy Nestlé Strawberry Quik and consume gallons."

Who knew that, along with being so quick and easy, Nestlé's popular drink would also be described by mothers as a miracle and something they couldn't get enough of? Wouldn't Henri Nestlé, after performing his own miracle by saving a baby's life with his infant formula, be happy that Fulton Nestlé workers had created such beloved products in his company's name?

[*] The author of this letter was not mentioned in the article.

THE SPECIAL PRODUCTS DEPARTMENT

After seeing the success of customer favorites like the Crunch Bar and various types of Quik, Nestlé created a department in the Fulton plant specifically for manufacturing new products. When it was founded, in the early 1960s, the department was referred to by the name of each product being developed; Strawberry Quik, for example. But by 1975, the location where researchers' ideas became popular Nestlé foods had its own name: Special Products. Special could also be used to describe the dedication of those who worked in that department, as their first project—the creation of a ready-to-bake cookie dough—would prove.

Plans for Nestlé Cookie Mix, a refrigerated cookie dough, had been in the works since 1950, but true to the company's high-quality pledge, two decades passed before researchers came up with a winning recipe. During that lag time, both Quaker Oats and Pillsbury had launched successful versions of the dough, but once Nestlé's brand was tested in several U.S. cities, all indications were that they had a great product to market. In early summer 1975, the decision was made to have Cookie Mix available across the country by the fall of that year, just a few months away. Fulton's Special Products Department had its first challenge.

Nestlé Corporate had good reason to give the problem to the Fulton plant. The factory had long proven itself capable of keeping up with extraordinary demands for large quantities of product. But the launch of Nestlé Cookie Mix was challenging beyond big numbers. With the fall launch date so close, Special Products' management, researchers and workers had to develop a new automated process, design and/or procure the necessary equipment, install it and begin mass-production. Experimentation took place around the clock, with lab staff who normally worked the day shift running tests far into the evening and overnight hours.

Fulton Nestlé employees didn't let corporate officials down. "As far as I know, we have never done anything this fast," said Gus van Nievelt, the corporate general manager overseeing the project. "This was for all practical purposes a record." By September, Nestlé Cookie Mix was reported to be "flying off the shelves," and predictions were made that it would become the fourth biggest product in the Nestlé line, behind Semi-Sweet Morsels, Nestlé Quik and Nestlé Crunch.

There were many Special Products experiments American consumers got to taste. Most were chocolate-based, such as Choc-o-bake, a baking bar, and the Puff Bar, which took on its balloon-like appearance by being filled with carbon

dioxide. But not all of those attempts to win over Nestlé customers succeeded. Charles Grower, a 35-year employee in management, remembered something called Quik Thick Shakes: "The powder was supposed to make a milkshake, and Nestlé ran it for one summer. They were pretty tasty, but the problem was, after a few months, the powder turned to a solid rock."

Sometimes it wasn't that the new product didn't appeal to the public. Legalities could get in the way of an exciting new Nestlé candy. Brian Kitney and Dick Atkins remembered something they refer to as "The Magic Ball Debacle." Brian started off the memory: "Nestlé decided to make a product called a Magic Ball. The idea was that inside a hollow chocolate ball would be a toy, but the toy they'd decided on was determined to be a choking hazard for small children."

It turns out that a rival candy company put up the red flag that halted the new candy's chance for success, as Dick explained:

> We lost the Magic Ball operation because Mars, Incorporated didn't want the competition. They enacted an old FDA law that said you cannot embed anything in chocolate because someone might bite into it. Well, the toy in the Magic Ball really wasn't embedded, it was surrounded by chocolate. But Mars won the lawsuit, and we had to stop production. We lost millions of dollars on that project.

Brian wrapped up the troubling story by explaining the problems Nestlé had with shutting the candy's production down: "Now we had trailer loads of this product that had to be destroyed. Corporate didn't want it taken to a landfill as is, so they presented the problem to us. We decided to put them through a grinder so that all the plastic parts were crushed into the chocolate. Then the Magic Balls were sent to the dump."

Maybe it was the word *magic* that jinxed Nestlé, because here's another case of bad luck for the company, this time due to a man named Magic. "We had a lot of success doing chocolate bars that were tied to Disney movies like *The Lion King, Beauty and the Beast* and *Pocahontas*," Dick Atkins explained. "Movie figures were engraved into chocolate bars and packaged in theme-related wrappers." Nestlé Corporate knew a good idea when they had one, so they decided to shift their popular theme bars to the sports world, producing a National Basketball Association Crunch Bar that focused on Magic Johnson, who was a major star in the '80s and early '90s.

"The moulds, featuring Magic holding a basketball, were expensive, and thousands of them were made," Dick explained. "We needed that

many, since our orders were to produce half to one million *cases* of the bars."

After approval from the NBA and Nestlé's Marketing Department, Magic Johnson Crunch Bar production was scheduled to begin on a Friday in November 1991. Dick had planned to run crews overtime for the big project. He'd ordered the production of extra chocolate and rice and had cases and labels stamped with an image of Johnson. A huge inventory of regular Crunch Bars was already in stock, since Fulton Nestlé was going to devote all its resources, time and employees to the new promotion. But the night before Friday's exciting startup, everything changed. Dick remembered:

> *Thursday night I was heading home, listening to the radio, and I heard that Magic Johnson had HIV. My heart stopped. I immediately called Tom O'Brien, the plant manager, and told him what I'd heard. He thought I was kidding, but I assured him I was serious. The phone went quiet for two or three minutes.*
>
> *I knew that corporate was still open on the West Coast, so I suggested Tom call them. They didn't hesitate with their decision. "Shut it all down," they ordered. I got home at 6:30, and by 8:00 that night I was back at the factory on my computer, reprogramming most of the factory. I ended up having to close down two lines of Building 30 and lay people off temporarily.*

Once Nestlé's Easter bunnies became popular, they could be found in all sizes. *Courtesy of Lynn Ricketts.*

Those were tough decisions to make for Nestlé Corporate and Fulton's management. The company lost millions of dollars, local workers were out paychecks and everyone's morale took a hard punch. Thankfully, those unexpected pitfalls were rare for Nestlé. More often, the company and its workers had a Special Products success story to celebrate, which made the occasional bump in the road a little easier to handle. One successful example that the company could always

count on was springtime's Nestlé Easter Bunny. The chocolate treat ended up in so many Easter baskets that it required its own year-round production line in Building 30. But things didn't start out quite so grand for the tasty bunny.

It was 1967 when Nestlé announced the first production of its special chocolate Easter Bunny, and Fulton's Brian Kitney was involved with setting up the new line. Brian was a shift foreman in Building 30's Moulding Department, and he remembered the less-than-ideal equipment they used for that first run: "The fillers that would feed the rabbit moulds were paint fillers we converted to dispense chocolate." From those primitive beginnings, the chocolate rabbits grew in popularity. A February/March 1969 issue of *Nestlé News* explains how the company got the idea to mass-produce chocolate bunnies, marketed as the Gala Nestlé Rabbit:

> [The Gala] *is descended from a long line of candy rabbits in Pennsylvania, home of the early moulders of hollow rabbits. Output was limited because chocolate would break once it was taken out of the mould, or the rabbits would be speckled with unattractive pinholes caused by trapped pockets of air. Nestlé's first Gala Rabbit, the 6-ounce size* [had problems. It] *carried a basket on his back,* [which] *reinforced the Easter theme, but it was a natural spot for air to be trapped. Nestlé engineers were not happy with the pocked rabbits and they made the 3½- and 8-ounce sizes without the baskets.*

Conditions for the moulded rabbits improved from there. *Nestlé News* reported:

> *Orders for the rabbits are up 50 to 150 percent over the previous year. The Company believes the rabbits are a hit with kids because they are solid-filled, the chocolate is high quality, and the Nestlé name. Mothers like them, too, because unlike the old hollow-moulded rabbits, solid rabbits don't break and spill on the floor. Nestlé has been preparing for the Easter rush each September. Thirteen Fulton employees in three shifts have been running 31,000 rabbits per day.*

I got out my calculator again and worked with the numbers Nestlé was reporting. Thirty-one thousand bunnies a day from September through February adds up to over five and a half million chocolate rabbits. That's a lot of happy children who woke up Easter morning to find the treat nesting in a basketful of multicolored grass. Yes, those Nestlé Special Products made for some special memories.

6

HIGH AS THE ALPS IN QUALITY

The phrase "High as the Alps in Quality" was not just a clever slogan Nestlé used to highlight the company's Swiss origins. Those words, first found on Peter's candy bar wrappers and then adopted by the Nestlé brand, reflected a work ethic that company founders lived by and inspired their employees to embrace. When Nestlé and Peter's came to the United States, they instructed Fulton workers to insist on quality within every aspect of the business, not just how milk or chocolate was processed. For example, the Swiss had stringent methods to keep track of numbers, as Dick Atkins confirmed:

> *The company was precise to the penny. That was due to the German's influence on our Swiss founders. When my department did our formulas, we figured them out to five decimal points. I started at Nestlé using a slide rule, and then we all had calculators to work out our numbers. Eventually, we moved to computers, but since the Swiss used the metric system, we also had to get good at converting kilos to pounds.*

Adhering to high-quality Swiss business practices might sound as simple as one-two-three, but you can be sure that Fultonians on Nestlé production lines were concerned with more than a by-the-numbers procedure. Mike Malash, who worked for years in the Conche Department, knows firsthand that the Fulton plant approached the making of chocolate as an art. "With other companies, you followed a formula, no matter what," Mike said. "Here

in Fulton, they'd hold up chocolate production and shipment for over a week trying to get a flavor just right. Some of the companies that bought Nestlé bulk chocolate would only take it if it was made at the Fulton plant. They knew if it was made here, it would be the right quality every time."

I heard many examples from Nestlé workers who agreed with Mike about the company's approach to chocolate production. Jo Ann Butler learned this about her great-uncle Emery Howard, whose work in the Almond Roasting Department was on his mind wherever he was: "Emery's home was only a short distance from the plant, and he would often head there for his lunch break. Sometimes, he'd call up the plant from home and say, 'The almonds are done.' They smelled right to him."

The other fact I learned about Nestlé workers' commitment to quality was how this ethic could be found at every step in the chain of command, from the person slicing open bags of cocoa beans to the leader of the entire plant. One example of how a boss can inspire workers to strive for excellence is Nestlé plant manager Charles Cieszeski. People who worked under Charles's leadership were expressive as they shared memories, speaking of their boss as a friend. I wondered how someone who held such power over people—one word from Mr. Cieszeski and a person could find themselves out of a job—could also be considered a friend. Several members of his family—Charles's two children, Charlie and Connie (Cieszeski) Tompkins, and Connie's daughter, Amy Tompkins Johnston—explained how Charles's life influenced his approach to managing a factory that employed over 1,500 people.

"Dad worked his way up from nothing," Connie explained. "His parents emigrated from Poland to Ohio, leaving one child behind because of their lack of finances. In Ohio, his father worked in the mines and died of black lung disease. Dad even worked in the coal mines at the very beginning of his career. His family was very poor, and he used to say, 'We were so po-o-o-o-r, there was a million Os in there.'"

Charlie added:

Dad went about as far as a person from his beginnings could go. He was born in 1923 and grew up in the middle of the Depression. His parents couldn't afford to care for all the kids, so Dad, as the oldest son, had to move out of their house. That's how he met my mom, Frances. Dad was working nights as a projectionist in a movie theater and Mom was a waitress at a diner where he'd get his meals.

Charlie and Connie explained that there were more hardships for their father. When he was quite young, he contracted polio, which affected his height and build. He tried to get a factory job, but his physical limitations made the work very difficult. This didn't stop Charles from entering the Army Air Corps, serving during World War II. As Charlie pointed out, serving his country was the only reason his father got to go to college.

"Dad had the G.I. Bill, which allowed him to go to Marietta College in Ohio. He wanted to be a doctor, but didn't have enough money to keep going to school. After college, Dad got a job working at a lab at Nestlé in Marysville, Ohio, where they had a milk plant." Connie added, "Dad started at Nestlé at the bottom and never forgot what it was like to be there."

After a few years in Ohio, Charles was transferred to Nestlé's Freehold, New Jersey plant, which was primarily a coffee factory. There he headed the team that worked in the lab to develop the decaf version of Nescafé. His success prompted Nestlé Corporate officials to advance Charles into the management division of the company. This resulted in the Cieszeski family having to move several times. When Nestlé was looking to transfer him to California, Frances put her foot down; the West Coast was too far from family. In 1957, the Cieszeskis moved to Fulton, which thereafter became their home.

While at the Fulton plant, Charles took business and management classes at Syracuse University and was promoted to assistant superintendent and then superintendent. Charlie remembered a time when the Fulton plant went through a lot of reorganization: "We were on vacation in Ohio and Dad got a call. 'Get back here right away,' he was told. The company had fired a bunch of people, and it turned into a promotion for him. Several years after that, in 1974, Dad was named plant manager."

As the leader of the Fulton factory, Charles never forgot his unconventional journey from poverty to plant manager, understanding that there was more to a person's success than family situation or schooling. Connie noted that "Dad always said that no matter what their education or background, new employees would still need to be trained for a specific job. As far as Dad was concerned, your education wasn't as important as your willingness to learn and be trained."

I'd heard that Charles made it a point to be involved with individual hires whenever he could. Knowing he supervised thousands of people during his tenure with Nestlé, I wondered how he found time to get to know his workers. Then I learned this: Charles walked the entire Fulton plant every day, logging several miles in order to see how the plant was operating and

Fulton Nestlé Plant manager Charles Cieszeski (*seated far left*) and his management staff team in 1984. *Courtesy of the Cieszeski family.*

checking in with his workers. Bob MacMartin offered an additional comment about his plant manager's daily walks: "Charles was busy all the time, but on big holidays, he would stop at each floor and shake everyone's hand. I'd never seen that before in the other places I worked."

"That doesn't mean my dad was a softy," Connie noted. "There were certain rules at Nestlé that could not be broken. You could have as much chocolate as you wanted when working, but you didn't dare take a candy bar out of the factory. Dad would fire you on the spot. It was the same thing with tools. That was the rule, and everyone understood and respected it."

There were also times when Charles intervened if he felt a Nestlé employee was in some sort of trouble. Amy shared something she learned at her grandfather's funeral: "One of his linemen came to pay his respects and said, 'Your grandfather saved my life and my marriage.' The man explained that he had been caught drinking or something and my grandfather insisted that he go to rehab. Granddad did that for several people."

Charles retired from Nestlé in 1986, and several people I interviewed mentioned the party held in his honor. Though there was a cost to attend the event, over seven hundred people showed up, including "Fulton's mayor, the city judge and all those people from Nestlé," Charlie explained. Retirement for Charles wasn't the picture of bliss many imagine their post-work years will be, as Connie recalled:

He was miserable. At Nestlé, he was always so busy. He and Mom thought they might travel and see things, but her health was not good, so they couldn't do that. In some ways, Dad deteriorated a little, though he tried to stay active. He'd go to the store a lot because he wanted to see people he used to work with and talk about Nestlé. It was really so much of his life, and he missed it after he'd retired.

As Charles's health declined, doctors suspected he might have Parkinson's disease, but that was never definitively diagnosed. However, the family knew for certain that, over time, he developed severe dementia. "Toward the end, he sometimes couldn't remember his family," Connie explained, "but he always knew Nestlé. He'd talk about the plant or about the lines running or if so-and-so was still there. After a while, he didn't talk about anything but Nestlé."

Charles was moved to the senior-living facility and then to a nearby nursing home, where many former Nestlé employees were receiving care. "He remembered all their names," Amy said. "He was like a celebrity there. 'Chuck Cieszeski is here,' people would say. But it went both ways with my grandfather: he respected them and they respected him. And they all respected the experience of working at Nestlé."

There were other leaders of the Fulton plant who exemplified the hometown management style that Charles Cieszeski did, including the man who replaced him, Harry Jewett. Harry took over for Charles in 1986 and served as the plant manager for only a few years, but he shared his former boss's philosophy about running a large factory: "I see myself as the head of Nestlé's family in Fulton, and I feel that trust is a key factor in holding this family together," Harry said during a newspaper interview. "An atmosphere of cooperation pervades in the plant, lending weight to my belief that Nestlé is indeed a great place to work."

There were other ways that Nestlé's management showed their upmost concern for their family of workers. Personnel manager Hugh MacKenzie once contacted Fultonian Paul McKinney, who taught in local schools, and Paul remembered that "Hugh was concerned about the literacy level of some of the workers. He felt it was holding those workers back in life and that it also affected production at the plant. He was searching for ways to offer literacy activities for his workers."

In the years following Charles Cieszeski's and other Fulton-focused plant managers' leadership styles, workers noticed a shift at the Nestlé factory, as Cieszeski's son Charlie reflected:

I saw a change just about the time Dad and managers of some other industries in town retired. Those guys all lived in Fulton and were involved in the community, such as our city's active Chamber of Commerce. Dad was very involved with our church and was on the board of Fulton Savings Bank. All the managers were in service clubs or supported the United Way, so they were friends and associates with the small business owners in town.

After those guys retired, a lot of the top managers of Fulton industries weren't living in town. Their kids didn't go to school here, they didn't go to church here and they were not as likely to be involved in our community. With modern roads and all, people could live in Syracuse suburbs and drive into Fulton to run Nestlé. But when Dad moved our family here, it never occurred to him to live anywhere else.

OPPORTUNITIES TO ADVANCE

Fulton Nestlé's welcoming environment and dedication to helping its employees develop strong leadership skills made the factory a premier training site. During its century in Fulton, Corporate Nestlé sent many management-level personnel to observe the highly efficient factory in operation, including Tom Higgins, an employee of Nestlé Australia. In 1979, he and his family spent two years in Fulton, the first time they'd been in the United States. I became acquainted with Tom while helping the Fulton Library collect memories from people who'd worked in Fulton's industries, and through the wonders of the internet, Tom discussed his time in our city:

Nestlé chose the location for my overseas experience extremely well. To our delight, right from the start, I found people at the Fulton Nestlé plant to be exceptionally friendly. Chuck Cieszeski was Plant Manager and he was of great assistance. I thought the management staff might resent someone from another country being imposed on them but, to the contrary, I found an acceptance that enabled me to soak up a large amount of knowledge.

Nestlé didn't just recruit management-level staff from around the world. It also groomed locally based employees for supervisory positions. Workers with potential were offered opportunities to advance, and future leaders were expected to follow the Fulton plant's code of conduct, including this inspiring section:

Encourage a spirit of comradeship and help make the atmosphere in which you work one with friendly rivalry. This will make your daily task a pleasure and lead to teamwork, which constitutes the greater part of your company's good will. Remember that wherever you are, you will always be in need of the counsel of your subordinates. Whatever position your intelligence and work have enabled you to obtain, stay modest and natural. Never let yourself be eaten up by excessive pride…

Many people I interviewed mentioned the path of promotion and success available to them at Nestlé. I heard dozens of examples of someone starting off on the lines and then advancing to managerial positions, including Gary Frost, whose family had a long history with Nestlé. Both of Gary's grandfathers worked at the Fulton plant—one of them, Clayton Frost, for fifty years, one of only a handful of people who devoted a half century to the plant. Gary's dad, Harold Frost, nearly matched Clayton's tenure by working at Nestlé for forty-three years. Gary put in thirty-eight years at the factory, beginning in 1967:

I started in June and was just going to work there for the summer, but they treated me real good.…If you worked hard there—if you took care of Nestlé, they took care of you. When you first started working there, they moved you around a lot. I went from Refining to Wrapping, which had a lot of machinery and I had a knack for machines. I became a foreman in 1972. At age twenty-four, I was the youngest supervisor there.

Just because someone is a good worker doesn't make them a good supervisor. But if you had a good attitude, got along with people and could get things done, Nestlé would consider you for promotion. If you were going in as a foreman, you took some classes, right on site, and then took a test. Then, people would coach you. These were often older guys who'd done the job for many years. So there was some book learning and discussion, and some on-the-job training.

Gary explained a new supervisor's typical training program, first filling in for managers on vacation, then moving through the positions of assistant foreman, shift foreman and then to general foreman, who oversaw the other supervisors and ran the department. Gary admits it was tough switching from working on the line to supervising. "But as long as you were fair and treated everyone the same," he said, "you could demand a lot of people and

they would still respect you. My dad was on my crew, but he understood the chain of command and it was never a problem."

In the same way management prepared employees for maintenance positions with a formal program, in 1976, Nestlé initiated supervisor training. Vondell Smith, who began working for the company shortly after he'd graduated from college, was in the first class of supervisor trainees. "The company was aware that many of their supervisors were reaching retirement age and they'd need to replace them," Vondell explained. "At the same time, manufacturing technology was rapidly changing and Nestlé wanted to help its Fulton factory supervisors incorporate those changes."

Vondell, who had already been asked to handle some supervisory duties in his position in the Wrapping/Cookie Mix Department, was recruited to be in the first official supervisors class. He and his classmates received training to improve their communication and leadership skills and how to work with all levels of staff. "The training sessions were offered through Cornell University, and they were excellent," Vondell said. "I've been in supervisory roles for my entire adult career, and in every one of my jobs I've used the skills we learned in Nestlé's training."

Once in their supervisory roles, leaders at Nestlé were expected to foster a team atmosphere, as their code of ethics encouraged. All employees' opinions and suggestions were considered for improving production standards and protocol. Here are a few examples of how Nestlé welcomed all ideas, which ranged from cost-saving tips to morale-building projects.

Brian Kitney recalled a Bean Room policy change that replaced the two-wheel carts used for moving cocoa bean bags with five-by-five wooden pallets:

A shot of beans, which was how cocoa beans were ordered for production, was always fifty-one bags and those new pallets were built to hold forty-eight bags. We asked why we couldn't change a shot from fifty-one to forty-eight, but were told we couldn't. That created an inventory problem, and we grumbled about it for a while. One day, the plant manager, Jim Gillis, walked through our department. One thing about Jim, he would talk to you. You could be a common hourly employee, but he'd discuss things with you. He wanted to know how things were, so we told him we had an issue with the new pallets. Well, the next day, a memo came around that said, "From now on, all shots will be forty-eight bags." Jim could see that it didn't make sense to mess around with an extra partial pallet. He listened to us and he understood what we were talking about.

Fulton Nestlé's Supervisor Training graduates, including plant manager Charles Cieszeski (*standing far left*) and Vondell Smith (*standing second from right*). *Courtesy of Vondell Smith.*

Dave Miner mentioned another example of the comfortable give-and-take between management and workers, this one involving an upcoming paint job:

> [At one point, the plant] *started having brainstorming sessions, where managers and employees would meet and discuss new ideas. It was decided to paint the hallway outside the Main Lab white and then hire an artist to paint images of our products: the Crunch Bar, Toll House Morsels, Butterfinger, Baby Ruth, etc. The mural turned out beautiful and the employees loved it.*

The relaxed exchange between line workers and their managers sometimes provided a little fun. When Dick Atkins was a division manager, he oversaw a good deal of the plant's operation, everything from production planning to warehouse and trucking. Dick sometimes kidded with the other Division Managers, noting that even though they were in charge of their departments, he decided *when* they ran their lines. Here's a story about a time when Dick got his fellow managers, as he put it, "a little ticked off."

"The other managers wanted some time off and I wouldn't give it to them because it was right during Christmas, our busiest season." Dick said. "I told

them 'I'll give you guys some time off when you bury me in chocolate.'" A few days later, Dick walked into work to find a big surprise: a wall of ten-pound Peter's chocolate bars stacked in front of his office door. In case Dick didn't get the hint, there was a sign taped to that tower of chocolate: "Happy Holidays from your friends in Condensery, Refining and Coating."

Daryl Hayden, another Nestlé employee who successfully followed the route from working the line to a supervisory role, remembered the relaxed and enjoyable atmosphere his supervisors created: "The managers were great; you could kid with them. Sometimes we'd get invited over to the Chalet for dinner meetings. And when we served on different committees or the United Way, we'd meet at the Chalet."

Other employees had told me about the Chalet, a company-owned house near the Nestlé factory. Its name evoked images of a Swiss cottage in the Alps, and I wondered why such a picturesque structure would be needed in Fulton. It turns out that the Chalet looked nothing like its Swiss namesake. It was a full-sized house that, from the plant's earliest years, provided plush lodging for VIPs from Nestlé's United States or Switzerland corporate offices. Dave Miner, who spent several years in charge of the Chalet, explained how it functioned: "When a visitor flew in to the Syracuse airport for Nestlé business, a chauffeur for the Chalet picked them up in the company car. Sometimes, if a new manager was being transferred to Fulton, he and his

Division manager Dick Atkins had a surprise waiting for him at his Nestlé office when he arrived for work one morning. *Fulton Nestlé archives.*

family lived there until they found a house." Dick Atkins elaborated on how guests were treated: "A housekeeper cleaned, cooked and made sure visitors were well taken care of. There was a pool table and a fully stocked bar, stereo, TV, library, and a large conference room. The basement was remodeled and was very comfortable with a card table for those that wished to partake."

As sophisticated as the Chalet sounded, it also embodied Nestlé's atmosphere of teamwork. Along with hosting visitors, it was the site of company meetings, where management and workers sat together to discuss factory issues. And during special events, the Chalet's staff could count on help. Amy Tompkins Johnston, granddaughter of plant manager Charles Cieszeski, remembered that her grandmother "helped plan the menus for special dinners." Though the Chalet was closed in the early 1990s as a cost-saving measure, the memory of it remains a symbol of how Nestlé management and employees came together to improve the work environment in their factory.

THE NESTLÉ BRAND

Along with the phrase "High as the Alps in Quality," Nestlé had other symbols of its commitment to family and teamwork, including one that didn't need a single word to convey that pledge. From the day Nestlé built its first factory in America, Fultonians identified their newest industry with its logo: a nest cradling three baby birds, their mother feeding them a worm. Derived from Henri Nestlé's family coat of arms, the logo appeared everywhere, from candy bars to common household items like matchbooks. It even found its way to the World's Fair. In 1939, New York City hosted the fair, and over its two-year span, forty-four million people visited. Among the innovative new products on display, fairgoers could purchase Fulton-made Nestlé chocolate medallions stamped with its distinctive logo.

The logo remained with Nestlé as it expanded beyond chocolate and candy products. Today, the nest of birds is found on bottled water, cereals, frozen foods and ice cream. But if you look closely, the current logo is not the same one that first represented its founder's company. In 1988, in an effort to distance its products from what some would call an unappetizing image of an earthworm, Nestlé removed it from the mother bird's beak. In addition, the three infant birds were reduced by one, reflecting a more modern two-child family image.

The Nestlé logo changed over the years to reflect shifting American cultural norms. *Fulton Nestlé archives; www.famouslogos.us.*

As neighborhood grocery stores gave way to citywide supermarkets, Nestlé introduced another marketing strategy: a family-friendly comic strip. During the 1940s, *Grocer Jones* appeared in newspapers across the nation. A typical strip shows a woman visiting her grocery store after hearing other mothers rave about Nestlé Toll House cookies. Though she's afraid to try the new product, Grocer Jones assures the woman that they are "foolproof." The strip's last frame shows the woman's family passing a plate of cookies around the dinner table. Above it, this caption: "Try the newest thrill in cooking: Nestlé's Semi-sweet chocolate."

Good advertising was always an important consideration for the company's survival as the food industry diversified. As Americans were being offered more choices to satisfy their sweet tooth, the cost of manufacturing those treats increased. Here's a company policy statement from February 1947 that explained a Nestlé chocolate bar price hike, which today would hardly seem noteworthy:

> *The cost of our chief raw materials, cocoa beans, has tripled. The cost of milk has more than doubled, and sugar and other costs, including payrolls, have shown substantial increases. Our standard "five cent bar" is now priced to retail at six cents and our other products are priced in proportion, but it should be noted that this increase does not fully cover the increases in our costs. We hope the next time your dealer charges you six cents for a Nestlé bar you will understand his position and ours.*

When 1960s America experienced a radical shift in morality, many established companies chose to reflect that change by portraying themselves as younger and more "with it." Nestlé, however, stuck to its family values. In 1967, it offered consumers an alternative to the other companies' brightly colored, flashy advertisements by introducing its new animated spokesperson, "Little Hans, the Swiss Chocolate Maker." Elderly and bespectacled, Hans was featured in dozens of television commercials, clad in traditional Swiss lederhosen: knee-length leather shorts, suspenders, yellow shirt and felt hat. He became so popular that Nestlé created the Hans doll, which became a collector's item.

Nestlé's image as a high-quality chocolate company got a major promotional boost in the 1940s, when an ad proclaimed "Hot Nestlé Helps Keep 'em Warm on North America's Highest Mountain...Mt. McKinley." The ad made this pronouncement: "As the Alaskan Expedition of the New England Museum of Natural History [attempts] to establish the world's

highest arctic cosmic ray research station, Hot Nestlé's—a product of Fulton—is going with them." Nestlé's EverReady Cocoa was chosen due to its "important nutritive value and the great speed with which it can be prepared under extremely difficult field conditions. A boiling hot drink before getting in your sleeping bag helps a great deal to get you started for a warm eight hours sleep at 30 degrees below zero."

Nestlé learned the value of associating its product to high-profile human achievements from the PCK Company, which ran an ad featuring a July 10, 1926 letter from renowned explorer Richard E. Byrd. Byrd wrote in appreciation of PCK for equipping his Antarctic expedition with chocolate and cocoa products from the Fulton factory. The letter reads, "It is our privilege to attest, and we most gratefully acknowledge, that without such assistance the accomplishment of the Expedition in the Antarctic would not have been possible....The chocolate supplied was an integral part of the emergency ration carried by the expedition's monoplane, the Josephine Ford, in her flight to the North Pole."

Twenty years later, Admiral Byrd was still touting the value of chocolate products from the Fulton Nestlé plant. Ads from May and June 1947 state "Nestlé's EverReady Cocoa—A Product of 'The Chocolate Works'—went along to Little America with Rear Admiral Richard E. Byrd and U.S. Navy Task Force 68 on this year's Antarctic Expedition."

From the highest peaks of the Swiss Alps to the coldest depths at the bottom of the world, Nestlé was proving the value of its commitment to quality. This was never more true than when the chocolate factory in Fulton got a call to serve our country as it went to war.

7

NESTLÉ CHOCOLATE

A World War II Hero

Nestlé's image as an all-American food company grew exponentially through our country's involvement in two major wars. Beginning with World War I, with the increasing popularity of individually wrapped candy bars, Peter's Chocolate was identified as an important component of a soldier's nutritional needs. American armed forces strategists included Peter's in their plans to properly feed the four million military personnel who fought in the four-year war. Along with the chocolate shipped overseas from the Fulton plant, Nestlé's European factories were supplying condensed milk, and both products became essential survival foods during the war's ground battles.

Strong demand for Nestlé's chocolate and milk products meant that their factories' milk refineries were working "flat out," according to historical data on the company's website. The Fulton factory's challenge to keep up with the demand for milk was actually good news for area farmers, who gladly added cattle to their grazing herds. However, things were not as easy on the chocolate-making side of the factory.

As more countries became involved with the conflict, embargoes were imposed, some of which severely limited Fulton's access to the raw materials needed for Peter's Chocolate. Whenever the company could receive shipments of cocoa beans and sugar, they were quickly processed into chocolate and sent to soldiers overseas. On those rare occasions when Peter's had sufficient supplies to manufacture candy for non-military consumption, they were moulded as one-pound blocks. The king-size bars were shipped to

retailers, who made the most of the welcomed treat by slicing them for sale as one-ounce squares.

By the time the United States became involved with a second world war, in 1941, Nestlé had already been contacted by military officials, who considered the Fulton factory's output an important part of their food plan for soldiers. According to Nestlé's promotional material released during the conflict, the War Food Administration considered cocoa beans as a "strategic material" and the manufacturing of chocolate as "an essential industry."

Everyone from Nestlé corporate executives to Fulton's plant managers to line workers were eager to serve our country, proud to think that their candy bar could be part of a plan to win the war. But in order to do so, the method of mass-producing Nestlé's famous chocolate had to be altered. The tasty candy bars made in Fulton were to become life-sustaining ration bars, but doing so wasn't as simple as wrapping them in a new label. There were several reports on the U.S. military's need for ration bars and the Fulton factory's challenges to produce them. One Central New York newspaper stated:

> *Whenever possible, food is served from hot mess kitchens, but the speed and fury of modern battle much of the time prevents kitchens from* [keeping] *up with the troops. When ideal conditions cannot be counted on and when the realities of war take their worst turns, United States troops have ready-to-eat emergency combat rations…individually packed for consumption and carried by each soldier.…Millions of pounds of these items are made at the Fulton plant.*

Before ration bars could start rolling off factory lines in big numbers, Nestlé had some homework to do. Other than a few unsuccessful trial runs at another plant, the company had never attempted to manufacture a life-sustaining chocolate product. There were no proven formulas available to Fulton's Technical Service researchers, who encountered several stumbling blocks on their way to the production of a quality ration bar. To start, they were asked to create a food that could both withstand extreme weather conditions in battle zones and travel the long distances to reach hungry soldiers. Additionally, Nestlé was expected to produce massive amounts of the ration bar while working with increasingly scarce raw ingredients, including the all-important cocoa bean.

The Fulton plant's first attempts at creating chocolate rations failed when it tried to address the lack of cocoa beans by reducing the amount

of cocoa butter in a bar and replacing it with an oat byproduct. The bars quickly went rancid. Further tests appeared to perfect the new ration bar formula until batches were sent to the Moulding Department, where it was discovered that the new recipe created an abundance of air bubbles, which also reduced its shelf life. It was Fulton line workers who figured out how to overcome that problem.

By upping the moulding machines' rate of vibration, workers discovered that they could force air bubbles out of the bars, allowing them to properly solidify. This discovery was key, but it only created a new problem: the factory's normal moulding equipment wasn't able to sustain the intense vibration required. With the availability of steel for new equipment construction severely limited, workers devised a viable alternative, jerry-rigging a piece of machinery most of us could never have imagined being part of a chocolate production line. In a 2003 *Post-Standard* article, Tom Cleveland, a thirty-seven-year employee at Nestlé, spoke of his coworkers' ingenuity:

> [Our] *employees spoke to mechanics, who said piston vibration was the answer. Nestlé was hard-pressed to replace worn out equipment, vibrators included,* [but] *inventive workers from the Moulding Department visited a nearby junkyard and were able to obtain several six-cylinder automobile engines. The junked engines were rigged by cutting off the tops so the exposed pistons could strike a steel plate under the moulds to provide the required vibration. Aside from the increased noise, the piston action provided the additional jiggle needed. When the bars were removed from the moulds, they were smooth and bubble-free. The Fulton line workers' idea worked!*

After months of formula testing and equipment modifications, soldiers began receiving their ration bars. Each bar came with special instructions, ensuring that those in battle could get the most out of this important food.

With much of Nestlé's output going directly to the war effort, corporate officials wanted to let loyal customers know why many of their favorite products were going to be hard to find. In a series of prideful advertisements, Nestlé referred to its candy bars and other chocolate products as "a fighting food," explaining:

> *Maximum nourishment with minimum bulk has been the objective of the U.S. Army in selecting the food for our fighting men....There is more quick energy packed into the familiar chocolate bar than is contained in*

MADE IN U.S.A. REG. U S PAT. OFF. **No. 635**

U. S. M. C. FIELD RATION D

To be eaten slowly (in about a half hour). Can be dissolved by crumbling into a cup of boiling water, if desired as a beverage.

CONTENTS: Chocolate, Sugar, Oat Flour, Milk, Vanillin, B₁ (Thiamin) 150 I. U.

4 OUNCES NET — 600 Calories

Prepared by
PETER CAILLER KOHLER SWISS CHOCOLATES COMPANY, INC.
Fulton, N.Y.

Nestlé/PCK ration bars were distributed to soldiers fighting in World War II. Supplementary information stated "Three bars a day were sufficient to sustain life." *Fulton Nestlé archives.*

many recommended energy foods. It has become one of the answers to the problem of keeping the soldier supplied with food in modern, high-speed mobile warfare.

The successful Nestlé formula was furnished to the army so that other chocolate companies could help meet supply demands. Additional requests from the military resulted in several variations on Nestlé's fighting food: a bar that could stand up in tropical climates, known as Nestlé's All Weather Chocolate; a first-of-its kind Army Cocoa Beverage, ready to serve in both hot or cold water; and the traditional candy bar, already familiar to soldiers, but with a new name, "Army Sweet Chocolate."

Once the Fulton plant began full-out production of army food supplies, it would remain at that rate for years, even after the war formally ended in 1945,* when management issued a morale-boosting brochure to its overworked employees. Titled "PCK and the War," it included this important message about company expectations:

We [have] *made increasing amounts of ration bars at the expense of making regular Nestlé bars. Gradually, the Army increased its requirements*

* Following World War II, Nestlé's commitment to the ration bar continued, with the company manufacturing the bar as a "Boy Scout Emergency Ration."

for our regular bars for the Post exchanges [and] *the first of next year will see a still higher percentage of our bar goods going to the services and less for civilian sale.*

The PCK brochure pointed out serious shortages of raw materials beyond the obvious cocoa beans and sugar. The Fulton plant also pledged to conserve non-food supplies vital to factory production: The Wrapping Department replaced aluminum foil with greaseproof paper. Glass jars were used instead of metal whenever possible. Cardboard boxes were redesigned to increase the number of units per case, and their pads and dividers were eliminated unless absolutely necessary. Printing on the outside of cases was limited to two sides instead of four. Used cocoa bags were repurposed for packing confectionary coating in bales instead of cardboard cases.

A major shortage Nestlé endured while meeting armed forces' ration requests was the lack of workers to run the Fulton plant. Another PCK brochure reported on the factory's reduced workforce due to increased enlistment:

To meet the demand for our products, it was necessary in 1941 to [switch] *to a scheduled 48-hour week. Six-day workweeks mean a hardship on everyone. It means one less day for rest or relaxation. It means having to take care of personal needs at odd times and it means passing up many things that one wishes to do.*

To understand the hardships Fulton Nestlé workers incurred during the war, I reviewed a questionnaire from 1945 that division manager Bob MacMartin shared with me. When the plant closed in 2003, Bob was sorting through decades of paperwork when he uncovered the questionnaire, which the U.S. government used to determine if a company such as Nestlé could be considered "an essential wartime producer." The questions it posed and the company's answers reveal the hard facts of what transpired at the plant during World War II.

An impressive detail covered in the questionnaire shows the percentage of Nestlé's production time that was devoted to supporting our troops. According to the company's answer, "the plant was able to operate at 82 percent of capacity [and] 42 percent of that effort" went to providing the United States with ration bars and other essential foods. Stated another way, during the war years, over half of what was produced at the Fulton plant went to our soldiers.

Keeping Nestlé's workforce strong during World War II was a challenge for the Fulton factory. *Fulton Nestlé archives.*

There was more to infer from those production percentage numbers. The main reason the plant was able to operate at only 82 percent was blamed on its manpower shortage. The company, which before the war was employing 1,700 people, clarified the extent of its low employment numbers: In 1943, 1,622 people were on the job at the Fulton factory. In 1944, 1,456 were operating the plant. And by 1945, 1,299 people were trying to still produce what 1,700 had been able to accomplish.

The PCK brochures issued during the war described how the company attempted to address the staff shortfall. Bus lines ran to bring workers in from nearby towns. People adjusted their shift schedules to carpool with others working at Nestlé or other Fulton factories. Farmers were hired during winter months. Workers were brought in on a part-time basis, including schoolteachers, ministers and store clerks. Management-level office workers and foremen took shifts on the line. The brochure then identified the effort that made the biggest difference:

> *Women on men's work are an important point in our wartime story. Ordinarily, about 25 to 33 percent of our employees are women on what has been called women's work. As men left us, it was necessary to engage women to do work formerly done by men, to such an extent that over half of our employees are women. They have done many kinds of work which before the war one would have said they could not handle; some of it heavy and tiring, some of it involving machines and processes, some of it in warm rooms and some of it dusty and sticky, if not dirty. Many women have shown a spirit of patriotism.*

Nestlé's answers to the U.S. government questionnaire looked at this "women doing men's work" issue differently, suggesting that the shift to a largely female staff was another reason for the drop in production rates. An answer to one question explained how the overtime required of men (twelve

147

hours versus the normal eight hours) was felt to be "too difficult for women to handle. Women and boys on men's jobs were unable to complete many of the tasks required." Other factors mentioned in the plant's low production rates included the required on-the-job training, which took valuable time from actual production. Whenever possible, people were cross-trained in several departments to ensure that lines would continue if workforce numbers dropped further.

Ultimately, C.W. Hill, the plant's manager during World War II, properly addressed the issue of women on the job in this postwar press release:

> At the peak of war production, women were the majority of those in our employ and they…made possible a full flow of chocolate food products to the Army, Navy, and practically every branch of the armed services.…We want to express our appreciation and pay tribute to these girls and women who have done such an excellent job of pinch-hitting for the men who were in the Armed Forces.

For certain, there was one "man" who must share the blame for the Fulton plant's inability to operate at full capacity during the war: Old Man Winter. Nestlé officials also addressed the government questionnaire's inquiry about plant production rates by assigning an unusually high 6 percent absenteeism due to several bad snowstorms hitting the Fulton area. Since many of the employees lived outside city limits, unplowed roads prevented them from even trying to make their way to the factory.

One additional wartime challenge added more stress to the limited workforce's noble efforts. Nestlé's commitment to help feed the troops meant it was required to follow regulations from the Office of Civilian Defense. The plant was forced to pull people off production lines, assigning them jobs such as armed and uniformed guards, watchmen, medical staff, messengers and fire watchers.* All employees were required to carry an ID badge and pass through a daily fingerprint check on their way into work. Truckers and visitors had to register within the plant. All this impacted production rates, and in an unprecedented move to keep the factory running during the war, workers made what many might consider the ultimate sacrifice: plant management announced that no one would be allowed to take their regularly scheduled vacations.

* Expenses for additional fencing around the plant's perimeter and construction of guard houses and a lookout station further stretched the plant's limited resources.

SUPPORTING THE TROOPS BEYOND CHOCOLATE

The plant did have bragging rights when it came to safety on the job. To comply with the nation's goal of creating total blackout conditions in the event of an air attack, the entire Fulton plant demonstrated its ability to do so in fifteen seconds. When the U.S. government's questionnaire asked about the company's wartime rate of safety-related incidents, Nestlé reported that "lost time ranged between 9.47 percent and 11.13 percent," well below the entire confectionery industry's average of 18.71 percent. According to the company's insurance carrier, Nestlé not only held one of the highest credit ratings, it also claimed the world record in the food industry for the largest number of man-hours worked without lost time due to an accident: 3,904,841.

Along with safely producing chocolate bars in unprecedented amounts, the Fulton factory also organized civilian efforts to support our troops. Plant workers sponsored Red Cross blood drives, with employees lining up to give, as well as their families. Corporate executives wanted to highlight their workers' efforts and encourage others to do likewise, issuing Nestlé's Milk Chocolate bars with this notice on the wrapper: "Give your blood," says (noted World War II correspondent) Ernie Pyle. "I beg you folks back home to give and keep on giving your blood....Plasma is absolutely magical...Thousands have already been saved by it in this war. Go Today! Send your blood overseas through the American Red Cross—and be a repeat donor."

A newspaper article found in Nestlé archives reported on the company's involvement with a citywide effort to promote war bonds. Industries included Armstrong Cork, Dilts Machine Works, Sealright and the PCK Company. The War Bond Committee raised $83,000 during its first week toward the goal of $600,000. The company also participated in the nation's victory gardens project, as evidenced by this October 1943 letter from the National Victory Garden Institute in New York City: "It is a great pleasure to inform you that your company was unanimously chosen by [our] judges to receive the certificate award...for the very real contribution to the Victory Garden Program in 1943." In 1945, PCK received a second award, noting the plant's "distinguished record of encouraging Victory Gardens and home food preservation."

A HEARTFELT THANK-YOU FROM SOLDIERS

From across the ocean, when soldiers weren't in the throes of battle, they wrote letters of appreciation for the support of folks back home. Sometimes those letters specifically mentioned Nestlé products. Private James Ives sent his thoughts to a Fulton newspaper, ending his letter to the editor by stating:

> *Last, but not least, comes another reminder of Fulton—in the form of a chocolate bar. I open up a ration package and, lo and behold, there on the wrapper I spot the words: Nestlé Chocolate, Fulton, New York. There are other chocolate companies that also make those bars, but I'll say here and now that the workers at Nestlé make the finest bar yet. I sincerely hope that Mr. Hershey isn't offended. Yes, Fulton is always being brought to one's attention over here. And, here's one G.I. who will be a very happy guy the day I can once again go back home to it.*

Other G.I.s would agree with Private Ives's sentiment, and John Procopio had a second reason to feel the pull for home when he served in the army during World War II. Not only was John a Fultonian, but he also was a Nestlé employee, and he recalled consuming Nestlé ration bars while on the battlefield in Italy. John had seen his share of chocolate bars while working in the factory's Wrapping Department, and he admitted that the wartime ration bar didn't taste quite as good, but biting into one while trying to get some rest in a foxhole prompted him to send a letter of thanks, noting, "I wanted the workers at the factory to know how much their efforts meant to me."

As the war dragged on, some soldiers wondered if they would ever get home. In January 1944, the *Fulton Patriot* published an article that captured the reality of those fighting for our country and our freedom. It also proved how a Nestlé chocolate bar could make all the difference to those in battle. The article was titled "Fulton Product Is of War-Time Importance" and it covered the story of Company E, a group of soldiers from Big Rapids, Michigan, the first American unit to land in war-torn New Guinea. Company E was expected to march over one hundred miles, starting from its arrival point, Port Moresby, through jungles and over a mountain range to surprise the enemy at Buna. During the march, the men were fed—sometimes—by transport planes that flew low and dropped food and equipment to jungle clearings. The article quoted Lieutenant Paul R. Lutjens, Company E platoon leader: "Whenever we heard a transport,

our mouths began to water. There was always a chance they would drop a chocolate bar. You would sell your soul for a chocolate bar."

The *Patriot* article goes on to say that a poll had been taken among troops at an American airbase in Italy. The survey revealed that next to pictures of a wife or sweetheart, the most appreciated Christmas gift was chocolate. The article also noted that Ernie Pyle commented on the importance of the Fulton plant's ration bars, stating that "when our infantry goes into a big push, each man gets three bars of D-ration chocolate, enough to last one day. He takes no other food."

Plant manager C.W. Hill offered a poignant ending to the *Patriot* article, explaining that he had received many letters from troops. He quoted a few of them, starting with a Marine private in the South Pacific: "Whenever the boys see I have some chocolate, they form a line by my bunk. No kiddin'. It sure goes over big down here with the fellows." Another letter sent to Hill was from a private in the Aleutians: "A buddy walked in with two cartons of Crunch Bars. You can imagine with what joy our tent hailed him—or can you? I've had chocolate bars in many places, but I guess they taste best of all here."

Many of the letters home included appreciation of and request for more Toll House cookies. Though chocolate was in short supply domestically, women on the homefront were encouraged to use what little they had to bake cookies for "that soldier boy of yours," as one Nestlé ad put it. Ruth Wakefield's Toll House Inn led the bake-and-send effort by shipping thousands of cookies to servicemen. Before the war, chocolate chip cookies were primarily an East Coast favorite, but through the efforts of mothers, wives and other loved ones, by the time peace again reigned, Toll House cookies rivaled apple pie as the most popular American dessert.

In 1947, a letter from Mrs. E.G. Whittaker of New Rochelle, New York, arrived at the Nestlé plant. Mrs. Whittaker had been held in a Japanese prison camp during the war, and PCK/Nestlé was one of the first companies to contribute goods for Red Cross prisoner-of-war packages. Mrs. Whittaker wrote: "To us, what came out of that nightmare was that Nestlé symbolizes so much. It was our first sight of food from home. I saw people weep with gratitude when the Red Cross nurses handed us those huge bars of your chocolate."

Not all the chocolate bars that made the long journey overseas ended up in the bellies of American soldiers. Marilyn Stevens, whose father, Raymond Bessette, served as military police in Rome, Italy's Vatican district, shared this story about Nestlé candy bars: "My dad talked about the widespread

famine conditions in Europe during the war. He and his fellow servicemen had to put a fence around the garbage cans because people would scavenge whatever food they could. When Nestlé bars came from home, Dad and other soldiers would slip them into the hands of those hungry children."

Whether they were bringing a satisfying reminder of home to American soldiers or helping a child make it through another day, Nestlé workers had much to be proud of. As manager C.W. Hill stated in one of the company's wartime press releases, "These achievements were not so much of a company, but of people—of men and women who worked at all hours until each problem was solved, each deadline met."

Those putting in long hours had a daily reminder of what their extra efforts meant. As workers entered the Nestlé plant, they could look up to the top of one building, where a large tally board kept track of the number of plant employees serving in the military. That number would top off at 676, suggesting that everyone at the factory knew someone fighting in the war. A plaque at the main entrance of the plant offered a more somber statistic. It listed PCK/Nestlé employees who left the plant to fight for our country and would never return home to report for work again. There were 32 names.

During the war, Nestlé workers made 70 million pounds of chocolate and cocoa ration components. In addition, the Fulton plant shipped 815 million five-cent Nestlé Chocolate Bars, which were sold at post exchanges and service stores around the world. As could be expected, the United States didn't see many Nestlé chocolate bars during the war years. When it looked like the fighting was finally coming to an end, Americans hoped that the domestic chocolate shortage would also be over. But in 1944, C.W. Hill issued a press release emphasizing the ongoing effort to support troops: "[The need] will not end with Nazi Defeat. Production at Nestlé will not slow down at the war's end. [There are still] huge orders to fill for the men fighting overseas."

A February 1946 *Syracuse Herald-Journal* article proved Hill's words were true. Even in Fulton, the article pointed out, local stores hadn't carried their hometown product since 1941. When this continued even after the war's end, local merchants felt that some of the candy should be available to those who worked so hard making it. The article reported a bit of good news. After Nestlé Corporate officials were informed of this request, "several cases of candy bars from the PCK Company will be delivered to Fulton dealers by an Oswego County distributor, who has received strict orders not to deliver any outside of Fulton."

The chocolate shortage continued. Two years after the official end of the war, a company statement, "The Scarcity of Nestlé Chocolate Bars,"

Memorial plaque honoring the Nestlé workers who gave their lives during World War II. *Fulton Nestlé archives.*

reported that "just like housewives, Nestlé is being rationed, limited to just 60 percent of the sugar of their 1941 rate. Coupled with the increased demand for Nestlé's chocolate products, this has led to a shortage of the chocolate bars." Anybody lucky enough to get their hands on a bar could read about the shortage on the back of candy wrappers. Comic strips featured kids asking: "Mom, why can't I have another Nestlé Bar?" or "Hey! Who took that last Toll-House Cookie?" Another wrapper stated *ten* reasons why there was still a chocolate shortage, covering everything from the importance of ration bars to the lift soldiers got from a cup of hot cocoa.

Throughout the years during and after the war, no matter where the shortage of Nestlé products was—in the town where all that chocolate was made or anywhere else in the United States—people spoke of how much they missed their candy bars, chocolate chip cookies and hot cocoa. But when they found out those satisfying treats were feeding and boosting the morale of Americans fighting in the war, not a single complaint was heard.

8

IT WASN'T WILLY WONKA!

On a twenty-four-acre factory campus, where sixty buildings housed a multitude of roasting, grinding and agitating machines—all of it made possible by over 1,500 employees—you can bet safety was a major concern for Nestlé. When the company's Swiss founders brought their work standards to America, among the issues they planned to address was the well-being of their workers. Providing a safe environment had already been a priority in European factories, but conditions for America's industrial workers had not yet been properly addressed. In fact, they were downright risky.

In the early 1900s, American factories were just beginning to experience consistent success in the manufacturing of products. Improvements in equipment and plant layout were designed with the goal of mass-producing commodities. Power to drive more and more equipment meant electricity sources were often hastily strung throughout large workspaces. Important work environment issues, such as an adequate supply of fresh air and tolerable temperatures, were often overlooked. In many ways, the machine operators' safety was secondary.

Shortly after the Nestlé plant opened, the 1911 Triangle Shirtwaist Factory fire brought the issue of safety to the attention of plant managers nationwide. The New York City–based factory lost 145 workers in the fire, primarily because its multi-floor design lacked adequate exit routes. Fulton's Nestlé plant had a similar multistory structure, and talk of how such a tragedy could happen to its workers spread as fast as an out-of-control fire.

Nestlé Corporate officials began to address the many dangers of a large industrial workplace, considering it as important as their commitment to high-quality products and an employee code of ethics. Management promoted new preventative measures, introducing policies that now seem like basic safety standards: hard hats, safety glasses and other protective gear. Improved lighting provided a brighter work environment, so it became easier to spot an accident waiting to happen. Adequate downtime offered workers breaks from their long hours of repetitive-motion tasks.

By the middle of the twentieth century, news of Nestlé's concern for worker safety was making regular headlines in local papers. In March 1953, a *Valley News* article noted that "in a state-wide contest sponsored, last fall, by the Associated Industries of New York State, the Nestlé Company received an Honorable Mention Award for its fine safety record during the thirteen weeks of the contest." Three years later, the *Valley News* reported on a "Safety Dinner" hosted by Nestlé for over 1,300 employees. The event was held in the company's cafeteria to acknowledge workers putting in 290 consecutive days without any lost-time accidents. Plant manager Jim Gillis noted that this accumulated to "nearly two million man-hours of safe operation," pointing out that "the million man-hour mark is usually a company goal, so two million is extraordinary."

Nestlé's promotions to encourage factory safety were often creative. The November/December 1977 issue of *Nestlé News* mentioned that the Fulton plant's Safety Committee had dressed a mannequin in protective clothing and ran a contest to name him. The winning name, submitted by employee Peg Laird, was "Dewy C. Hazards." The entry won Peg $250. A year later, a female mannequin was dressed in similar clothing, and another contest was held. With the clever name "Ima Safechick," John Saltamach earned himself a $250 bonus. Rumors of the two mannequins dating helped keep safety in mind throughout the factory.

Of course, as attempts to encourage safety got more creative, there was always a chance that a good idea could turn bad. In his years overseeing production at the plant, Dick Atkins saw some safety awards that weren't exactly safe, as he explained:

> *Bill Pluff was a Division Manager, and he was known as our Safety Guy. At one point, we'd gone a year without a single accident in the entire plant; nothing that caused lost time or even a reportable incident. To give the workers an incentive to keep this excellent safety record going, Bill bought everyone a Swiss army knife. It was a real beauty with all those attachments—and*

Wall-sized charts kept track of the number of accident-free days at Nestlé, displaying the company's commitment to safety. *Fulton Nestlé archives.*

they were expensive. Bill handed them out at eight o'clock in the morning, and by eleven o'clock we had a guy over to the hospital. He'd cut himself with the knife. Bill went out and collected all the knives, and that was the end of that reward.

Dick made sure I knew about Nestlé's excellent safety record, but he was also forthcoming about the plant's occasional accidents. This was factory work, after all, where thousands of employees attempted to keep hundreds of machines operating properly, and there was always a chance an injury might occur. "We had forklifts running all over the place," Dick noted. "They weighed 15 tons and they were moving things like two pallets of chocolate 10-pound bars, each full pallet topping 1,800 pounds. Once, a worker on a forklift was loading a truck from its back end. Other workers thought he was done, but the guy was still back there. When the truck started to move forward, his wheels were hanging over a five-foot drop."

All the electricity running through the plant posed a safety concern, and Dick saw examples of that danger, too: "One day, a contractor onsite was breaking up concrete with a jackhammer and he went right through a 440-volt line. He got lucky and it didn't kill him, but it shorted out the building."

Longtime employee Vern Bickford remembered a particularly scary accident that happened when the plant switched its energy source from coal-fueled furnaces to a gas-powered generator. "Once they had installed the new co-generator, they found out they had to quit using the railroad cars," Vern explained. "Here's why: One day, we had a railroad car loaded with a large supply of the two-pound Quik canisters and the train derailed out in the plant's yard. The new gas lines were installed so close to the train tracks that the car almost hit them."

There were some injuries that weren't a result of an accident but came from working at the same job, on the same machine, for years. Repetitive shoveling of chocolate from a conche machine to a Jumbo vat would eventually take its toll on the conche workers. Women on the Wrapping Department line would often experience arthritis-like pain in hands, wrists and hips. Those kinds of injuries were gradual, and the company made efforts to relieve stress for its workers by adjusting work details, rotating job responsibilities and, in some cases, replacing humans with machinery.

Other injuries were random. The July/August 1978 issue of *Nestlé News* reported:

Fulton Supervisor of Boilers and Refrigeration Fay Sanford was fortunate to be wearing his hard hat when a metal tube expander fell 12 feet and struck him on the head. While Sanford needed three sutures and suffered from a sore neck for a few days, the hard hat was only scratched slightly. "Boy, am I glad I was wearing my hard hat!" Sanford said. "Can you imagine what would have happened to me if I were wearing my Nestlé soft brown cap?"

Dick Atkins's job included the evaluation of several unusual injuries at the factory, including this one:

I got a call one day that we had to shut down the coating line because the operator had a plugged nozzle. This nozzle moved like a piston, back and forth, pulling chocolate into it, then down an open valve, dropping just enough chocolate for the product they were making. One of the nozzles plugged and when a guy stuck his finger up inside to clean it, the piston took off the end of his finger. We looked and looked in the chocolate mix, but couldn't find it. That whole line of chocolate had to be dumped.

A number of fingertips were lost during Fulton's Nestlé years. Here's another unfortunate mishap Dick was called in for, this one at the plant's Tea Department, where seventy-five to one hundred envelopes were sliced open with a blade, filled and sealed every minute:

The machine got jammed up a little and a guy put his hand down to clear the jam. He got the end of his finger cut—just the tip of it, so it wasn't a serious injury, but he had to get it bandaged up. Bill Pluff, our safety guy, went up to the worker and asked him what happened. As he was explaining, the guy put his hand in to show Bill how it got caught, and the machine got his hand again. He ended up with a second cut.

Though Dick's stories about accidents aren't necessarily humorous, it's hard to ignore the comic overtones to some situations: "We were making milk chocolate in the Jumbos and had to make an adjustment to the chocolate," Dick said. "The operator handling the adjustment leaned over the Jumbo and had a sneeze come on him real fast, so he didn't have time to turn his head. The guy sneezed all over fifty thousand pounds of chocolate and blew his false teeth into this huge Jumbo." Dick assured me that the sneezed-tainted mix was headed for the dump, but not until they

solved the mystery of the man's missing set of teeth. "In a container that large we couldn't find the teeth," Dick explained, "so we had to pour all that chocolate into what were called red tanks, metal tanks that held about 1,500 pounds of chocolate. We put a screen in the tanks and screened the chocolate until we'd fished out the guy's false teeth."

Sometimes accidents can occur when workers get overenthusiastic about doing a good job, which happened when Nestlé launched a new product called Choco-Bake, a liquid chocolate packaged in an envelope. A foreman on the Choco-Bake line was so proud of the successful production that he called for plant manager Charles Cieszeski to come take a look. "The foreman wanted Chuck to see how durable those envelopes were," Dick said, "so he took one of them and put it on the floor. 'Look,' he said, 'Even if you step on it you can't make these pop open.' Then he stepped on the envelope and it broke open, squirting chocolate liquid all over his manager's dress shirt and tie."

There are times when an accident or injury can actually lead to good fortune. Nestlé employee Andy Taylor met his future wife, Gladys, while they both were on the job. He calls his story "Love between the Crunch Bars." "I delivered moulded chocolate bars in huge heavy push carts to the Wrapping Room," Andy said.

Gladys had injured her hand while working in Wrapping, and the company was always good to their employees in situations like that. Instead of laying Gladys off while her hand healed, they gave her a "light duty" job running the elevator that moved those push carts from floor to floor. After seeing her on the elevator for several days, I thought, Boy, is she good-looking. We'd talk a word or two, but I was so shy. Finally, I said to her, "Does this elevator stop in between floors?" She said, "It sure does!" And I gave her a big kiss!

EMERGENCY AT THE NESTLÉ PLANT

Those lighthearted stories of factory misfortunes and unexpected romance helped Nestlé workers contend with the accidents that were nothing to laugh at. Here's a memory told by Dave Wolfersberger involving a Nestlé employee in the Refining Department who narrowly escaped a tragic demise:

The guy was working on a conveyor belt system with a scroll that product ran through. Normally, if you picked the scroll up it would automatically shut off. But this guy was trying to go quicker, so he bypassed the switch. By accident, he stuck his arm in the scroll and it got caught, and before the scroll stopped, his arm had done a complete revolution on the machine.

Dave Robbins, a friend of Wolfersberger's, was just coming on his shift when they both heard somebody yell out, "We got a guy who's pinned!" Company nurses came running, and someone in emergency response called an ambulance. Dave W. ran to get his tools and headed for Refining, climbed onto the machine and tried to figure out what to do. "While my friend Dave held this guy up because his weight would have pulled his arm right off, I started taking the conveyor apart," Dave said. "I dug at the chocolate surrounding this guy's arm. After close to an hour, I had moved enough chocolate away to see that his arm was basically severed, holding on by a piece of skin."

Through all this trauma, the man remained awake, vocalizing his great pain while the medical team offered whatever help they could. The group decided their best option was to take hold of the man's arm and do a quick pull. His arm popped off, it was put on ice and the ambulance whisked him away, heading for the hospital where doctors tried to reattach the limb. "He ended up losing it," Dave explained, "but he lived. Thankfully, the heated chocolate mix cauterized the wounds, which stopped the bleeding. Otherwise, he would have bled to death."

It was only after the accident that Dave was able to sit down and reflect on what happened. "I cried," he said. "The nurse helped me to relax, but I was in shock." Eventually, the man returned to Nestlé to thank Dave, who received wide recognition for his efforts. The company named him employee of the month for safety, but Dave summed up that horrendous accident by insisting that "it was the chocolate that saved his life."

Dave's unselfish acts of kindness came to the rescue again when another company accident put him in the right place at the right time: "I was heading into work and had punched in near the aisles where supplies were sometimes stacked. All the sudden, I heard screaming—two women had leaned against a two-thousand-pound pallet of candy bar wrap rolls. The pallet's load was a little tipsy, and it collapsed on them. One was pinned at her arm, the other at her leg, and there wasn't a forklift around to move the pallet."

Looking back on the incident, Dave has trouble explaining how he was able to do what he did: "I walked over to the pallet and lifted it up. Two

people grabbed the women, pulled them out and I dropped the pallet. The women survived, but one's arm was unusable and the other's hip was broken and they weren't able to return to work." Dave had never lifted that amount of weight before, and he admitted that it did cause him some pain. But the next day, he was back at work.

The most unusual factory accident I heard about involved a milk tank in the Condensery and a loyal worker who had a dangerous encounter with it. The story was related to me by Carrie Butler, whose father, Joe Rogers, began working at Nestlé when he was quite young. "It was my father's first job, back in the late 1920s or early 1930s," Carrie explained. She remembered her dad "as a quiet man who never mentioned much about his job at the Chocolate Works. But, when he came home and I sat on his lap, he smelled good."

Carrie recalled a few other details about her father's work when Syracuse newspaper columnist Dick Case interviewed her in October 2002. She told Dick that her father spent forty years as a condenser, working his way up to a foreman's position. His job included taking milk samples from huge thirty-thousand-gallon two-story tanks, and one day, as he attempted to collect a sample, Joe became known around the plant and in the city of Fulton as the man who fell into a milk tank.

Since this all took place when Carrie was only five or six years old, she doesn't remember the exact details, and other members of Joe's family are unsure. But they do know that, prior to that day, he had been experimenting with different methods of taking milk samples. Joe wondered if it made a difference to take samples from the top or the bottom of the tank or if the time of day when new milk was delivered affected the test. On the day of the accident, Joe appeared at work early and decided to gather his first sample from the top of the tank. He tied a length of rope to the test container, climbed a ladder to the tank's top and opened its lid, exposing the huge volume of agitating milk. Somehow, while Joe was conducting the test, the lid fell on him, lacerating his scalp and knocking him into the tank.

Disoriented from the heavy blow, Joe somehow managed to cling to the agitator, which was moving both in a circular motion and up and down. Each time his head came up out of the milk, he called out, hoping to get his coworkers' attention. He even used his keys to bang on the metal tank, thinking the noise might attract someone. But neither idea worked, perhaps because his voice and the keys would have been barely audible from inside the tank's noisy agitation. Joe hung on for two hours, with no rescue. At that point, his coworkers realized their foreman was missing, and after another

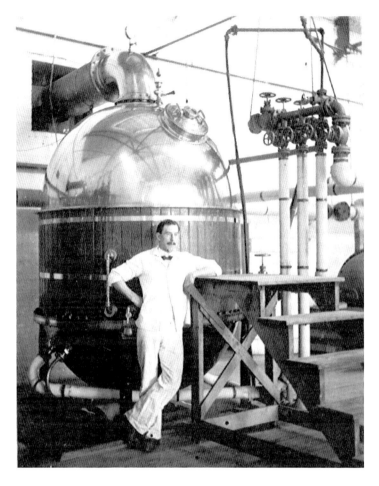

Milk tanks in the Nestlé plant's Condensery were important and sometimes dangerous machines. *Fulton Nestlé archives.*

hour of searching everywhere they thought he might be, they decided to look in the tank.

Wet and shaken, Joe was taken to the factory's physician, Dr. Fivaz, who thoroughly checked him over. After his many lacerations had been cleaned and bandaged, the good doctor sent Joe home with dry clothes. Carrie remembered seeing a bed set up in the dining room. "He laid there for a week, recovering," she recalled.

Back at the factory, workers and management were left to deal with the issue of a person inadvertently contaminating the huge vat of milk. They knew the tank needed to be emptied and its milk discarded, but in the

confusion of rescuing Joe and getting him medical aid, some of the milk had already been sent down the chocolate-making line. The error was only discovered after a fresh batch of chocolate had already been loaded on a railroad car. Once the mistake had been caught, instead of traveling to candy lovers somewhere in the United States, the chocolate was headed for the dump—or at least that's where it was supposed to go. Carrie explained that, over the years, she's heard several versions of how her father's misfortunate story ended, including this one reported by Dick Case: "From what we've heard, the railroad car of chocolate made from that milk was going to be thrown out, but it ended up with a farmer who fed it to his pigs."

SAFETY IN SUGAR SILOS AND WATER WELLS

It's hard to imagine something as tasty as sugar causing safety concerns, but Nestlé workers assured me there were dangers associated with the twin sugar silos at the Fulton plant. Each silo could hold nearly two million pounds of the sweet ingredient, and no matter how much somebody loves sugar, no one would want to get caught inside those silos. Here's why: should someone wind up on top of one of those sugar mountains, they'd find that it acts a lot like quicksand. Though there was little chance of that ever happening, Nestlé wasn't taking any risks with its workers. The only people allowed inside those silos were maintenance cleaners, and before they were lowered in from the top, they were tied into special harnesses and had oxygen supplies strapped to their backs.

There were other dangers associated with storing large amounts of sugar. The silos were filled by bucket loads, and as that took place, static could build up between sugar particles, potentially creating a combustive environment. Should even one spark occur from sugar colliding, it could have rapidly traveled from granule to granule.* Dick Atkins described the precautions Nestlé took to avoid such a disaster:

> *It wasn't the first explosion from a spark that mattered; those were usually small. But that explosion would make a cloud of dust and cause a second,*

* There were other reasons sparks could fly in the silos. Motorized equipment inside them could cause a reaction. Even two metal pieces rubbing together near the silos could be a problem, prompting workers who were unloading the railcars of sugar to use brass or plastic—i.e., non-spark—tools to loosen the sugar.

bigger explosion. Were that to happen, a chemical suppression system had been installed in both silos. If a spark flew, in the fraction of a second the system filled the silo with halon to suppress an explosion. Additionally, the silos were designed with special covers to safely vent them at the top.

Dick has another sugar silo story, this one not so much an accident as an error—but it was a costly mistake:

One time, Owens-Illinois, which made bottles for the nearby Miller Brewery, had brought in loads of sand to their plant for melting into glass. Somehow, one of their railcars got mistaken for sugar and was delivered to our plant, sending a whole lot of sand to the top of the silo. It didn't take long for workers to discover the mistake and shut the process down, but we ended up with a mixture of sand and sugar in the silos. To correct the error, we lowered people down to shovel out the sand, and they took out 200,000 pounds of the mixture, including a lot of sugar. But Nestlé wasn't going to risk the chance that even a little sand ended up in their sugar supply.

Ron Woodward, who was in charge of Nestlé's water-treatment system, would agree that working in a chocolate factory had dangerous and sometimes life-threatening situations. Part of Ron's job was to make sure the treatment system properly dealt with water used in chocolate production before it was sent back to its original source. Ron explained that the system's well had two pumps that adjusted the wastewater's pH level. If the pH was registering high, one pump's valve opened and added sulfuric acid into the well. If the pH was low, the second pump sent in sodium hydroxide. The water would be mixed until it had reached the proper pH level, and then the valves shut down.

The waste treatment plant had an alarm if something went wrong, and Ron told me about a particularly dangerous time when that happened:

I was working days, so if it went off at night, the production people would call me at home. I'd come in to see what was wrong and make an adjustment. Most of the time it was just a high water alarm, and you'd hit a button to correct it. Since it was a fairly simple method, I made the mistake of showing the night production foreman how to do so. When the alarm went off one evening, the foreman thought it was just high water, so he shut off the alarm and turned off the water.

The next morning, Ron arrived at work to find the system's alarm light on. He couldn't figure out what was wrong until he checked its flow meters and found that one of them had sprung a leak and all the distilled water keeping the pumps working had leaked out. Ron fixed the leak, filled it with new water and restarted the pumps, and they began feeding the well—real fast. Ron explained what transpired next:

> *What I didn't realize was that with the flow meters down, water in the well had been calling for sulfuric acid, so the system had been sending acid all through the night. That then opened up the sodium hydroxide valve all the way and now we had pure acid mixing with pure sodium hydroxide, which caused a violent reaction.*
>
> *There was a vapor so thick that you couldn't see. Luckily, because I knew the dangers of vapor, I made sure the door into the system's room was always tied open. I got on my hands and knees, closed my eyes and crawled out. No one could go back in for two or three hours. We had to call the city to close down our waterline. It got so hot in there, it blistered all the paint off the pipes. It would have burned my eyes out if I had kept them open.*

FIRE AT THE FULTON CHOCOLATE FACTORY!

With the awareness that there was always a chance for machine malfunctions and employee accidents, from the company's earliest days Nestlé management took preventative measures to provide a safe work site. The company designed a number of special volunteer groups from within the workforce. They were known as brigades or teams, and Dick Atkins provided me with a little background about them:

> *All departments had a rep on one of those teams. I was part of the Emergency Response Team and our biggest worry was ammonia leaks, which could be deadly. When we responded to a leak, we had to be sure we were downwind of it. Once, when the fire department showed up, they started coming down the sidewalk and got hit right in the face by a cloud of ammonia, bringing them to their knees.*

Another brigade was the plant's own volunteer fire department. In its years as a safety division at Nestlé, upward of fifty members signed on, and

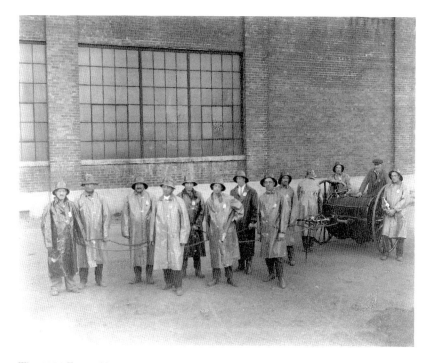

The 1924 Fulton Nestlé Fire Brigade. *Fulton Nestlé archives.*

with company-furnished uniforms and equipment, the team held contests and drills to stay proficient. Their cautionary measures worked most of the time, but the brigade couldn't prevent every fire. An April 1946 *Palladium-Times* front-page headline announced that "Fulton Firemen Have Five Calls," including one at the "new Cocoa Bean Roaster at the Peter Cailler Kohler Plant....The fire was confined to the roaster, but [firemen also] wet down a roof over the building housing the roaster."

Three years later, a July 1949 photo in Syracuse's *Post-Standard* included this caption: "$100,000 Fire in Building 2 of Nestlé Plant." The accompanying article described the scene:

> *The fire broke out in a large quantity of bags of powdered milk on the third floor of Building 2 at 12:45 pm....A foreman spotted the fire and spread the alarm. Firemen poured water into the four-story building for almost four hours before finally extinguishing the flames....60,000 to 80,000 pounds of cocoa were damaged by water and smoke, and 50,000 pounds of powdered milk, packed in burlap sacks, were ruined.*

The cause of the fire was unclear, but people were talking about two possible reasons. One theory blamed it on sparks from a welder's torch on the fourth floor dropping through holes in the floor onto bags of powdered milk. Another theory suggested that the fire spontaneously combusted in those heavy bags. At any rate, the plant shut the building down for several days, affecting 150 workers. Thanks to Nestlé's fire brigade and city firefighters, none of those workers suffered injuries as a result of the blaze.

All my research and discussions about fires, ammonia leaks and machine accidents showed me that the pleasurable experience of eating a good chocolate bar didn't come easily. It was Dick Atkins who I think best expressed Nestlé's unique business of candy production: "People think that making chocolate is just this fun and happy thing, but it can be a dangerous operation. People can get hurt. Let me tell you, it's not Willy Wonka."

OVERTURNED TRUCKS AND TRAIN WRECKS

Certainly, there were very real safety concerns in Fulton's chocolate factory, but, as I learned, occasionally an accident could lead to a little fun. I heard stories about a few such incidents, including one that happened right outside Nestlé's gates. During the many years that chocolate was moulded and wrapped in Building 30, it was sent by the truckload across Fay Street to a warehouse on the main campus. No one thought too much about it, in terms of safety, until a truck driver took one corner a little too fast and pallets of chocolate bars landed on the street. Word spreads quickly in a small town, and within minutes, children arrived on the scene, stuffing their pockets with what Nestlé called damaged goods and kids called their lucky day.

There were other accidents while chocolate was en route, especially when you consider that the Fulton plant spent the better part of a century moving its products across the country. Corporate officials were constantly trying to improve shipping methods and cut costs, and they ran into a little trouble when they experimented with shifting from trucks to railcars. In the late 1980s, three train cars left Fulton carrying 600,000 pounds of Semi-Sweet Morsels, headed for the West Coast. When the shipment hit Phoenix, Arizona, it found reason to stop and somehow managed to stall there for five days—five days that fell right in the middle of an Arizona heatwave. Thermometers topped out at 115 degrees, and Nestlé ended up with a 600,000-pound lump of chocolate.

What appears to be the biggest transportation catastrophe in Nestlé's Fulton history also took place on the railways. It was big news when it happened in September 1955, and several newspaper articles helped me patch together the unfortunate incident, which became known as the Great Chocolate Train Wreck.

The scene of the accident was the village of Hamilton, an upstate New York community best known as the home of Colgate University. But after that autumn evening in 1955, Hamilton's claim to fame would switch from collegiate to confectionary. The story starts when the New York, Ontario and Western Railroad, known as the O&W, was carrying a shipment of Nestlé chocolate products from the Fulton plant. By 1955, the O&W had been nicknamed "The Old and Weary" because of its transportation troubles. The railroad had been in bankruptcy since 1937 and was heading for a full business collapse when one of its trains took a shortcut to the company's demise.

When it headed into Hamilton, a bit past 9:00 p.m., the O&W was moving at approximately thirty-five miles an hour. Its 230-ton diesel engine powered sixty-two cars loaded with steel, lumber, household furniture—and a generous supply of Nestlé products. After the train's engineer missed a red reflector light, the whole lineup was erroneously rerouted onto a track meant for coal deliveries. By the time the engineer realized his mistake, it was too late. He hit the brakes, but the train's momentum pushed it off the tracks, sending sixty-two cars into a coal shed. On its misguided journey, the train dropped twenty-five feet and landed upright, thirty yards from where it first took flight.

The village of Hamilton, New York, knew how to make lemonade out of lemons—or, in this case, a chocolate festival out of a train wreck. *wibx950.com*

Three men in the engine's cab were injured, although none seriously. Miraculously, no one from the village was near the "flying train," as the *Mid-York Press* referred to it, though it was noted that the freight cars missed smashing into two large oil tanks by just a few feet. There was more good luck for the business owner of the destroyed coal shed, who reported that normally a loaded coal car would have been parked inside it. On the night of the wreck, the shed was empty.

Not surprisingly, the noisy accident attracted quite a crowd to the crash site. For the children of Hamilton, that September evening may have seemed like an early Halloween or an even earlier Christmas. Among the damaged railcars were those carrying Nestlé Crunch Bars, Semi-Sweet Morsels and Quik. Like diligent miners, some of the youngsters pulled their toy wagons to the open railcar door and filled up. Grownups got in on the action as well, and local media reported that Toll House cookies were the dessert of choice for several weeks in many Hamilton households.

Once the tasty food raid was over, there was still the matter of cleaning up and assessing the damage to the railcars and the coal company's shed. Within a few days, big hooks and cranes were brought in to clear the derailed freight cars, with trucks hauling away smaller debris. Less than a week later, one could hardly tell that there had been an accident, but the people of Hamilton decided that all the excitement of a chocolate disaster was just too good to forget.

A half-century later, Hamiltonians were still talking about the night chocolate bars flew through the air and morsels rained down like the sweetest storm. Thinking that such a rare event should be noted, in 2005, the village decided to mark the fiftieth anniversary with a Great Chocolate Wreck Festival. The center of town came alive with carnival-type activities and games, including hanging piñatas in the shape of the '55 O&W train cars. Children took turns trying to whack the candy-filled piñatas, hoping to be the lucky one who made chocolate fly again. But officials planning the party saved the biggest event for the evening of their celebration.

To properly honor the legacy of the train wreck, festival planners organized a chocolate spill reenactment. Using miniature freight cars on loan from a local museum, the replicated train traveled through the village, its cars full of Crunch Bars. The route ended at the village green, where those bars were ceremonially dumped. There, the grandchildren of those who once filled their pockets with candy repeated history, paying tribute to a delectable chocolate memory.

9

A JOB FOR LIFE

In Central New York, Fulton is known as the city that the Great Depression missed. During those years, while our nation was in an economical panic, dozens of factories in the Fulton area were in full operation, with the PCK/Nestlé Company one of the city's leading employers. A review of local newspapers from that era and the decades that followed turned up countless advertisements promoting work at the Fulton chocolate plant. Those ads didn't need a lot of fancy words. "Plenty of Good Jobs" was often their entire message, with "Nestlé" or "PCK" printed in bold. No address or phone number was given, and there were no instructions on how to apply. People just knew.

I heard some inspiring stories of Nestlé's hiring practices. In 2003, when the plant was closing, the *Post-Standard* ran a story about how, in 1929, at the onset of the Depression, Emerson Pero found a job at the chocolate factory. As Emerson's granddaughter Christine Ostrowski explained,

> *He stood in line at the factory with hundreds of others vying for one of the available jobs. A senior employee was scanning down through the line asking what type of work each man was looking for. Most said they would do anything. When Emerson was asked, he said, "I am an electrician." When he was asked what else he could do, he responded, "That's all. I'm just an electrician."*

Christine explained how Emerson's honesty earned her grandfather a chance at securing one of those Nestlé jobs:

The senior employee asked Emerson to go into the factory, as there was a glitch in the machinery that controlled the wrappers. When he was able to fix the problem quickly and efficiently, the senior employee found him a few more tasks, "at least enough to last a couple weeks," Emerson was told. My grandfather retired from Nestlé in 1967 after thirty-eight years of being hired for a few weeks.

Many years later, Cindy McCormick found herself in a similar situation when she'd heard about job openings at Nestlé:

I was in a line of people applying that ran from the front of the building to McDonald's! I never dreamed I'd get hired out of all those people. By the time I reached the end of the building, at the corner of 4th and Fay Street, security guards were handing out applications outside. We had to fill them out and hand them back because Personnel was closing soon. I got the call two days later!

People often went looking for work at Nestlé as soon as they'd graduated from high school—and some, like John MacLean, didn't even wait for that:

I was a teenager and a senior at Oswego High, but I became discontented and left school. I started with a company in Oswego, but they said the machine wasn't running or something and let me go. Then I went to Sealright, but when they offered me a job they asked to see my birth certificate. You had to be eighteen, and I was only seventeen, so I told them I couldn't find my certificate. "Sorry," they said. So I went up to Nestlé, got a physical and my uniform, and was told to report back that afternoon in the Roasting Department.

That was in September 1953, and John would go on to work forty-seven years at Nestlé.

Workers were hired at an even younger age back when the factory first opened. Sally Parkhurst, who worked for Nestlé from 1979 until the plant closed in 2003, explained that her grandmother Rolene Kenyon Ensworth went to work there when she was barely a teenager:

She was thirteen or fourteen and had left school years before that to earn money and help take care of her grandmother. Her floor supervisor at Nestlé kept asking to see her birth certificate, but not everyone had that kind of

paperwork back then. My grandmother worked at Nestlé for many years. She later raised a large family of nine daughters and five of them ended up with jobs at The Chocolate Works.

After hearing so many stories of being hired by Nestlé, I began to think that everyone got a job there as soon as they applied, but John Procopio corrected my misperception. John put in an application straight out of high school, but he needed to check back several times before getting hired. Each time, he'd speak with the Personnel Office's manager, who politely said they didn't have any jobs at the time. Finally, John's aunt, who worked as the plant manager's secretary, learned the real reason why.

"My aunt asked her boss to check with Personnel," John said, "and come to find out, the manager there thought he had a perfectly good reason not to hire me. 'He doesn't weigh enough, and he'll never be able to handle the heavy work,' he said. I *was* a thin guy, but I knew I could get the work done."

John is pretty sure it was his aunt and her persistence with the plant manager that finally landed him a job in the Wrapping Department, where he proved his worth to the company by "handling the heavy work" for the next forty-five years.

People raised families, enjoyed a comfortable life and prepared for retirement while working at the plant. As one employee described her good fortune, "My house was built by chocolate," and many former Nestlé workers agreed with her. Here's another story of how a young start at Nestlé led to a lifelong job. Vern Bickford, who started with the company in 1966, remembered the 1960s and the '70s as a time when they hired about fifty people a week. Like John MacLean, Vern was interviewed and hired the same day "and I was never laid off. When I started, I was called a roustabout. I was a jack of all trades, so I could do anything they needed me to do: mop floors, move chocolate, dump trash…whatever. From there, you would work your way up."

Being a roustabout was a first step for many at Nestlé. Thomas Heaphy remembered why he was excited to start out as one: "They passed the roustabouts around to different departments until they found out what kind of work you could and couldn't do, but I'd heard that once you got in at Nestlé, there were no layoffs."

Actually, there were occasional times when people lost their jobs at Nestlé; most of those were temporary, during slow production periods. If possible, an employee would be shipped to another department if there was an available job. If not, layoffs went by plant seniority, with the most recently hired being

laid off first. Hiring and keeping track of thousands of Nestlé workers was handled by the plant's Personnel Office, and Sandy Traficante worked there from 1986 until 2001. Sandy's job was to organize and maintain each person's employment information, and she explained what happened during the plant's slow periods:

> *I took care of laid off workers, filing their paperwork and such. Later, if a boss from one of the departments called to say "I need five or ten people back," I'd go through and call those with the most seniority, bring their paperwork up to date and get them back on the job. After me, they went to the first aid station next door* [for a health checkup] *and then found out what shift and what department they'd be working in.*

The Personnel Office also had a regular system for acclimating new hires to the company and their departments. That included a handbook covering all aspects of working at the factory. A 1946 handbook, titled "As the PCK Employee," covered how job benefits were dispersed, health and sick leave, retirement options, service awards and rules for work. The handbook also pointed out a few particulars to a food-industry job, noting that "people don't wear perfumes and lotions in the plant where their fragrance would be absorbed by our products. Women should not wear nail polish."

The handbook also covered uniforms, which were required in some departments, generally where employees worked close to chocolate production. During one era, men were required to wear pants and a shirt with the company logo. For women, it was white or brown dresses, with hairnets mandatory in the Wrapping Department. Later in the plant's history, as a way to make the hairnet requirement more enjoyable, employees could purchase their required head coverings in a variety of colors. As men's hairstyles changed, they were also required to cover their heads. "At first, guys wore brown baseball caps," Dave Miner explained: "Then they added a 'legionnaire' piece on the back of the cap with elastic on the end to cover the guys' hair. Later, all men were required to go to hairnets and even beard nets."

Eventually, uniforms, including specific footwear, became mandatory for all employees, which Wendell Howard liked: "Sometimes people coming in for work from the dairy farms had boots with a strong odor to them."

The Nestlé employee handbook also covered the financial aspects of working at the plant. I heard from many people about the fair wage Nestlé provided for its employees, and newspaper reports show that this practice

Uniforms were required for many Nestlé departments, and the factory's shoe store helped provide needed supplies. *Fulton Nestlé archives.*

began in the company's first year. Nestlé initially planned to match the highest prevailing wage offered in Fulton at the turn of the twentieth century: $1.15 for a ten-hour workday, which compares to about $31.00 today. But the company changed its mind, influenced by the fact that elaborate milk production standards would demand more of its workers. Additionally, the company learned that many of the new hires would be walking great distances to get to work. The decision was made to up a day's pay to $1.25, equaling almost $34.00 in 2018.

Those ten-hour workdays for good wages evolved into eight-hour shifts, with the factory running round-the-clock to meet high production demands. The three shifts were split into days (7:00 a.m. to 3:00 p.m. or 6:00 a.m. to 2:00 p.m.), evenings (3:00 p.m. to 11:00 p.m. or 2:00 p.m. to 10:00 p.m.) and nights (11:00 p.m. to 7:00 a.m. or 10:00 p.m. to 6:00 a.m.).* Each department set its shift's start and end times, while office staff and maintenance crews normally worked straight days, coordinating their hours as needed. The staggered shifts' start and end times helped minimize congestion in the plant's parking lots and on busy city streets.

* At times, the plant ran two twelve-hour shifts, with workers alternating four days working/ three days off and three days working/four days off.

Most Nestlé employees worked shifts, and as anyone who has rotated from days to evenings to overnight can tell you, that can take a toll. Many Nestlé workers told me that shift work's toughest challenge came on the Sunday of the night shift, which was immediately followed by the next week's evening shift. On those days, workers headed home dead tired at 7:00 a.m., only to have to report back at 3:00 p.m.

A typical eight-hour shift at Nestlé included a ten-minute break, a twenty-minute meal break and a final ten-minute break during the last half of the shift. All were paid breaks. When the plant was running twelve-hour shifts, workers earned an additional ten-minute and twenty-minute break. During those breaks, workers often headed to the cafeteria, where a full-service (privately owned) dining hall operated. I heard that meals were reasonably priced, but the best deal of all could be found at the end of the cafeteria line, where a vat of broken chocolate pieces always offered a tasty free dessert.

To minimize the stresses of shift work, whenever possible, the company allowed people to either choose their preferred shift or trade shifts with a coworker. That kind of flexibility was also offered if an employee wanted to work in a different job at Nestlé, as Dave Miner explained:

> If a position opened in a department, it would first be posted there so those employees could bid on it. Approving a worker's request would take place according to seniority in that department, not the whole plant. If the open job was not bid on by anyone there, the newest hire in that department who was not already in a bid job would be required to fill it.
>
> Transfers happened frequently at the Fulton plant, and there were times when a department did not have enough people to fill all its positions. In those cases, the plant superintendent would be notified of the opening(s). He would check his files for workers who had filled out a request to be transferred to that department should an opening occur. In those cases, the senior person in the plant who wanted to work in that department was offered a job there first. If he or she no longer wanted it, a chance to work in that department would be offered to the next person based on plant seniority.

Some department transfers required special training, but Nestlé never held a person's level of education against him or her. If they had proved themselves a good worker and were willing to learn, the company provided the necessary schooling for advancement. Dave Miner, who started working at Nestlé with a high school education, benefited from his training there, as he noted:

The company sent me to sixty-five different training sessions over the years, some of them at their other chocolate factories. I was sent to Burlington, Wisconsin, where they made bar goods similar to the Fulton plant. I also went to the Nestlé plant in Bloomington, Illinois, where they made specialty candies; Franklin Park, Illinois, where they made Baby Ruth and Butterfingers; the Willy Wonka plant in St. Louis, Missouri; the Beechnut plant in Canajoharie; and then the Kit Kat plant in Toronto, Canada.

Not only could Nestlé be a job for life, but employees could also offer good wages to their college-aged children through the company's summer work program. Along with the experience of putting in a full day's work, there were also those sweet perks only found in a chocolate factory. Amy Tompkins Johnston remembered how she spent one summer packing wafers for Fanny Farmer:

Those were the disks that you could melt for cooking and baking. There was a peanut butter line and a chocolate line, and we kids would put the two together and eat them. We also had to take morsel bags that were marked incorrectly, cut them open and pour them into a huge dumpster. We would hang over it, reach in and take a handful to eat. I ate a lot of chocolate that summer.

College students might also have been involved with Nestlé's annual two-week shutdown, when the entire plant (excluding its administrative offices) closed for a thorough cleaning and repair work. Student summer workers could have found themselves on a painting crew, working on outside cleanup or even remodeling. Year-round Nestlé employees had the option to take vacation or work during the shutdown. Chuck Hewitt chose to split the two weeks, working the first one and taking the second off. "When I went in for my shutdown week," Chuck said, "the foreman asked me to clean all the pipes that were used to fill hoppers [Jumbos]. Those pipes hung from the ceiling with chains, so I asked my foreman how he wanted me to clean them."

Chuck's boss wasn't particularly helpful. "I don't care how you do it," he told Chuck. "Just get them clean." So Hewitt came up with what he thought was a pretty good idea: "I went down to Maintenance, got a couple pipe wrenches, and used them to take the pipes down. I spread them out on the floor and cleaned them, which took a couple days. When I tried to put them back up I couldn't remember where they went, which made my foreman pretty upset. A mechanic had to put the pipes back in place."

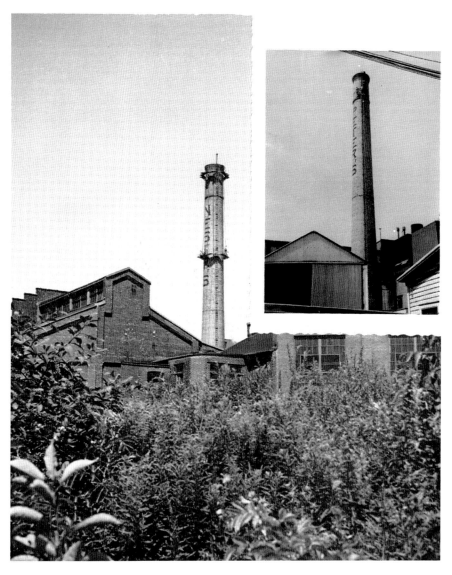

In 1959, the name on the Chocolate Works' smokestack changed from "Peter's" to "Nestlé's." *Fulton Nestlé archives.*

Shutdown was often hard physical labor, so some employees found interesting ways to let off a little steam. Charlie Terranova worked as a forklift driver in his thirty-plus years at the plant, most of it spent on a loading dock. His son Terry remembered hearing how his dad managed to have a little fun during one shutdown: "They were painting the warehouse during the

break, and Dad, who was pretty good at drawing freehand, amused himself by painting Mickey Mouse on the wall. Management wasn't happy, and he had to paint over it, much to the chagrin of his coworkers."

After the 1959 shutdown, people returned to work to find one of their factory's most recognizable symbols dramatically changed. For more than four decades, employees and passersby had seen the name Peter's on the company's smokestack. But during the summer of '59's two weeks without production, the stack got a facelift, the proud name of Nestlé's reaching for the sky.

As it was for most blue-collar workers, tracking hourly wages was done with traditional time cards and punch clock. I didn't think there would be anything newsworthy about this aspect of a Nestlé workday until Amy Tompkins Johnston mentioned an important lesson she learned while waiting to start her shift:

> *The workers would line up a minute before you could clock in, with card in hand. One person would have their card in the machine, waiting to push it down. While we college kids were in line, I noticed several 5x7 cards around the time clock. They were memorials for employees who had passed. The cards noted the worker's date of birth and death, and I noticed that some of them died quite young. After spending a summer of working there, I could see how it took a toll on their bodies. Some of them had worked their whole adult life at Nestlé, clocking in each day.*

NESTLÉ'S PIECEWORK AND OTHER INCENTIVES

It wasn't just high pay rates that kept Nestlé employees punching that clock day after day. For certain departments, workers could earn even more money through an incentive program known as piecework. Many former Nestlé employees I interviewed spoke enthusiastically about the piecework policy, and after I learned how it operated, I could understand why. Here's how piecework operated at the Fulton factory:

After years of production runs, factory supervisors were able to determine, on average, how long each step of chocolate making took. They carefully studied each department's duties, from mixing ingredients to handling products on the line to workers loading cases of candy bars. Factoring in some variables—an occasional machine breakdown or a limited staff

due to illness—the company was then able to establish a quota for each department's workers to reach during their shift. When all was going right and workers were operating at their full potential, the pace could be sped up and the department could produce more than its set quota. Every increase in production earned workers in that department extra money, and soon Nestlé's piecework was one of the most popular reasons why people wanted to work at the Fulton factory.

Piecework was an incentive in several plant departments, but especially in Wrapping. The whole department, including Wendall Howard, focused on hitting the quota and beyond. "My job was to get boxes ready to be filled by the women wrapping," he said. Wendell knew exactly what to do if a machine went down: "I'd collect the bars that kept coming out until the wrapping machine got fixed. The women could then catch up and not lose money."

Wendall assured me that the people on the lines—both the women wrapping and the men operating the machine—were serious about their work, using the word *vicious* to describe some of them. "You didn't take

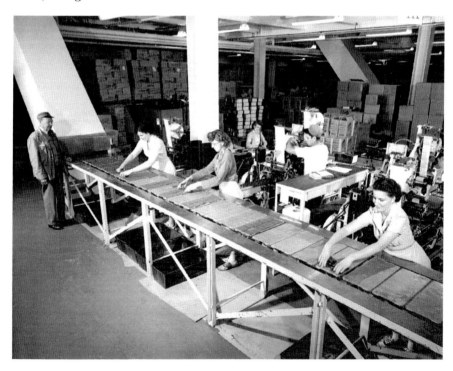

Getting candy bars wrapped and packaged as quickly as possible was a lucrative incentive for Nestlé plant employees. *Fulton Nestlé archives.*

anyone's candy from another line or grab a candy bar off the line for a snack. If anyone did, they'd get their hand slapped. Especially from the women wrapping, who saw dollar signs on their candy."

William Mason would agree with Wendall. When he was interviewed by the *Syracuse Post-Standard*, William, who worked at the plant in the mid-1930s as a wrapping machine operator, shared this story of how serious people in his department were about piecework:

> *There were many problems that caused the machines to experience "downtime," which, of course, resulted in missed quotas. The solution to downtime, from the ladies' point of view, was to increase the speed of the machine* [once they had been fixed]. *As the operator, I was pressured to add gummed paper tape to the drive pulley so the machine would run a little faster, thus making up some of the lost production. The department manager, who received the production reports, saw the increases and would come with sharp knife to cut the tape from the pulley. The next day, the little game would start all over again.*

A new employee or temporary college student could really mess up the system if they didn't know piecework rules, as Amy Tompkins Johnston learned in her summers at Nestlé: "When I first started and the line would stop because of a broken machine, I'd say, 'Oh, good. I can relax for a minute.' Then I learned that we could make more money if we moved faster. After that, when a machine went down, I'd call out along with the others, 'Somebody get over here and fix this machine!'"

LABOR UNIONS AT THE FULTON CHOCOLATE FACTORY

Assuring Nestlé workers a fair wage, good working conditions and supportive leadership became important goals for the company's labor unions, which had a presence at the Fulton plant from its earliest years. Various unions represented workers throughout the plant's history; its most prominent one was first referred to as the PCK Employees' Union, Independent, and later became the Nestlé Company Employees' Union. According to its employee handbook, the union was open to all "hourly employees in or about the production and repair & maintenance departments, regardless of race,

creed, or color, except people in a supervisory capacity or with authority to reject work or material of any product." A second union covered company staff, including "salaried workers, foremen, assistant foremen, laboratory workers, inspectors with authority to reject any work, and company guards."

A 1936 handbook spelled out company working conditions and rules that were in accordance with the union contract. My review of contracts between management and workers showed that they thoroughly covered standard workplace practices, such as scheduled hours of work, overtime, rates of pay and seniority. Occasionally, a new issue, such as a worker's status when he left the company to serve our country during the war years, might show up in that year's agreement. Working out the details of each three-year contract took place between company management and the union's committeemen and women, who were representatives from each factory department. If there was a contract dispute, committee members would first approach the department head, and if that didn't resolve matters, they would take the complaint to management.

John Procopio served as a union committeeman and later as the entire plant's union secretary, and he remembered:

> People on both sides were generally fair. Most of the workers and managers lived locally and for many years my next door neighbor was Personnel Manager Hugh MacKenzie. He and I were often on opposite sides of the negotiation table, but it never interfered with our friendship. "John," Hugh would say, "I want you to know that whatever I do in regards to the plant, I am thinking of the people of Fulton." But Hugh had his job of representing the company, and I had my job representing the workers.

The 1948 edition of the company's handbook offered a little more information about the workers' union, stating that "it is completely independent, runs its own affairs, and receives no financial support from the company. Most PCK people who are eligible belong to this union. Dues to join the union seem quite reasonable." A June 19, 1946 newspaper notice stated that PCK Union monthly dues would rise "from 50 cents to one dollar. New people coming to our company are free to join as they like. Your company will not discriminate against anybody because he joins or doesn't join."

One section found in every Nestlé contract that I reviewed covered strikes. During the 1940s, language about workers agreeing not to strike stated that this "not only bears on the sanctity of our contract, but in the time of

war, on our patriotism." During the World War II era, that agreement was honored, but a few years later, PCK had issues that led to a worker walkout. A May 1948 *Post-Standard* headline announced the controversy: "900 PCK Employees Reported Voting in Favor of Strike."

The article stated:

> *Members of the PCK Swiss Chocolate Co., Inc., Employees Union, Independent, were balloting…on whether to call a strike against the PCK Company, should a requested pay hike be refused. Two meetings were held to accommodate shiftwork schedules of the 900 members of the union and those in attendance adopted a resolution to accept no less than a 10-cent hourly pay boost and voted to strike if the company failed to meet the demand. The company had originally offered a five-cent per hour raise. Further negotiations were planned.*

Three days later, a follow-up *Post-Standard* report showed that an agreement between the two sides had not been reached and workers took their strike outside the plant gates, where "sign-bearing pickets made traffic congested on S. Fourth & Fay Streets." (Other press coverage noted that picketing lasted around the clock for the multi-week strike, without any disturbances or arrests reported.) The number of employees affected by the strike was now at 1,200. Union reps said that their demand for a ten-cent hourly raise had been lowered to eight cents an hour, more closely matching the 8.4 percent cost-of-living increase showing up in national statistics.* Again, the company refused.

The PCK Company tried to strong-arm the dispute, issuing a statement that the plant's shutdown was jeopardizing orders urgently needed for the U.S. Army. The company ended the statement with a compelling number: "$60,000. The 1,200 workers now on strike at the Chocolate Works usually earn this amount of money per week, or nearly 30 percent of the total industrial payroll of the entire city of Fulton. That money is lost and can never be recovered, because wages are only paid for what is produced. No production; no pay."

On June 8, after two weeks, the *Syracuse Herald-Journal* reported that the union and company's differences were nearing resolution. A day later, the *Post-Standard's* headline stated "Employees to Vote on Pay Hike," and June

* Nestlé maintenance staff were negotiating at a higher rate: the union wanted twelve cents an hour; the company offered ten cents.

10's local papers featured a display ad from the PCK Company welcoming its workers back and pledging to once again work in harmony. Ads in the June 16 issues of the *Post-Standard*, *Herald-Journal* and *Palladium-Times* all reveal the agreed upon increase: seven cents an hour for the remainder of the year and an additional four cents an hour in 1949.

For the next two decades, negotiations between the unions and Nestlé management were relatively smooth. Workers continued to get regular pay hikes, generous benefits and satisfactory working conditions. But, in 1972, a major sticking point concerning job descriptions could not be resolved at the negotiation table. The company wanted to be able to assign workers to different tasks, depending on the factory's needs, and some employees, especially those in the Maintenance Department, believed their jobs should remain specialized. This concern had been bubbling under the surface for years and had a strong tie-in with a worker's pride in his or her area of expertise. Joe Cernaro is an example of what happens when pride clashes with managerial power.

Joe was hired in 1956 as a Nestlé mechanic. He was known around the plant as someone who understood his craft, always did a good job and enjoyed his work. Years before the 1972 strike, corporate offices put out a notice of their intention to begin something called "flexibility" with the mechanics. Here's how Joe's son, Sam, explained it:

> *They wanted the guys doing that job, including my father, to do other jobs at the plant; things like welding and electrical work. But my father, and a few of the other mechanics, didn't want to accept that change. They felt they were hired for a specific job description and they wanted to stay doing what they'd been hired to do.*

Over time, most of the other mechanics who had resisted the change gave in, but not Sam's dad. Sam continued:

> *At one point, my dad's supervisor came over and said, "Joe, just sign this paper saying you'll agree to the change and we won't make you do the change—we just want you to sign it." My dad said, "If I do that, I'll need someone to sign a paper that says no one is going to make me change what my job is here." "We can't do that," his boss said. So my father never signed the papers. When he retired from Nestlé, after twenty-five years with the company, he was the lowest paid mechanic at the plant. But he was doing the job he was hired to do.*

That wasn't the only time a worker's loyalty to job and his fellow employees was an issue at the Fulton plant. John MacLean, who ended up taking a major role in the Nestlé union by serving as its president, remembered a similar situation involving a fellow member of his maintenance team, Sam, who had been fired for not agreeing to work outside his job description. The team rallied behind Sam, thinking there was safety in numbers, and confronted the big boss in the maintenance shop. "Did you hear about Sam?" John remembered their boss asking. "We said yes and that we would get back to work as soon as he comes back to us. Our boss said, 'Well, if that's the way it is, you're all fired.'"

With that news, John's entire team walked off the job, went to the union hall and spent the next few days out of work. "Eventually," John explained, "the union got involved, and they did put Sam back to work after a ten-day suspension. We also went back to work, but without the pay for the days we were off the job—and we got a note in our personnel file."

THE 1972 STRIKE

At the 1972 contract talks, flexibility was still an issue for the Maintenance Department, but it had also spread throughout the plant, making it a major concern for both sides negotiating the contract's terms. As Daryl Hayden, whose tenure at Nestlé included both line work and supervisory positions, explained, "Not only did the company want the mechanics—and there were 100 of them at the time—to do other jobs, but also the millwrights, who they wanted to do electrical jobs. One guy put it this way: 'It sounds like if you had an earache they'd want you to go to the dentist.' And the workers didn't want that."

In May 1972, the workers voted to strike. A *Palladium-Times* report noted that of the 1,500 workers at the Fulton factory, 1,000 were to be affected. So were their families. Darci Dorval-Bowering shared this memory of that turbulent time for everyone at Nestlé: "When it happened, my mother went to work at Birds Eye. The agreement in my family had been that my mother wouldn't work until all of us girls were in school, but with the strike she went to earn some money while Dad was home with me and my sisters." Some Nestlé workers' family members, including Darci, also walked the picket line. Shirl Skutt remembered that her father, Elton Bowersox, "had all 10 of us kids picketing."

Workers on strike at the Nestlé gates in 1972. *Fulton Nestlé archives.*

There were strains on family relations. Married couples who both worked at the factory—one on the production side, who would be picketing, and the other in management, who had to cross that picket line to report for work—ended up facing each other day after day, both at the Nestlé gates and at the dinner table. It was a major event in the city of Fulton, and as week after week of the strike added up, tensions escalated.

In September, after a summer of stalled negotiations, the *Palladium-Times* ran this headline: "Nestlé Ready to Move Production Elsewhere Unless Strike Settled." In an urgent telegram, the president of Nestlé Corporate sent a strong ultimatum to Fulton's workers: move this negotiation to settlement or we'll move the production of Nestlé products out of Fulton. Following such a shocking demand, the union took another vote. Again, the management's contract offer was rejected, this time by a two-to-one margin.

October arrived, moving the strike into its twentieth week. Fulton's mayor, Percy Patrick, appealed to the union, pointing out that Nestlé was the city's largest taxpayer. "If we lose this plant," Patrick warned, "it would cripple our city." Father Joseph Champlin, a beloved Roman Catholic priest from a Fulton parish, was brought in to mediate a

discussion between the two sides. For over two hours, representatives from management and the union dug into their concerns, contract offers and the all-too-real possibility of Fulton losing Nestlé. The decision was made to have union members take one more vote.

The vote was scheduled for Tuesday, October 3, and with the large crowd expected, it was held at the city's high school, G. Ray Bodley. The public would not be invited to witness what many were referring to as "The Last Chance" vote, and media could not report on what was happening inside the school building. But Barbara Bartholomew, a *Palladium Times* reporter covering the Nestlé strike, waited outside, and she remembered the tension in the air, which, during the factory's shutdown, put a damper on the city's pleasurable chocolate smell:

> *The strike vote was going to be at high noon and the* Palladium-Times *deadline for my reports was usually right around that time. But this strike vote was important news and they held up printing the papers until I got the information on the vote results. I called in to the* Pal-Times *office in Oswego, dictating the story and literally writing it in my head as I spoke. The managing editor took my call, and believe me, my adrenaline (and theirs, too) was pumping. This was big news that impacted all of us.*

When Barbara's story finally made it to the front page of the paper's October 3 edition, its title read like a sigh of relief: "Nestlé Strike Ends as Union Workers Accept Contract." The vote this time was more than two-to-one in favor of ending the strike: 769 workers were ready to get to work, while 242 wanted to take a chance and hold out. In addition to reporting the facts of the new contract, Barbara included a few comments from those who heard the news outside the Fulton High School, including a woman who stated: "It's a new day, and the sun is shining doubly bright. We're going to have the fresh aroma of chocolate in the air again."

EQUAL RIGHTS FOR ALL WORKERS

Those early-1900s newspaper ads that only needed a few words to let people know about Nestlé's plentiful jobs eventually became more specific. Some ads began using phrases like "Men Needed" or, as a 1924 *Palladium-Times* job posting stated: "Girl Wanted with Typing and Comptometer Experience."

Another ad, "Girls Needed for Two Shifts," reflected a longtime company policy that women not work the overnight third shift. Nestlé, like most other factories at the time, categorized positions as "Women's Jobs," known as P-1, or "Men's Jobs," referred to as P-5. Today, such gender-specific job restrictions are unheard of, but it wasn't until President Kennedy's Equal Pay Act, in 1963, that fair employment standards began to be enforced.

Prior to that legislation, Nestlé did not deny a woman from bidding on P-5 jobs, but there was an unspoken understanding that she not do so. The company felt it had a good reason. Many jobs at the Fulton factory were physically demanding, and management considered it common sense that a woman not push tanks of chocolate or hoist bags of cocoa beans. When Roxanne Hollenbeck joined Nestlé in 1974, job equality was still a concept both management and workers were reckoning with, and she saw firsthand how industries were adjusting to a changing societal norm. Here's how Roxanne described it:

> *Because the majority of jobs in the plant were men's, women were the most frequent to be laid off.* [Eventually], *a new union contract changed the policy so that when a layoff occurred, a woman* [with seniority] *could take a man's job or the layoff. At the time, the younger women thought this was a great breakthrough. Essentially it was, but there was a price to pay. Having my husband working there, in a different department that was male dominated, I learned that this new change was not well-received by most men….Statements were made that if a woman took a man's job, they would receive no help whatsoever. How dare they take a job that might put a major wage earner on unemployment!*

Longtime Nestlé employee Wendall Howard remembered this controversy getting especially heated when women began moving into leadership roles at the plant: "As women became supervisors, some men tried to undermine them. There some dissent, because, in their minds, it had always been a man's job to supervise. It was a big change for industry, and workers had to acclimate to it."

Roxanne had a few female friends who worked in what were long considered men's jobs, and she heard stories about guys standing back and watching women struggle with a particularly tough physical challenge. Prior to women being allowed to bid on those jobs, she'd watched two men working together to accomplish it. "It wasn't always easy," Roxanne noted, "and those early days were far different than the later years. Many changes took

place with each union contract renewal and revised labor laws. It doesn't seem like that long ago, but forty years later, it's a totally different world."

Fulton Nestlé had some key players who helped create a new, more inclusive work environment at the plant. Charlotte Arcadi, who started with Nestlé in the Cocoa Department in 1977, became involved with the plant's union in order to help advance fair worker policies. At the same time, she was also benefitting from career development opportunities the Fulton plant offered its employees. In our interview, Charlotte shared how she and the plant learned from each other during a time of great change for workers:

> I quit high school before graduating and began working in factories. While I was at Nestlé, I was laid off from time to time during production slowdowns, and during one of those layoffs, I decided to pursue my dream of finishing my education. I'd earned a GED and applied to attend Oswego State, where I worked my way through its bachelor's and master's degree programs in art. After taking a break, I also earned a second master's degree, that one in education, from Syracuse University.

It took Charlotte nine years to finish her degree work, and during that time, Nestlé helped her achieve her educational goals. She learned that Nestlé offered its employees a tuition-assistance program, which helped cover educational expenses. "I would pay for the semester upfront, and then, as long as I passed my classes, Nestlé would reimburse me," she explained. "I tried to stay on the nightshift so I could take classes during the day."

Though Charlotte's supervisors warned her she was taking on too much, she assured them she could do it. Some of the credit for her achievements, she believes, goes to her coworkers: "Joyce, the lady in the office who did the scheduling, tried really hard to keep me on the nightshift, but there were seniority rules that had to be followed. So, if lines went down and we had to go on days, I would ask people to switch shifts for me. And they usually did."

Taking a break from her studies, Charlotte wanted to help improve her workplace. The best way to do so, she felt, was to become involved with the union at Nestlé: "I saw things going on in the plant that just weren't right. For example, in the Cocoa Department, part of the packaging process involved a glue used to seal the boxes of cocoa. When the glue was heated, it gave off a terrible smell, and many of us were getting headaches. We complained to the union stewards and the company about it, but nothing was being done."

Because of her concern for the health and safety of workers, Charlotte was appointed as one of the union's industrial hygienists. She was sent to a school in Wisconsin, where she learned about safety concerns in factories and began noticing some unfair and potentially risky practices going on at her home plant: "Most of the people on the floor—the hourly workers—wanted to fight against this, but they never had a voice. Some of this had to do with gender inconsistency; women weren't always treated with the same respect as men."

As time went on, Charlotte was encouraged by her coworkers to run for an officer's position in the union. Eventually, she was elected as its vice president, which was met with a lot of resistance. Company management and foremen weren't used to having a woman in such a powerful position, and some people encouraged her to take a submissive role. Then, through an unfortunate circumstance, the president of the union unexpectedly died and Charlotte found herself in the top position. She recalled:

> *The men caucused and told me not to worry, nothing would change. They said that everything was going to be worked out, but basically they wanted me to step down. I refused. There was a lot of resistance to me, but we worked through it, only because of support from the workers. I was later reelected for a second term as president.*
>
> *After the monthly board meetings, men would go in the kitchen to have a beer and discuss work issues. I wasn't going to let those kinds of unofficial meetings go without a woman present. Even though I don't like beer, I went right in there with them and opened one up. I wanted my presence there.*

Real change takes time, and the improved standards Charlotte and others were looking for came slowly at Nestlé. The issues that the company, its union and all employees were grappling with were not completely resolved when the plant closed in 2003. And today, in the workplace and in the greater world, equality for all remains an important goal.

Charlotte Arcadi put her college education and union experience to work. Today, she helps others learn how to use art as a form of self-expression by teaching classes at Cayuga Community College's Fulton campus, not far from the old Nestlé plant. While the factory was being torn down, she often stopped to take pictures of the buildings being demolished. In those photos, she sees an artistic representation of the way old attitudes can shift to new beliefs. Sometimes Charlotte is moved to add words to what she sees in the photographs. Here's one of her reflections about the Nestlé plant:

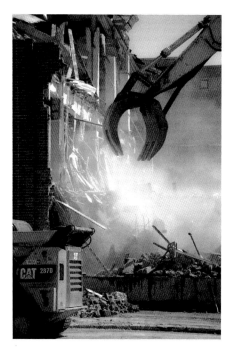

Walls gone,
workers gone,
memories raw as winter's wind,
healing restores faith.

Charlotte Arcadi's photograph *Jaws on Demolition. Courtesy of Charlotte Arcadi.*

10

MORE THAN A PLACE TO WORK

In 2018, the average length of time a person remains in the same job is five years. This short-term commitment to a company or field of work has not only come to be expected, but is also considered wise. It's been suggested that each new job provides employees with a unique and challenging work environment, one that requires them to stay engaged and at the top of their game. Moving from job to job has become the new norm for those on a successful career path, which is why it was so interesting to hear story after story of Nestlé employees who'd given lengthy service to the Fulton plant. Denise Borek-Morganti's father, John Borek, is one example:

> *My dad worked at the Fulton plant more than forty years. When he retired, in the late 1980s, he'd worked his entire career running a machine in the Moulding Department. Dad would hear about someone moving to another job or another city to look for work and he'd say, "Why do people do that? Once you get a good job, you stay there because you're lucky to have a secure job." I don't know what my father's pay rate was, but he was happy with it. I know we weren't rich, but we ate well, lived well.*

Most of the industries in Fulton paid a competitive wage, and former Nestlé workers insisted that their chocolate factory salaries were among the best. But there was more than a steady job with a good salary that kept Nestlé employees loyal. There were programs that encouraged workers to take initiative and invest in their company's future. For example, the One

Hundred Club was established so management could show their appreciation for jobs well done. It was a point system of sorts, as Dick Atkins explained: "People could accumulate points for things like working a certain number of days without any accidents, perfect attendance or manufacturing accuracy. Once workers reached one hundred points, they'd receive a jacket with 'The 100 Club' embroidered on it."

Showing up ready for work, day after day, year after year, also garnered celebratory events and gifts, including the company's annual Perfect Attendance dinner. Jim Schreck remembered that those special evenings were always held "at a really nice restaurant. The honored worker and their wife or husband attended, and some years there might be 150 employees with their spouses. Everyone was recognized by the plant manager, who called us up by department to shake our hands. If someone hit a milestone—five or ten years of perfect attendance—they received a special gift.'"*

There were occasional complimentary factory-wide meals in the plant's cafeteria. Offered to all employees, these meals celebrated a milestone in production or a record number of days without an accident on the job. Additionally, if an individual made a unique contribution to the company, Nestlé wanted to show its appreciation. Darci Dorval-Bowering remembered a time when her father, Tom Dorval Jr., helped out the company:

A fresh batch of milk had been brought in and they were getting ready to mix it with chocolate. Dad thought it smelled funny, so he stopped the machine, which you weren't supposed to do without getting the foreman's okay. When the foreman inquired what was going on, Dad told him that something wasn't quite right, so they sent a sample of that batch of milk to the lab and found out it was spoiled. If Dad hadn't caught it, the chocolate would have had to be destroyed. A couple days later, he got a gift—a Nestlé Quik bunny, about a foot high, red nose, Q emblem on his collar and a smile on his face. It was unexpected that company higher ups would do something like that, and it meant a lot to my father.

Though complimentary meals and keepsakes were appreciated, for some, there was nothing like a cash incentive. A 1971 newspaper article mentioned two such achievements at the Nestlé plant: Louis Tetro, of the Cocoa Department, won $200 for his suggestion to haul two loads of Strawberry

* Among the awards for perfect attendance was a jewelry box engraved with the worker's name. Each subsequent year that the employee maintained his or her perfect attendance earned them a dated plaque, which could be added to the box.

Quik at the same time, thereby accomplishing in eight hours what used to take sixteen. Fellow worker Earl White, who had already won a total of eight awards, added a ninth when he suggested an improvement on the Moulding line. Including the financial compensation for that suggestion meant an accumulated $2,800 in cash awards for White, the highest total ever paid in the history of the plant's suggestion program.

Not everyone at the Fulton factory was able to win awards paid out in U.S. currency, but they all had the opportunity to earn something just as good: Nestlé Dollars. Dave Miner explained that innovative program:

> *Nestlé Dollars were given out as awards for quality and safety. For instance, when I was working in the lab and we did an inspection, if an area was really improved and outstanding since the last inspection, we would reward the employees with Nestlé Dollars. Workers could use them at the company's shoe store, located right in the plant, which sold steel-toed shoes. The cost to employees was really good, but with Nestlé Dollars you could get a pair for almost nothing.*

The shoe store was definitely a benefit to Nestlé workers, but it wasn't as special as the plant's very own Company Store. Imagine a shopping destination where only Nestlé products were sold, anything from the tiniest Toll House Morsels to the hefty ten-pound Crunch Bars. Then consider the fact that as a Nestlé employee you could buy those products at incredibly low costs. Former workers remembered seeing price tags offering ten candy bars for $1.75 or Nescafé coffee for a buck. Employees could even buy Nestlé's version of Rice Krispies, made right in the plant for Crunch Bars. A forty-pound bag of the cereal would cost $2.00, which provided a lot of snap, crackle and pop in Nestlé households.

Former workers described their Company Store as a miniature BJ's warehouse where shoppers selected products that were displayed in shipping cases. There was an incentive to keep going back to the store. All Nestlé products were sold there, even ones manufactured at its other factories. Every trip to the store was an adventure, since you never knew which products would be on the shelves. However, people assured me, you could always count on Crunch Bars and Semi-Sweet Morsels, made fresh daily at the plant.

People loved the Company Store during the holidays. Daryl Hayden was a frequent customer when he played Santa Claus for his neighborhood at Christmas. "I'd buy candy bars and give them out to kids whenever

Fulton Nestlé's Company Store offered great products at unheard of low prices. *Fulton Nestlé archives.*

they came up at my house." Pam (Natoli) Sturick remembered how her grandfather Phil Pappalardo handed out Nestlé candy bars at Halloween: "He had a basket filled with hundreds of those full-size bars he was able to purchase at the Company Store." Hunting season could even be considered a holiday for friends of Dave Wolfersberger. Dave bought mini candy bars at the Company Store "for three cents or a nickel a piece. When I'd go hunting, I'd buy a big bag and give them out at the restaurants and bars we visited. It was good public relations for our city."

The Company Store was a friend to home bakers, too. Sharon Figiera's father worked at Nestlé for forty-three years, and she recalled never having to buy a single bag of chocolate chips until her father passed away: "After he retired, Dad could still shop at the Company Store, and he'd keep my supply of chocolate chips in stock." Another Nestlé employee's child told me that when the plant closed in 2003, her mother bought cases of Toll House Morsel bags at a greatly reduced price. Fifteen years later, she thinks of her mother every time she takes one of those bags out of the freezer.

Dave Miner explained a little more about the Company Store's operation and its policies, which sometimes even allowed non-workers to shop there. "The Store was normally open Monday, Wednesday and Friday. It also

opened at 6:00 a.m. on Friday mornings, when the night shift got out, so they could buy from the store before heading home. Workers' spouses or other family members could also shop at the store after getting a pass to purchase things."

NESTLÉ'S RECREATION PARK

The benefits of being employed at Nestlé went beyond all the chocolate you could eat on the job or purchases for pennies at an in-factory store. There was also good reason to work at the factory beyond its gates. About halfway through Nestlé's century in Fulton, it began offering workers their own recreational haven, known as Nestlé Park. Daryl Hayden explained its origins: "In 1948, the plant's Recreation Association was formed, initially so men could play horseshoes and women could get together and sew. Then the Association bought a fifty-one-acre property just outside the city." (A few years later, nineteen more acres were added to the park.)

A 1952 *Palladium-Times* article offered a little more background on the park, noting that it was purchased by the company as a tribute to Nestlé employees who'd lost their lives in World War II and the Korean War. Wooded areas at the park site had been cleared for baseball and other sports, and plans were underway for a refreshment stand, comfort stations, picnic benches and outdoor fireplaces. By the following winter, the association hoped to have ski trails and toboggan slides. Eventually, a waterfront facility on the Oswego River would feature docks and a boathouse.

Creating a park for its employees' recreation fit nicely with Nestlé's commitment to offer more than a good wage. The company had been caring about workers' leisure time for decades, as confirmed in a 1924 newspaper article covering a Chocolate Works picnic. The annual event, held at Fulton's Recreation Park, featured good old-fashioned fun: a greased pig contest, three-legged and wheelbarrow races, a pop-drinking contest and a horseshoe pitch. Prizes for lucky employees and their families also seem quaint by today's standards: a pair of candlesticks, beads, a belt, a tie, a pipe and a box of twenty-five cigars.

Interest in the company's social events grew, and by 1955, two thousand people attended the Nestlé picnic at their new park. On the agenda for the day were over twenty competitive races and activities. A baseball game pitted Fulton employees against a rival team from the corporate offices

in White Plains, New York. A mysterious "Mr. X" wandered around the Nestlé Park grounds; the first person to find him was awarded five silver dollars. One activity isn't something you'd find at a modern-day company picnic: a pipe-smoking contest, which a newspaper reporter noted was "for both men and women." There was no mention how the contest would be judged. On the menu were traditional picnic foods: hotdogs, hamburgers and lemonade—and one item not often seen at a summer picnic, but right at home at a Nestlé event: chocolate milk.

In 1971, an issue of *Nestlé News* noted that the annual picnic, now referred to as a clambake, attracted 400 workers and their families. The article made note that the association was employee-run and sponsored numerous group and family activities for its 1,200 members, including dances, bowling, team sports and picnics. An update on Nestlé Park's amenities mentioned its driving range, softball diamonds, swing sets, tennis and basketball courts and pavilions. Dave Miner pointed out this fact about the recreation facility: "Employees could have the use of the park for family events with no charge if they were a member of the association, and most employees were." Dave also noted that "Nestlé Corporate backed the park and donated a lot of money for it."

Sandy Traficante, through her position in the Personnel Office, was in charge of the Recreation Association and Nestlé Park. She worked with a committee made up of both hourly and salaried employees who oversaw the facility, which was also available to the general public for a fee. "Many weddings and family reunions were held there," Sandy said. "When we rented out the facility to non-employees, I would collect that money and we would use it for the children's Halloween and summer parties."

The Recreation Association offered its employees just about every team sport. Baseball was popular for the company as far back as its PCK days. The Nestlé archives include a photo of its softball team after winning the season title in the Fulton Industrial League. Dave Miner remembered a charity baseball game at Fulton's Recreation Park between Nestlé workers and WHEN radio: "Both management and employees participated; it didn't matter if you were unloading beans or running an office. I believe the Plant Manager umpired the game. Those were the sort of things we all did together as a plant and they were good times."

Most of the Fulton factory's team sports were covered by *Nestlé News*, which regularly listed its bowling team scores. And when the company started a golf league, the magazine reported that forty teams were registered. This led to golf tournaments, which were sponsored by the

corporate office. "Those were open to everyone who worked at the plant: supervisors, management and employees," Dave Miner noted. "Nestlé paid three-quarters or more of the course fees."

The chocolate factory even had an active Fulton Freshwater Fishermen's Club, which dropped lines at the various waterways in the area. It seems as though any sport would have been supported by the association and the corporate offices—well, almost any sport. Touch football sounded like a fun idea for workers, but one day, Mike Malash saw a notice posted on the bulletin board. "It said there could be no more touch football," Mike explained. "Too many foremen were getting injured and had to take time off from work."

Aside from sports, Nestlé's Recreation Association hosted daytrips. "We'd go to Vernon Downs [for the horse races]," Dave Wolfersberger said. "A blanket on our horse read: 'Nestlé Sponsored.' We also had a day for Seabreeze Amusement Park. Tickets were just $5.00 per person, and when we got there, the company had special events and food set up for us."

The Recreation Association had subgroups, such as the Managers Club for supervisors and foremen, who annually attended a Carrier Dome football game. "Kids today don't appreciate how big a deal that was for us," Dave Miner suggested. "Nobody else was doing that back then, but Nestlé did, and they paid for everything." Jim Schreck also mentioned the company's generosity toward employees' leisure activities: "Once a year, our Nestlé Office Club would get a check from Corporate and we'd decide what activities to sponsor. A favorite was our annual trip to a Buffalo Bills football game. We'd buy a block of forty tickets, rent a bus and buy food for a tailgate party."

CHRISTMAS WAS SPECIAL AT NESTLÉ

Yes, Nestlé was known for its recreational events. Some were blue jeans and T-shirt affairs and others "dressed-to-the-nines" parties, as Amy Tompkins Johnston referred to the annual adult Christmas party: "They were held at the Chamber of Commerce in downtown Fulton and were very formal. My mother used to get fancy dresses to wear to those events, and we college and high school students looked forward to them."

But of all the social activities Nestlé workers wanted to talk about, none was remembered as enthusiastically as the children's Christmas

The annual Christmas party provided holiday magic for children of Fulton Nestlé employees. *Courtesy of the City of Fulton, Mayor's Office.*

party. Charlie Cieszeski broke out in a big smile when I asked about his Nestlé Christmas memories: "When I was a kid, the State Theatre was in operation, and Nestlé rented the whole place on a Saturday afternoon. All the Nestlé kids would be there; hundreds of them. There would be a movie and games, and Santa Claus would come."

At some point, this magical holiday experience for children moved to Fulton's War Memorial, the only place in town that could hold the crowds of children that sometimes topped one thousand. Dave Miner was in charge of this undertaking as part of his job overseeing the Service Department. "Every child, up to age eighteen, would get an age-appropriate gift. The presents would show up at the War Memorial having been loaded onto one of our tractor-trailers." Denise Borek-Morganti reflected on being a child who received one of those gifts: "They were really good presents from Nestlé's Santa. Not like a little water gun or something; they were like a nice doll or such."

Colleen O'Brien has a special memory from one of the children's Christmas parties she attended, one held in the plant's warehouse:

My dad had just been made foreman and he took Mom, my brother, and me on a tour of the factory. All I remember is standing in front of the chocolate chip line as row upon row of morsels came off the belt to be packaged. My dad snuck me a handful. I don't remember what present I got at the party, but I have always remembered those delicious morsels.

That memory came rushing back to Colleen when she began working at the plant's lab as a young adult:

I was asked to go collect Toll House Morsels directly off the line. As I collected a sample from the conveyor belt, for a moment I was transported back in time. I stood there watching the morsels coming down in neat rows and I wasn't a twenty-four-year-old employee of Nestlé; I was five and with my dad, sneaking a bit of chocolate to taste.

It wasn't just children who were receiving holiday gifts from Nestlé. For years, as the Thanksgiving and Christmas seasons approached, employees would see a company tractor-trailer set up in the parking lot. Heading for their cars at the end of a long workday, employees stopped at the truck, where they would be handed a good-sized turkey—one for each Nestlé family.

And for generations, there was the Nestlé Christmas box. So many former employees or their family members couldn't wait to tell me about this holiday gift from Nestlé; many can still describe what they looked like. "It was a cardboard box, about a foot and a half by a foot and a half," recalled Denise Borek-Morganti. "The box was dark ivory or light beige, and in the bottom right corner it had, in red letters, Nestlé. A red ribbon on the cardboard vertically and horizontally was a part of the design, but it looked like a real ribbon. I remember we'd get the box a few days before the actual holiday, but it never got opened until Christmas Eve." For Connie Lynn, whose father's forty-two years at Nestlé meant many Christmas boxes for her home, "it was the delight of our family when Mom would bring it out during Christmas. We were in awe."

When opening their Christmas box, Nestlé families could count on the company's popular candy bars and cocoa, but some of the tasty samples changed from year to year. Virginia Tilden remembered seeing "a little sampling of new products, like Strawberry Quik or jellies from Crosse and Blackwell, a company which Nestlé had acquired. One year, there were even watermelon pickles."

While everybody who worked at Nestlé received a Christmas box,[*] being the plant manager got you a little something more. Amy Tompkins Johnston remembered her grandfather Charles Cieszeski receiving "a premier box of Swiss chocolate from [longtime Nestlé confectioner] Chris Klaiss." Amy's mother, Cindy, and her uncle Charlie have an additional memory of Klaiss's holiday gift: "At our family's Christmas Eve party, those fancy hand-dipped Swiss chocolates were set out. Some of them were made with adult substances, and we kids weren't supposed to be eating them. But when everyone was in the kitchen fixing dinner, we snuck a chocolate-covered cherry filled with liquor, and the fire that came out of our mouths…"

The November 1966 issue of *Nestlé News* reported that corporate offices had decided to forego the Christmas box tradition for one year, replacing it with a gift that would honor the centennial of Henri Nestlé's infant formula breakthrough. Workers were to receive a sterling silver bowl imprinted with the phrase "100 Years" in several languages, representing the many countries Nestlé now served. The article explained that "this change represents the company's desire for our employees to have a lasting and valuable memento signifying Nestlé's 100 years in operation." While I'm sure many people appreciated the importance of honoring their company's founder, I can't imagine anything could replace the joy that those Christmas boxes brought to Nestlé workers and their families.

FREE CHOCOLATE AND HARD-EARNED DIAMONDS

Nestlé couldn't claim to be the only factory in Fulton that hosted sporting events or handed out Christmas gifts, but it was the one workplace in town where employees could enjoy free chocolate on the job. It was a well-known fact that whenever you needed a pick-me-up, containers of broken chocolate pieces or samples of the latest new candy bar were there for the taking. Workers had their favorite places in the plant to satisfy their chocolate cravings. Wendell Howard, a self-described "chocolate fanatic," remembered enjoying the broken chocolate, but for something really special, "I'd go to Refining when they were making a fresh batch. Using a rag or handkerchief, I'd scoop up some being processed and kept a supply in my desk."

[*] One holiday box was given to each employee, but additional boxes could be purchased at the Company Store. Even non-employees could buy one at Ingamell's, a neighborhood mom-and-pop store near the Nestlé plant.

Joyce Cook, who worked in the plant's Research Department library, admitted to what I'm sure happened for many people working on a job with unlimited chocolate: "I knew exactly where that barrel of broken chocolate pieces was. I only worked at Nestlé one day a week for about eight years, but I gained a significant number of pounds—much more than anyone should have."

With Christmas boxes filled with sweet treats and chocolate snacking going on all the time, you might think that Nestlé only celebrated its workers with candy. But there were also more traditional, sincere tributes bestowed on employees, especially those who'd stuck with the company over the years. Twenty-five years, to be exact. Those who reached that milestone could look forward to being inducted into the company's esteemed Quarter-Century Club, an annual event with dining, dancing and more. In Fulton, it was the talk of the town.

A December 1971 issue of the *Fulton Patriot* covered that year's Quarter-Century banquet, held at the city's Iroquois Village. Five hundred people attended the event to watch twenty-two Fulton employees receive commemoration from a Nestlé Corporate vice president from White Plains, New York, and Fulton plant manager Jim Gillis. By 1999, the banquet had been moved to Syracuse's Holiday Inn, where forty-one of the Fulton plant's workers were inducted as new members. A handsomely designed brochure for the event opened with a congratulatory letter from the Nestlé USA president Hans J. Wolflisberg:

> *When a young man or woman starts to work, the possibility of staying with the same company for 25 years seems remote. As years go by, as attachments grow, as work becomes satisfying and progressively more challenging, loyalty to the company develops and a long service record emerges. Probably most of us reaching our 25-year mark say with a certain sense of wonder, "I never would have thought…"*

Quarter-Century Clubs were formed at other Nestlé plants across the United States, and the brochure included their honorees, too. But year after year, the list of new inductees was overwhelmingly composed of Fulton plant workers. The 1963 banquet brochure welcomed thirty-five new members; twenty-four of them were from Fulton. Beneath each new name were two photos of the worker—a head and shoulders, and a candid "on the job" shot—followed by their bio. One of those 1963 Quarter-Century inductees was Fultonian John Tilden, and here's what the brochure had to say about John:

The 1924 Quarter-Century Club banquet (notice the seating used in the front row); the annual banquet at the Hotel Syracuse. *Courtesy of the Fivaz family; Fulton Nestlé archives.*

Cocoa Technician, Quality Control Laboratory. John began his Nestlé career on July 8, 1938. He worked on the floor of the old Unmoulding Room, hauling by hand-lift trucks racks of chocolate from the knockout tables to the storage cooler and bringing back empty racks. After short stays in this department and the Cocoa Room, John transferred to the Laboratory as a Tester in 1941. He was promoted to his present post seven years ago.

John's bio continued with an overview of his family life, hobbies and community involvement. In 1965, Lillian Tilden joined her husband in the Quarter-Century Club, and her brochure's bio stated:

Inspector, Cocoa Department. Lil was hired May 20, 1940, and assigned to the Cocoa Department. Her first job was on the Packomatic Machine. All her years with Nestlé have been spent in this department. Lil and her husband, John, a Quality Control Technician and QCC member, are sports enthusiasts. They enjoy playing golf, watching football and hockey games, boating and "trailering."

I was impressed with the effort that Nestlé put into the brochure's overview of each new Quarter-Century Club member, but when I met with John and Lillian Tilden's daughter-in-law Virginia Tilden, I found out the company took it one step further. Along with pictures of her in-laws dressed up for the Club banquet, Virginia shared personalized letters to John and Lillian from the president of the Nestlé Company. Since I was able to compare both congratulatory notes side by side, I saw they were not form letters. In John's, the president wrote of his work in the lab: "Since quality control is a very vital matter in our manufacturing process, you certainly deserve a feeling of satisfaction with your own progress to this position. The fact that you took a quality control course a few winters ago also showed a commendable desire to keep improving your value." In Lillian's letter, the president mentioned this fact: "I know you have worked your entire career with Nestlé in the Cocoa Department until you have become an Inspector there. Nestlé certainly does appreciate such long and faithful service, and we value the hours of conscientious work such a record represents."

Virginia Tilden noted the significance of her in-laws' inductions into the Quarter-Century Club: "Both [of them] worked their whole career at Nestlé. They met in high school, got married right out of school and then went there to work. They enjoyed their work and made a lot of friends there. I never heard my in-laws say a bad thing about Nestlé."

Eventually, membership in the esteemed club became just one stop on the road of a Nestlé worker's success. When people continued to serve the company beyond a quarter century, new milestones were created: The 30-Year, 35-Year and even 40-Year Club. Honors were also bestowed on those achieving lesser-year goals, and to properly acknowledge all those achievements, the company began printing a booklet of the awards given out for each year of memorable service. In 1976, it described ten-, fifteen- or twenty-year employees earning a gold-filled tie tack, tie bar, key chain, pin, bracelet or watchband. At ten years, the keepsake was embedded with a synthetic golden sapphire; at fifteen, a synthetic ruby; at twenty, a synthetic emerald. Twenty-five-year employees received a full-cut six-point diamond. Every five years beyond the quarter century, the diamond in the award was slightly larger, until, at forty-five years, it measured twenty points—almost a quarter of a carat.

The award booklet didn't indicate any honor for someone like John Huss, though I'm sure the company found an appropriate way to acknowledge his momentous achievement. John was hired as a production man in Fulton Nestlé's Moulding Department in 1919. In 1969, upon his retirement, he reached his fiftieth year of service to Nestlé. At the time, John was only the second employee in Fulton to achieve that goal.

Dave Wolfersberger has kept the dozens of Nestlé awards and keepsakes he earned in his thirty-two years at the plant, and when we sat down for an interview he had them spread out on his dining room table. Following our talk, Dave gave me a tour of his home, where I saw other Nestlé memorabilia on shelves and mantels. Among his awards was one with Nestlé's "birds in a nest" logo and these words: "Dave Wolfersberger. In recognition of your contribution to our quest to be the very best." His twenty-five-year award was a combination barometer/clock, and he earned a windup clock in 1995 for excellence in training. A series of three medallions—bronze, silver and gold—were recognition awards given when teams or workers completed training programs or offered safety and production suggestions to improve the plant. Dave's thirty-year award—a gold wristwatch with an engraved congratulatory message on the back—has never been out of its box; he prefers to keep it as a treasured memory of his time at Nestlé. Dave said this about his Howard Miller windup grandfather clock earned for twenty-five years of service: "It's the pride and joy of my days at Nestlé."

Along with his cherished awards, Dave also shared some Nestlé collectibles: A Quik Bunny, standing about ten inches tall and sporting a

tux and a red bow tie, came with a pocket watch; a "Little Hans" doll, the onetime chocolate-maker mascot of Nestlé; and packs of basketball cards that were once tucked inside chocolate bar wrappers. Many of those items would have been available for purchase at the Company Store or through Nestlé's national headquarters. All of them, Dave explained, will be passed down to his grandchildren.

Another Nestlé memorabilia collector is Kathy (Putnam) Gallagher, who showed up for her interview wearing a Nestlé long-sleeved denim shirt with the company's logo on the pocket. Affixed to the shirt was a Toll House Morsel–shaped pin. "Sometimes they gave things like that away during quality control programs," Kathy explained. "We went through all sorts of workshops at Nestlé to improve the conditions and work ethics, and they gave out awards at those programs." Kathy also showed me an order form for a Nestlé Baking Club. "You could order items from the company, things like bakeware sets, pastry sets, measuring cups or a hand mixer—all with the Nestlé logo on them."

Kathy also discussed the Nestlé memorabilia currently decorating her home: a wall clock with traditional numbers sporting reminders of popular Nestlé baking seasons; several Nestlé-related posters; shelves of Nestlé canisters; a Toll House cookie jar; and a square tin that holds exactly two bags of morsels. For the true chocoholic, there's a shot glass especially for Nestlé hot fudge. "It measures just the right amount for a sundae," Kathy explained. Many of those items can be found online today, but others are true rarities, only available during onetime grocery store promotions.

The many awards and gifts Nestlé workers received for their years of service became important keepsakes once the factory closed. *Courtesy of the Tilden family.*

Kathy and Dave are two of the thousands of people who count Nestlé awards and memorabilia among their most prized possessions. All over the world, in the homes of those who once worked at the Fulton plant, these keepsakes are on display or safely tucked away. From time to time, they are brought out to share with family and friends and to help people like me understand why so many former Nestlé workers want to preserve their memories of the chocolate factory in Fulton.

ON THE FULTON CHOCOLATE FACTORY TOUR

While chocolate workers have firsthand experience with the sights, sounds and smells of Nestlé, some who never worked there also managed to make memories, especially those lucky enough to have gone on a factory tour. Generations of Fultonians and visitors to our city got a taste (literally) of Nestlé production while on a tour. Sometimes a journey through the factory was offered in coordination with special events, like the city's old-fashioned Cracker Barrel Fair, and other times, like a 1951 ad announced, general tours of the plant were offered to the public. Everybody I talked to who participated in a tour enjoyed it, but those who were children when they visited the plant have the most vivid memories. Shirley Jensen Hanley was six when she toured the factory in 1960 with her sister's Brownie Troop. Here's how she remembered it:

> *First they showed us a film with chocolate candy growing on a tree. Then we started the tour of the factory, which seemed spacious. When we left, they gave us each a clear plastic bag with unwrapped broken candy pieces. They were different colors: pink, green, white and milk chocolate. I've never seen the pink or green candy again. Imagine getting a bag of unwrapped candy…*

The company's employee magazine, *Nestlé News*, expanded on young Shirley's tour memories with a 1977 article, "Family Day at Fulton a Sweet Treat, Indeed." The article explained the tour, beginning with an introduction in the plant's conference room, where guests saw samples of the plant's products, the Nestlé Chocolate Machine (affectionately referred to as "Charlie") and a film called *The Chocolate Tree*. Visitors then toured the plant departments, observing just about every step of the chocolate-making process. After the tour, the five-hundred-plus people in attendance were greeted by the Quik Bunny (for many years portrayed by Division I maintenance supervisor Bernie Hayden, in a costume designed by his wife), who distributed candy bars.

Showing up for the tour on the right day could have also meant an appearance on a TV show for some lucky children. That's what happened to Pam (Natoli) Sturick when she and her family were on a Nestlé tour in the summer of 1989. The Natolis were heading into the tour when a representative from the Nickelodeon TV show *Total Panic* approached twelve-year-old Pam's mother, Jo Ann, to ask if her children would like to be

Tours of the Fulton Nestlé plant were memorable for many, especially children. *Fulton Nestlé archives.*

part of the game show. I met with Jo Ann and Pam, who invited me to watch a videotape of the show's visit to the Fulton plant.

"The movie *Willy Wonka* was out at that time," Pam remembered, "and we were excited to tour the plant. But we never thought we'd end up on TV." After *Total Panic*'s host, Molly Scott, gives TV audiences a tour of the factory, she lines up several children for a contest. Each child is challenged to unwrap and eat a large Crunch Bar, raise his or her hand and scream out "I love chocolate!" Included in the lineup are three Natoli girls: Amanda, Debbie and Pam. "I had sprained my wrist earlier that summer, and my arm was in a cast," Pam explained, "but I was determined to win." She made a noble attempt, but one boy proved to be the fastest, completing the delicious challenge in nine seconds flat. It really didn't matter who won though, according to Pam: "It made that Nestlé tour a really special memory."

Nestlé had always been very generous with the free treats at a tour's end, but kids in the 1950s got a little something extra as they exited the plant.

NESTLÉ IN FULTON, NEW YORK

Richard Wallon Jr. recalled how the Fulton factory also gave away comic books. Bob MacMartin showed me an example of the colorful booklet Richard remembered, titled "The Flavor of Friendship around the World." Its storyline featured three teens who learn how chocolate is made at the Fulton plant and come to realize the many ways it is part of their life. To me, it looked like another creative promotional tool for Nestlé, but to Richard Wallon, who is a comic book historian and collector, it was more than a clever advertisement. "Those comics are very rare, and it is one of my favorite books," Richard commented. "I look at it and can still smell chocolate in the air."

Adults also made lasting memories on Nestlé tours. When New York history blogger Ed Pitts visited the plant in the mid-'90s he noticed an aspect of the factory most people would have missed: "Inside the oldest section of the plant, every piece of woodwork had absorbed so much cocoa butter from the air that the wood was dark and oily." Ed also "marveled at the completely automated chocolate morsel machine, [with its] hundred or more tiny nozzles [that] dipped to almost touch a wide moving conveyer.… The entire apparatus was at least a block long."

Yes, people of all ages found something to make their chocolate factory tour memorable, and most of those memories were pretty sweet. But there were times when being around all that chocolate could get you in trouble. One tour participant who asked to remain anonymous told me that, as a young boy, he secretly reached into the huge vat of freshly made morsels and stuck a handful in his pocket. Arriving home and anticipating a private treat, he reached into his pocket and pulled out a glob of melted chocolate.

In 1989, after the tours had been discontinued for several years, the factory reopened them during a city-wide event, the Chocolate Fest. Shirley Jensen Hanley, who had taken a tour as a six-year-old many years before, participated in that tour, too, and commented: "I was so glad to see the factory as an adult. When we left, we were all given a baggie with wrapped mini-candy bars, so different from the unwrapped chocolate pieces I'd received in 1960. How standards have changed in twenty-nine years."

FULTONIANS GOT FREE CHOCOLATE AND MORE

You didn't have to attend a tour to get a chocolate handout in Fulton. If you were related to a Nestlé worker, like Mary Schlieder was, you could always

expect a treat. Mary's uncle, Johnny Crisafulli, worked at the plant for decades, and when asked what her favorite Nestlé memory is, Mary shared: "Uncle Johnny brought us brown paper bags full of broken, unsellable candy bars. We thought he had the best job in the world!" Betty Fadden's grandfather worked at Nestlé, and she remembered getting lots of broken rabbit ears at Eastertime. Jeanne Murphy's family had a friend who turned out to be just as good as a relative: "My parents' friend, John Huss, was an executive at Nestlé who traveled extensively for the company. He sent me postcards from around the world and always showed up at our home loaded with chocolate."

Kids living in the Nestlé neighborhood had a good chance of being on the receiving end of free chocolate. Anthony Squitieri shared this about his younger years: "Before fences and security, we would walk past the Nestlé lab on our way to play baseball, and [workers] would slip us chocolate out the Quality Control Lab windows." Apparently, there were other windows at the Nestlé plant where neighborhood children might get a treat. Wilma Castiglia lived just a few blocks from the plant, and she and her friends rode their bikes to the back windows of one Nestlé building. There, she recalled, "workers handed us hunks of chocolate."

Being a raw-material supplier to the plant also had its advantages. Daniel Hawksley worked at Roy Johnson's dairy farm, just outside Fulton, and he remembered that the driver of a milk truck "would bring us Nestlé bars. They were great treats as we milked and did barn chores." Vince Cardinal, who worked on the railcars that went in and out of the Nestlé plant regularly, has a special Thanksgiving memory: "Every year, out on the plant's rail dock, the train conductor got a ten-pound block of their baking chocolate. He'd take it back to the yard office and everybody would get a chunk."

You might think that there were no limits to Nestlé's free chocolate, but Robert Washer learned otherwise. In the early 1960s, Washer was hired to do some electrical work for the factory, and he remembered what happened after he'd taken a lunch break in the cafeteria: "You could eat all the chocolate you wanted for free there, but you couldn't take anything out of that room. I was walking out with a piece of candy and someone in security stopped me. 'You've got candy from the cafeteria,' the guy said. He made me put it back."

Nestlé's generosity went beyond tasty handouts. Community organizations in and around Fulton greatly benefited from the company's altruistic ways. Some donations were sizable, like a $50,000 check from the company to help Fulton's YMCA build a new pool. The city's service organizations often counted Nestlé management, foremen and line workers among their

members, and for many years, Fulton's Noon Rotary Club had a special gift for its guest speakers: the popular ten-pound candy bar. But the gift was no ordinary oversized bar; embedded in the chocolate was the Club's Rotary wheel emblem. Several Rotarians told me it was Westreco manager Joe Allerton who created that unique gift.

Nestlé always showed support for its employees' contributions to the community. During the Christmas season in 1978, workers and their company banded together to donate 1,200 chocolate bars to the Percy Hughes School for Exceptional Children in Syracuse, making those youngsters' holiday a little sweeter. Nestlé Test Kitchen technician Janet Ferlito spearheaded the project. A November 1963 issue of *Nestlé News* focused on the company's close ties with 4-H, a nationwide youth empowerment organization. Nestlé earned 4-H's Gold Clover Award as an industry that financially contributed to advance the program's efforts. The article included stories of 4-H groups in their factories' towns, including Fulton, where Nestlé plant employee LeRoy Wade and his wife had been 4-H club leaders for over ten years. LeRoy worked in the plant's Condensery, and he shared his dairy production knowledge with club members.

Nestlé employees also had fun when supporting community events. Angelo Caltabiano remembered his company's involvement with the Annual Adult Spelling Bee to support Catholic Education in Oswego County: "I participated as a Nestlé team member for ten years. Teams of three competed in standard spelling bee format, but most importantly, an evening of friendly but fierce competition laced with lots of laughs was guaranteed."

In what appears to be the most unusual expression of Nestlé's community support is this story of how the worldwide corporation helped one young man fulfill a dream. It began with a letter to the editor of *Nestlé News*, in which a college-aged student explained his desire to build a Model A Roadster show car. He'd designed his vehicle in the theme of a candy bar and had the novel idea of covering the car's exterior with candy wrappers instead of paint. "Would you be so kind as to forward me a supply of your various wrappers?" the young man inquired.

The response from the editor surely must have made the letter writer's day: "We are very honored that you picked our candy wrappers to cover your roadster. To help you finish off your project, our Fulton, New York, plant is forwarding you the chocolate wrappers you will need. We are sure the car will make a 'hit' when finished!"

PARADES, FAIRS AND FESTIVALS

Nestlé was also involved with many annual celebrations in the Central New York area. As early as July 1916, the plant had a presence in local parades. That year's Fourth of July celebration in Fulton featured a large milk truck decorated with Nestlé emblems and slogans. Thereafter, company floats would be seen on Fulton streets nearly every year of its century in the city.

"We had competitions with other industries," Dave Miner recalled. "We all tried to see who could come up with the best float and our employees really got involved." Costumed Nestlé workers were often a highlight for those watching from street sidewalks, and it was Sandy Traficante who was largely responsible for the creation of those memorable characters. Sandy explained:

> *Sometimes, we rented costumes from a Syracuse Theatre, and Nestlé always paid the rental fees for them. The themes were hugely popular, but parade crowds particularly enjoyed the Nestlé-related costumes: Crunch Bar, Milk Chocolate Bar, The Nestlé Quik Can, The Chunky Bar, a chocolate chip cookie, a morsel and the Quik Bunny—both strawberry and chocolate. My volunteers were the best people you'd want to work with. I'd just make a phone call and tell them about an event coming up and they would never hesitate to join in.*

Nestlé also had a presence at the New York State Fair. The company set up a display covering the history of chocolate making in the fair's Horticulture Building. A factory team, dressed for the fair in matching polo shirts with the Nestlé logo, greeted the public. "For weeks before the fair, employees in the Wrapping Department would assemble a variety bag of Nestlé candy bars," remembered team member Roxanne Hollenbeck. "It included two Milk Chocolate Crunch bars, a White Chocolate Crunch, an Almond and a Chunky Bar. Our supply of goods was stored in an air-conditioned trailer, and there were many trips made there throughout the day to replenish our rapidly sold goodies."

Nestlé saved its biggest celebratory event for its hometown. Fulton had long enjoyed playing host for citywide social events, including the 1960s–90s Cracker Barrel Fair. But in 1987, Nestlé proposed something entirely different: an all-things-chocolate extravaganza. On Mother's Day weekend of that year, Fulton was the place to be, when the city's biggest public space,

For many years, Nestlé's float was one of the most popular entries in Fulton-area parades. *Fulton Nestlé archives.*

Recreation Park, was transformed into a candy bar wonderland. Nestlé's organizers called it the Chocolate Fest.

The community-wide effort was evident by the list of organizations that supported Nestlé's grand plan: the YMCA, Salvation Army, Polish Home, and the Lions, Rotary and Kiwanis Clubs. Three community mainstays took the lead for the Fest: the City of Fulton, its chamber of commerce and Nestlé. Sandy Traficante, already well-acquainted with parades and festivals, was on the committee, and she remembered the cooperative effort to make the Chocolate Fest a success:

> *Mayor Muriel Allerton was on that first committee and what a wonderful woman to work with. The city provided rides, games, food vendors and two evenings of entertainment. Nestlé volunteers decorated the whole War Memorial, and our volunteers bagged up hundreds of candy bar bags to hand out. We called them the Costume Crew, and they walked the festival dressed as Nestlé products.*

To kick off the inaugural fest, New York State's Lieutenant Governor Stanley Ludine proclaimed Fulton as "Chocolate City," and a *Valley News*

212

pre-event special edition announced the full list of activities festgoers would find: Tae Kwan Do and gymnastic demonstrations, barbershop and women's quartets, a bluegrass band, a dance group and six hundred wrestlers from the northeastern United States battling it out in a tournament. An oldies tour featuring the Shirelles, Marvellettes, Drifters and Tokens would transport the crowd back to the 1960s. Amusement rides spun children up, down and all around, while adults enjoyed a horse-drawn wagon's saunter along Lake Neatahwanta.

But the real star of the event was chocolate. The smell of fresh-baked Toll House cookies was a potent advertisement for passersby. Once at the festival, crowds found five booths of Nestlé-related items. One special Mother's Day–themed booth was set up with an original Syracuse Conche machine churning out fresh batches of chocolate poured into heart-shaped moulds. Nestlé provided a comprehensive overview of its chocolate production, and the Fulton Historical Society organized a history of Nestlé. There was even a chamber-sponsored baking contest, with cash prizes for these categories: cookies, cakes, pies, tortes, candies, brownies and, for the adventurous, miscellaneous.

At the conclusion of the first fest, plant manager Harry Jewett announced that Fultonians and other attendees consumed "thousands of pounds of chocolate." Local newspapers had other numbers to measure the Chocolate Fest's impact. The city had hoped to draw 10,000 people, but the *Palladium-Times* estimated the actual number in their headline: "20,000 Descend on Fulton," nearly doubling the city's population for the weekend. The most impressive figure, in my opinion, was 520, the number of former and current Nestlé employees who volunteered for the event.

Nestlé management didn't want to let the efforts of Chocolate Fest volunteers go unnoticed. When reviewing a scrapbook compiled by former plant manager Charles Cieszeski, I found a letter from Harry Jewett and his director of personnel, Hugh MacKenzie, expressing their gratitude for Charles's donated time. The letter mentioned an upcoming party for all five-hundred-plus contributors to enjoy dancing, drinks and food. Naturally, the celebration was to be held at Nestlé Park, where all those volunteers could have a festival of their own.

Nestlé intended to sponsor the Chocolate Fest for many years to come, but the company cited "a budget crunch" preventing a second festival from taking place in 1988. A decade later, Fulton and Nestlé resurrected the idea, and the Chocolate Fest ran three more years, from 1997 through '99. When city planners suggested adding a cost to attend the event, Nestlé pulled out,

not wanting to be associated with a celebration requiring an entrance fee. However, nearly twenty years after the last Chocolate Fest, its remains a bright memory for Fultonians who recall a time when Nestlé volunteers pulled out all the stops and made a visit to our city a real treat.

11

THE NESTLÉ FAMILY

I knew how important it would be to talk with former Nestlé workers in order to properly tell the company's century-long story, but I wasn't prepared for the emotion with which they shared it. Making chocolate at a factory was a job, after all, and I was just hoping to hear people's firsthand experiences of a typical workday. But after a few interviews, I could already see what Nestlé meant to its workers, many whose only career had been inside those brick buildings. At some point, in almost every discussion, this sentiment came up, often expressed with the very same words: "The people I worked with at Nestlé were like family."

At first, I thought nostalgia was getting in the way of my hearing an accurate portrayal of factory life. I doubted that a work environment, which in its busiest years employed over 1,500 people, could ever be thought of as something as close-knit as a family. But by the time I'd finished my interviews, I realized I could trust former workers' emotional recollections of their close ties to the chocolate factory. As I reviewed my notes and reread testimony after testimony, I was able to identify two reasons why people held such strong family feelings for Nestlé. The first, in fact, had to do with actual families.

When I asked people how they found their way to a job at Nestlé, most mentioned following in the footsteps of a family member or members. Sons and daughters who had been raised on their parents' salaries knew the financial benefits of work at the chocolate factory. It was often seen as a smart move that, upon becoming an adult, children would follow the lead

of their parents, and soon, generations of the same family could claim a long history with Nestlé. This practice began with the first Swiss workers who came to our city, as I learned when Renee Michaud Klubeck shared her family's lineage at the Chocolate Works: "My great-grandfather Louis Michaud was an original foreman from Switzerland, and my grandfather Andrew Michaud was a chemist in the plant his entire working career.* Also, my great-uncle Ernest Zahler worked second shift, and my father, Donald Andrew Michaud, worked there shortly after serving in the Air Force during World War II."

Renee herself joined the Michaud family's contributions to Nestlé, though not in a traditional job. She explained that she had been featured in a marketing photo "at age eight, taking a bite out of a piece of solid chocolate with my grandfather." Renee's photo shoot means that four generations of Michauds were part of Nestlé's history.

I would hear variations of this extended-family connection to Nestlé countless times during my research. One particularly impressive example is the story of the Hayden family. I spoke multiple times with Daryl Hayden, not only to hear his memories of the chocolate factory but also to fully understand the extent and scope of his family's work there. The Haydens' association with Nestlé began back in 1927, when Daryl's grandparents moved to Fulton from Gouverneur, New York. Daryl explained:

> At the time, they were looking for jobs because the Gouverneur factories had come to a screeching halt. But Fulton was the city with a future. There were so many factories in the town, and if you didn't like Nestlé, you could go to Armstrong or Sealright or Victoria Paper Mill. So, my grandfather and grandmother, Frank and Eliza Hayden, and six of their seven children came to Fulton. (One of my father's older sisters stayed in Gouverneur.)
>
> My father, Bernie Hayden, was still in high school when the family moved. He went to work right out of school and ended up at Nestlé in the Conche Department, beginning in 1930. One of the things I remember about my dad was that he never wanted to miss work. During terrible snowstorms, Dad would walk into Nestlé from where he lived behind Babcock Oil. He had perfect attendance for twenty-six weeks, and then he had an appendix attack. When he got back to work, the boss jokingly said, "Don't make a habit of it."

* A newspaper clipping found in Nestlé archives shows Andrew receiving his forty-years-of-service award in 1964.

Along with Bernie, four of the Hayden brothers—Derwood, Raymond, Mark and Carlton—and their brother-in-law, Bob Allen, went to work at the chocolate factory in the 1930s. From then on, as Daryl explained his family's generation by generation presence at Nestlé, some Haydens worked there until the plant closed in 2003. Daryl was employed there, too, but getting hired wasn't as easy as riding on his father's coattails:

> *I started putting in my application at age eighteen, and it took me nine times before I got hired. Dad was a supervisor at Nestlé, but it didn't matter. I didn't go in there saying "I'm Bernie Hayden's son." Dad always brought us up that we were on our own. You either make it or you don't—and that was same for sports or school or a job. "I'll stand you up," Dad would say, "but it's up to you to walk."*

The Hayden family's belief that you make it on your own can be seen in Daryl's thirty-five-year association with Nestlé. He started off loading beans from the railcars in 1961. Five years later, when the maintenance training program opened up, Daryl applied. The years-long training graduated thirteen new maintenance men, and Daryl was one of them. "I put in for pipefitter," Daryl said, "and that involved four more years of schooling while I worked. One of my jobs was to take out all the factory's galvanized pipe and replace it with four-inch K copper. Sweating the whole factory took a while, but it was good experience because I ended up knowing every waterline in Nestlé."

In essence, Daryl had learned the entire factory layout, which came in handy when he moved to his next position at Nestlé. In 1973, he entered the management field by becoming a production foreman. A few months later, he was promoted to assistant maintenance foreman and, a few months after that, to head maintenance foreman, responsible for "over 68 percent of the product," Daryl noted. "In 1979, the company promoted me to project supervisor in charge of new products, and in 1986, they gave me an offer I couldn't refuse: a promotion to assistant plant engineer in charge of utilities. They later added facilities and maintenance to that position."

While he was fulfilling his thirty-five years at Nestlé (Daryl retired in 1996), several of his brothers and sisters also worked at the plant. Those included Bernard Hayden Jr., thirty-six years in the Refining Department; Dawson Hayden, thirty-eight years in the Conche Department; Lorraine Hayden in Special Products; and Cheryl (Hayden) Ingersoll. Also part

Bernard L. Hayden

Bernard L. Hayden, Jr.

Daryl Hayden

Robert Allen

Carlton Hayden

Carrie Hayden

This photo collage of some Hayden family members who worked at Nestlé was featured in the book *The Chocolate Works through the Generations. Fulton Nestlé archives.*

of the Hayden family's Nestlé lineage, through marriage, were nineteen-year employee William LaDue and Dick Dennison, who racked up forty-one years there. Shortly after the plant closed its doors in 2003, someone in the Hayden family decided to total up the number of years they'd logged at the factory. "We came up with the number 225," Daryl noted, then immediately added, "but working at the plant was more than an accumulated number of years for the Haydens."

To explain why Daryl felt that way, he asked me to take a little drive with him. He wanted me to see something. Three blocks from his family's former workplace is one of Fulton's cemeteries, and Daryl drove past hundreds of grave sites until he came to his parents' headstone. We got out of the car, and he leaned down, pointing to the stone's bottom left-hand corner, which was imprinted with a small Nestlé bar and these words: 44 Years. "When Dad decided he wanted that on his headstone," Daryl said, "I asked him why. 'They were good to me,' he said. 'We raised nine kids because Nestlé was good to me.'"

BEING A MEMBER OF THE NESTLÉ FAMILY

Standing with Daryl at his parents' headstone, I began to understand the second reason why so many former workers consider the Fulton plant a second family. Daryl expressed it this way:

> *At Nestlé, if you were a good worker, you could go as far as you wanted to go. You had the opportunity whether you had a college degree or didn't even have a high school diploma. It depended on how far you wanted to advance. When they offered me the chance to move up, I wondered why, because I didn't have any special education. But they said I'd get along with people.*

A look at Daryl's contributions to Nestlé attests to his ability to work with others. He served two terms as president of the Recreation Association, was on the board of directors for the plant's credit union and did two terms as president of the Supervisors Club. In all those situations, Daryl pointed out, "we worked together. We used to say, 'You throw your union book over there and I'll throw my company book over here and we'll work as a team.' And we all got along great."

Denise Borek-Morganti shared an example of the family-like ties that were often maintained between management and those on the lines. Her father, John, was a forty-year Moulding Department worker and she recalls telling her parents about a new friend at school. "It was Lynn Siebers, whose dad worked in management at the Westreco Department. When I told my parents about Lynn, my father said, 'Oh, yeah, that's Bart's daughter.' That's how he knew him; not as a manager, but as a Nestlé worker."

One aspect of what it means to be a family, even a factory-based family, is the sense of responsibility members feel for one another. Denise added this memory about her father's loyalty to Nestlé: "Even when he was sick, Dad went to work. One day, he overslept, and that never happened. The company called our house, and my mother was shaking him, 'John! John! Get up! You overslept! Oh my God!' One day in forty years, and they were both frantic."

Thousands of Nestlé workers and family members would have understood the panic in the Borek home that morning. After all, being loyal to a job and one's coworkers was a reflection of the company's motto. I found it printed in a Nestlé handbook from the 1950s: "Where reigns the family spirit, there reigns happiness. Dedicate yourself to that disposition."

Evidence of Nestlé commitment to family values and workplace pride can be found in all eras at the plant. In 1928, in an effort to create a welcoming work environment, management launched a "U-Name-It" contest for its new company newsletter. The winning entry was the *Chocolatier Echo*, and my dictionary's definition of *chocolatier* affirmed that it was the perfect name: "A maker or seller of chocolate candies" and "a person who is skilled in chocolate business and makes it their life work." As workers read each issue of their *Chocolatier Echo*, whether on break from unloading bags of beans or sweeping up leftover chocolate pieces, they saw themselves as part of that chocolatier family.

The *Echo* was in print for decades. In the 1940s, factory manager C.W. Hill used it to spell out his company goals from bottom to top:

> *The entire plant* [should be] *a clean, healthful and safe place to work. Employees should…take an interest and pleasure in their work,* [be] *industrious and stand well in their community. Foremen should strive to assist these high type workers by representing the management to* [them], *be fair, lead and inspire workers. Management must inspire to build an effective organization of executives and workmen, all working together in good spirit of endeavor and teamwork.*

Along with Manager Hill's lofty goals, the *Echo* reported on more down-to-earth matters for the Nestlé family: an announcement of the formation of a Foremen's Club, which would strive "for friendship and to encourage support of one another." There were also notices of building lots for sale near the plant for those wanting to live close to work, cost-effective options for life insurance and a thank-you for those who had "contributed money and labor to planting flowers and shrubs at the plant."

The *Chocolatier Echo* was succeeded by the corporate office's *Nestlé News*. That publication included a section called Personalities in the News and covered family-friendly information such as employees' fishing trips, Red Cross blood drives, Boy Scout events and marriages of employees. The magazine was distributed to all U.S. Nestlé factory workers, but its publishers still paid attention to the finer details. When Fulton employee Sidney George received his November 1961 issue, which featured him in the Personalities section, it was accompanied by a congratulatory letter from the *Nestlé News* editor.

IN SICKNESS AND IN HEALTH

Sometimes, Nestlé's family atmosphere provided an environment where new families could form. Like many, Sandy Traficante has a long list of relatives who once worked at the Fulton factory, including a brother, a sister-in-law, several cousins and her stepfather. But it was Sandy's story about her mother and father, Dorothy and William Crandall, that showed me, in simple terms, how new families were born in the workplace: "During the 1948 strike, both of my parents were working at the plant. My father was salaried and my mother was hourly, and he was breaking through the picket line to go to work. That's how they met."

Cindy McCormick has another story about people finding love at the Fulton Chocolate Works. But, as Cindy explained, that love wasn't realized until she'd been through many struggles and challenges:

> Getting that Nestlé job was a real game changer in my life. Until that time I'd had many jobs, but I was living in a very abusive first marriage, and I always ended up quitting jobs at my ex-husband's insistence. When I got to Nestlé, not only did I find a great paying job and benefits, I'd gained oodles of friends, a support group who saw me through a terrible end, but led me to a beautiful future! I met my second husband, Ed McCormick, at Nestlé. He was my supervisor and my angel.

Cindy went on to explain how the plant managed to bring a community, families and individuals together:

> We fought and worked hard, but we were such a proud group of lives intermingled. Things weren't always perfect, but what family is. Most of all, working at Nestlé saved my life and my children. Without that place and those people, I wouldn't have had the money and loving support to escape an abusive marriage and find true love.

Kathy (Putnam) Gallagher echoed Sandy's thoughts about Nestlé's family environment:

> I worked there for nine years. I was in my late twenties and thirties back then, and it was a great place to work. There was a group of us that started at the same time and we all hung out together. We went to happy hours together, some of us married each other and we even shared having our babies at the same time.

Of course, with so many people working together in one plant, knowing who was married to who and which family was connected to which could be a problem. When he first went to work at Nestlé, Mike Malash made a negative comment to a coworker about somebody who was bugging him. Mike was shocked when the woman said, "Hey, that's my mother you're talking about."

As it says in the vows of marriage, the family-like environment created at the plant meant workers were there for their coworkers in good times and bad. Employee Gary Frost remembered this story he heard from his grandfather, who was also employed at the factory: "A Nestlé worker's family home got burned in a fire, and the company fronted them the money they needed to rebuild. Nestlé did this without even thinking about it."

There were other marriage-like vows, including "in sickness and in health." June Swarthort Puffer told me this story about her father-in-law, Carrold Puffer, who went to work in Nestlé's Wrapping Department during the 1940s. Prior to landing a job at the Fulton plant, Carrold had worked in northern New York talc mines, and in the late 1950s and early '60s, he was diagnosed with silicosis of the lungs, attributed to his work in the mines.

June explained:

> As his illness progressed, he still went to work each day. He'd be so exhausted he would have to sit at his machine, and after a while, he became so weak he was not able to do his job. His "girls" on the line loved him and decided to take care of him. They loaded the machine and did any maintaining that needed to be done. Carrold was so ill he never really realized what was going on. Until the day he could no longer work, the girls did his job so he was able to get paid. And after he passed, some of the workers would check on the wife and children he had left behind.

Nestlé was there for the good things in a family's life too. Don Nihoff described the company as "like second family. We knew each other's birthdays, anniversaries, and when our kids were born." When Kenneth Cooper reached a career milestone at the plant, in 1965, he and his coworkers saw this sign above the entrance gate as they began another day of work: "Congratulations Ken Cooper on Your 40th Anniversary."

Darci Dorval-Bowering helped me understand that the family feeling at Nestlé also extended to a worker's actual family. If Darci's father, Tom Dorval, was working the 7:00 a.m. to 3:00 p.m. shift, she used to walk to Nestlé after school, getting to the plant just about when her dad was getting

done. They'd walk home together and talk about their day. She loved the stories about her father's sense of humor. "He lived to get people laughing," Darci recalled. "Dad felt that making people laugh and acting kooky kept them up and awake on that late 11:00 p.m. to 7:00 a.m. shift. The machines in the Refining Department were very dangerous and he didn't want to take a chance of someone falling sleep."

Darci's dad wasn't afraid to let workers have fun at his own expense:

My father was bald, and right before he was fifty he bought a toupee and wore it to work. Everyone was hysterical, taking pictures and all. On his actual birthday, they hung his photos that stated: "Rogaine Wonder" or "Miracle Man Grows Hair in Fulton." But the girls who worked with Dad were also protective of him. At Christmas, he always bought my mother and us girls a piece of jewelry, but first he showed them to all the ladies at the plant. He wanted to know if he did well or if they thought he needed to get something nicer. Those women saw what we got before we did.

When Colleen O'Brien started working at the plant, she realized the lasting impact Nestlé coworkers could have on one another. Colleen's father, Don O'Brien, had worked at the plant years before Colleen got a job in its Quality Control Department. Though her father had passed away eighteen years before, she was surprised at what people said to her when she was introduced by her boss:

I extended my hand, but, before I could speak, my hand was enveloped in a warm handshake. I was greeted with a beaming smile, but not with the words I expected. Not: "It's a pleasure to meet you" or "Where did you work before?" or "How's your first day going so far?" No, the words I heard were: "You're Don's girl." Not a question, but a statement....When I met the division managers, I was to hear stories about my dad and how much he was missed.

Nestlé's family atmosphere wasn't reserved for those who had lifelong ties to the factory and Fulton. The company and its host city also welcomed out-of-towners. Here's how Muriel Allerton described her family's move to Fulton in 1963, when her husband, Joe, was transferred to Nestlé's Westreco division:

We were city people, from the New York City area, who moved around a good bit, as corporate jobs required....In those days, companies owned houses

which they rented to employees. My husband's predecessor had lived in the big white house with a porch, and it was to become our home. We loved the house—the roomiest we'd ever had. I was thrilled my husband did not have to travel by car, train and bus to his workplace every day. He could even come home for dinner and go back to the office in minutes, if he needed to.

The Allertons hadn't been in Fulton long before they began to feel welcome in their new hometown. Muriel reminisced:

Before I was unpacked, a lady arrived with a cake. Shortly thereafter, another Nestlé wife called to invite me for a tour of the community and lunch. There were many others. They became our friends....We knew the plant manager and his family, whom we saw in the grocery store and in church on Sunday morning, as well as other fellow workers at the plant. The Nestlé Company was the unifying force for all of us because we were able to support home and family on our earnings, and Nestlé workers seemed to have a deep and personal interest in their jobs.

Both Muriel and Joe Allerton became true Fultonians through their community-minded spirits. Muriel sat on various boards and committees and served a term as the city's mayor. Joe offered his engineering background when one of Fulton's favorite recreational sites, Lake Neatahwanta, became an environmental concern. In the 1980s, the once pristine body of water was determined to be unsafe for the public, and Joe helped found a committee to study Neatahwanta's problems. Fultonian Tim Carroll also served on that committee, and he noted that a 1991 feasibility study for the lake made special mention of Allerton's contributions: "It states, 'The project was administered locally by the Lake Neatahwanta Reclamation Committee under the dedicated, tireless leadership of Joseph Allerton, co-chairman, who assisted with monitoring.' I've read a lot of these kinds of studies, and rarely do you see an acknowledgement like that."

As this book goes to print, efforts to revive Neatahwanta continue, in hopes that someday the waters will again be clean enough to swim, fish and recreate in. All of this, in part, was inspired by Joe Allerton, who found his way to Fulton and Nestlé, became part of both the plant's and the community's family and then found a way to care for it like one would do for a relative in need.

Today, as many former workers look back on their time with Nestlé, fifteen years after the plant's closing, that unique blend of work and family

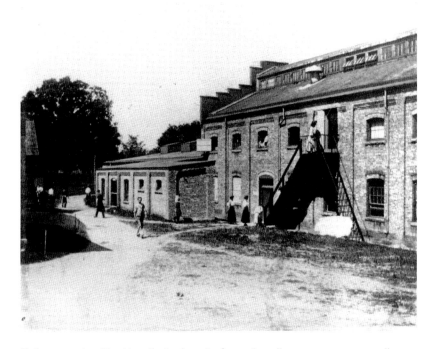

Going to work at Nestlé, as far back as the factory's earliest years, meant spending time with your company-wide family. *Fulton Nestlé archives.*

is foremost on their minds. For years after the factory stopped producing chocolate, workers held regular get-togethers at places like Recreation Park, Mimi's Diner and Muskies Bar & Grill. Those became less frequent, as people moved on with their lives and sometimes moved out of the area. But memories of family never completely fade away. One poignant reminder of Nestlé's strong family ties can regularly be found in local newspapers. More days than not, the obituary page will include a Nestlé worker. The recently deceased's loved ones often see fit to add this brief, but important statement: "Worked many years for Nestlé."

With just a few words, Jim Schreck was able to express the importance of Nestlé's family atmosphere:

> *Over the years, you work with a lot of people, and you end up working alongside some of them eight hours a day, day after day. The real test of whether you enjoy those people is this: At the end of the workday, if there's a social activity and you still enjoy being with them, that's family. And that's what I most remember about Nestlé.*

12

THE LAST CHOCOLATE BAR

Most Fultonians weren't surprised when, in 2002, the announcement came from Nestlé Corporate offices that its first U.S. plant would be closing. For years, if not decades, many of those employed at the factory were aware of changes the company had been making. Telltale signs of this shift in focus came as early as 1973, with a Nestlé business report titled "Progress in the Second Century." Featured in the report were photos of the company's newest plants, all of them streamlined and modern, looking nothing at all like the Fulton factory's brick structures. The report included a double-paged photo collage featuring 102 food products that were owned by the Nestlé Company, including coffees, teas, specialty foods, cheeses, domestic and imported wines, bottled spring water and, yes, chocolate. But one had to look closely at the photo to find products with the Nestlé name; there were only eighteen, and just a handful of them were chocolate-related and made in Fulton.[*]

Nestlé's decision to diversify its product line resulted in buyouts of several companies, and as part of those acquisitions, managerial-level staff were shifted to various plants. Some ended up at the Fulton factory, despite the fact that those new bosses knew little about chocolate or chocolate-making.

[*] Nestlé's shift away from chocolate and candy products continued, and in January 2018, the company took a final step by selling its U.S. confectionery business to an Italian chocolate and candy maker. Though its 2016 U.S. business report showed a healthy $900 million in confectionary sales, that only represented 3 percent of the company's domestic transactions. Today, Nestlé's only remaining chocolate product is its ever-popular Toll House Morsels.

One longtime Fulton Nestlé employee, who preferred not to be identified, explained the change in management as the factory headed toward closing:

I had to run trials over and over as [the new managers] *tried to change things. There was a test to figure out how to improve the appearance of morsels, which one new manager said looked "scuffed up." So I ran them special, hand-carried them to packaging and shipped them off, but by the time they'd ridden in a railcar across the country, they looked scuffed up anyway. Anytime you'd get a new manager or a new quality-control manager, you'd have to do those trials over again.*

The new companies Nestlé acquired also opened up opportunities for changes in where chocolate was made. Throughout much of the 1900s, the company's biggest candy manufacturer remained its Fulton plant, with a few smaller Nestlé factories contributing to its total output. But when the company added candy bar brands like Illinois-based Butterfinger and Baby Ruth, it started to spread production among all its factories. That may have made financial sense, but consumers started noticing a difference in their favorite candy bars.

"When they started making chocolate at the Nestlé plant in Burlington, Wisconsin, even though they used the same formula, it was made in a different factory," remarked Angelo Caltabiano, who worked in the Fulton labs. "We did tests of their product and it just didn't taste the same. Chocolate is funny—the flavor varies depending on the equipment being used and temperatures inside and outside the plant. Burlington was a more modern facility, but it didn't make better chocolate."

The taste of one Nestlé chocolate bar in particular experienced a major change when its production was moved out of the United States. As part of the Nestlé Company's worldwide expansion, in the 1960s, it built a factory in Caçapava, Brazil. By the 1990s, when Nestlé Corporate was refiguring where its products would be made, the Caçapava factory had a production line sitting idle, and the decision was made to fill that void by moving the Crunch Bar production from Fulton to the South American country. However, two vital components of the famous candy bar did not make the trip to Brazil.

First, to avoid the expense of shipping fresh milk or maintaining dairy farms in Brazil, the Caçapava factory manufactured its version of the Crunch Bar with powdered milk. Second, the all-important ingredient of rice was added to the chocolate mixture, not in its natural intact form, but as a composite made off-site. Problems with the bar's production arose; most

importantly, a Crunch Bar that didn't have its signature crunch. Shortly after production started, Nestlé reversed its decision and sent the Crunch Bar back to the United States—not to its original home in Fulton, but to its Bloomington, Illinois plant.

The shift in where Nestlé made its chocolate had a major impact on production practices at the Fulton factory. Charlie Cieszeski, who remained a Fultonian after his father retired as plant manager, made this observation:

> [When I grew up] *in the '70s, Fulton made Nestlé Quik, Strawberry Quik, Nestea, Crunch Bar, Milk Chocolate, Nestlé Almonds and all the coatings and special products. Little by little, they eliminated the Beverage Department, and then the Almond Bars weren't made here. Though Nestlé acquired brands like Butterfinger and Baby Ruth, those candy bars were never made in Fulton. They said it was because we didn't have the right machines and retooling to make them here. So the handwriting was on the wall for about fifteen years before they closed. Fulton wasn't part of those really successful new candy bars.*

It was difficult for some chocolate workers to understand why their corporate offices were making those cost-saving changes, but through his work in Fulton Nestlé's Accounting Department, Jim Schreck got to see some of what was driving the top management's new strategies. Here's an example from Jim:

> *If all three U.S. Nestlé plants were running a certain product, but none were doing so at 100 percent capacity, Corporate took a product away from one plant and put it in another. That plant would then be running nearer to capacity, and that's what you want to do as a plant. You don't make any money when machines run idle. You want them to be running around the clock, if possible.*

Decisions on where Nestlé could most efficiently make chocolate were based on a number of feasibility studies conducted in the 1980s and '90s. One of the studies' outcomes identified the costs associated with a multi-floor factory operation like Fulton's. In contrast, those new plants Nestlé featured in its 1972 progress report were of a single-floor design, where raw materials could be turned into finished products more efficiently. Like many established factories transitioning to a modern industrial world, Fulton's multi-building, multi-floor design attempted to remain competitive

with Nestlé's more streamlined plants. However, the steps in how Fulton made chocolate didn't meet the company's proficiency standards, as Dick Atkins pointed out: "In Fulton, we were shipping ingredients all over the plant. There was only one pipeline for chocolate going over to Building 30; everything else was moved by truck. Even in 1995, with our new building, it wasn't cost efficient enough for Nestlé Corporate."

There were other financial concerns that company officials had to consider. Standard expenses such as lights and heat for Fulton's dozens of buildings wouldn't be reduced just because the factory was employing fewer people or running updated production practices—neither would taxes, which Ron Woodward brought up when he and I met to discuss the closing of the plant. Ron, who had worked at Nestlé and then served as Fulton's mayor, identified some of the financial realities for an upstate New York factory:

> *Two of our city's oldest industries, Nestlé and Birds Eye, were both here for over one hundred years and both ended up moving to Wisconsin. Without any* [incentives or] *deals, the utility power in Wisconsin is 40 percent cheaper than it is in New York. Fulton is not the only New York community that has suffered from loss of industry: Volney lost Miller and Owens-Illinois; in Oswego, Hammermill is gone; in Minetto, the Shade Company; and in Syracuse, New Process Gear closed. They all left New York.*

THE NOVA INITIATIVE

Despite the reality of the Fulton plant's physical and financial challenges, Corporate Nestlé did not just give up on its first U.S. plant, which, well into the 1990s, continued to be the largest chocolate-making facility in North America. Those feasibility studies Nestlé conducted resulted in one more company-wide change, which it put into practice through an initiative called NOVA. Though NOVA stood for "Nestlé Organizational Value Analysis," the name also had symbolic meaning, as Dick Atkins, who was involved in its changes at the Fulton plant, explained: "The company used a star to represent the study results, and a nova is when a star's brilliance collapses in on itself. Nestlé was this huge company in operation, and its goal was to shrink down, to reduce its size and expense."

A March 1988 *Palladium-Times* article laid out NOVA's ambitious goals:

> *The Fulton plant was one of seven Nestlé facilities to undergo a bottom-up review of all departments to determine where costs could be cut. The purpose of the six-month study was to make Nestlé more competitive in the chocolate market.* [To initiate these changes, the company has] *hired a new plant manager and announced that a $40 million cogeneration facility will be constructed behind the chocolate plant.*

In addition to NOVA, management at the Fulton Nestlé plant implemented a worker training program called High Performance Work System (HPWS). It took several years to incorporate HPWS, but when Building 95 began operating, its highly automated system and smaller number of workers fit nicely into the new work regime. One of the major changes HPWS initiated was to replace supervisors and foremen with a team-style approach. Team leaders, chosen from the workers in each department, were offered communication and community-building skills training. The hope was that the team atmosphere would encourage all workers to be invested in the company's success.

Like any new program attempting to overhaul how an organization conducts business, NOVA and HPWS had their share of challenges and success. Jim Schreck explained some of the more positive results he observed with the new program:

> *Employees and managers would brainstorm how to improve the operation and eliminate unnecessary costs. It wasn't all about cutting jobs; there were waste streams within the operation that hourly employees knew about. In fact, they knew the operation better than anyone else in the plant and some of their ideas were implemented into the factory's protocol.*

Those kind of good business decisions showed that NOVA and HPWS had value, but Fulton Nestlé personnel had a hard time adjusting to such a radically new worker chain of command. Brian Kitney recalled:

> *The whole dynamic of management changed when it went from a foreman to team decisions.* [They were expecting] *someone who'd been on the job for twenty years or more to take a leadership role. Those workers never had to do that before; they were used to taking their problems to a supervisor, who took care of them. But the company's new philosophy was, "Don't*

*park your brains at the door. We want you to think for yourself," and it was
a hard adjustment.*

Others agreed with Brian, with one worker stating:

*We had done something one way all our life and then were asked to make a
big change. If the company had started with a "green field," a brand new
crew who learned this new operation from scratch, it would have been fine.
But when you start with a "brown field," people who'd been working a long
time, it was a different story.*

One other procedural change in particular did not go over well with
Fulton factory employees. It was a companywide policy instituted after
workers at another Nestlé plant were involved in a case of embezzlement.
Corporate officials wanted to send a strong signal that those types of
illegal transactions would not be tolerated. In order to put a stop to them,
Nestlé urged anyone noticing improper behavior to report it anonymously
via an 800 number. The Fulton plant's union took offense to it, calling it
"1-800-SNITCH," and the policy was short-lived.

New management techniques and cost-saving plans at Nestlé could have
been interpreted as either positive or negative, depending on how you
looked at them. But there was one factor in the NOVA announcement that
could only be seen one way by its employees: some of them were going to
lose their jobs. The *Palladium-Times* reported that "212 salaried employees
were notified in late February 1988 that their jobs would be permanently
eliminated." (This *Palladium-Times* quote is misleading. My research indicates
there were indeed 212 salaried positions at the time of NOVA's proposed
changes, but the company would not have been able to cut all those jobs
and continue operating the plant. Instead, I believe all salaried workers were
told their jobs were being evaluated and that some positions would be cut.)
Dick Atkins, the Fulton plant's division manager responsible for instituting
NOVA's cost-saving changes sent down from corporate offices, remembered
the challenges he had:

*We were told to cut how we operated by 40 percent while still meeting
all production requirements. That meant we needed to rethink things so
the plant could run more efficiently. So we looked at everything: how
many steps it took for a person to do a certain task, or making sure that
when forklifts brought a pallet of raw materials from the warehouse, it*

carried a full load back on the return trip. But how could I reduce the cost 40 percent. I sat with the Corporate VP of manufacturing and said, "I got it down to about 35 percent." And to tell you the preciseness and seriousness of the company, he said, "Well, Dick, if you can't do it, we'll find somebody who can."

NOVA was all about efficiency, and part of that meant reducing our number of employees. There were salaried and hourly reductions in my area. Long-term employees were given a severance package, and early retirements were offered, but at a reduced benefit. I had to let people go who had thirty or forty years with the company, and that was hard.

Nestlé's decision to lay off a significant number of people confused workers and the Fulton community, especially since the *Palladium-Times* article also mentioned Corporate's plan to build a cogeneration facility slated to "provide steam for the chocolate manufacturer." The projected start-up target date was "late 1989, and between 10 and 40 people will be hired to build the 100x150-foot facility." (The actual startup date was 1991.) With layoffs and an unpopular method of supervision instituted on one side and a new energy-producing facility and state-of-the-art Building 95 on the other, Fultonians were cautiously hopeful that Nestlé would be heading into its second century in their city.

CELEBRATING ONE HUNDRED YEARS

In an effort to shift attention away from persistent rumors that the plant would close, Nestlé focused on the more positive news of its upcoming 100th year of operation in Fulton. In 2000, a contest was held to come up with a new slogan to symbolize the many accomplishments of the Fulton factory workers. Sally Parkhurst was one of the people who submitted a phrase to the contest, and when I asked her how she came up with her entry, she told me she'd grown up with inspirational words:

My grandmother Rolene Kenyon Ensworth was always saying things like, "Many hands make light work," and "What you don't have to laugh over, you don't have to cry over." I heard those sayings all my life, and so putting words together to make a meaningful slogan was something I thought I could do.

100 *Years of Making Life Just A Little "Sweeter"*

Nestlé adopted this slogan to celebrate its first U.S. plant's century in Fulton. *Fulton Nestlé archives.*

When Sally saw the contest rules posted on a bulletin board at work, she noted that it had to be shorter than ten words. On her way to work one day, this phrase came to her: 100 Years of Making Life Just a Little Bit Sweeter, which was one word too many for the slogan rules. "I played around with it some more, took out the word 'Bit,' and submitted it."

Sally worked the night shift, and when she got home the next morning, she told her husband, Ed, she thought she had the winning slogan. "He thought it was too easy, too simple, and I kind of lost my confidence."

But Sally needn't have worried. About a week later, she got a call from Nestlé that her slogan had indeed been selected. Sally won fifty dollars for her entry, and by 2002, as the Fulton Nestlé plant crossed the century mark, "100 Years of Making Life Just a Little Sweeter" could be found on everything from candy bar labels to banners hanging in several locations of the factory.

The future was looking pretty bright for Nestlé and the city of Fulton. Eight months later, though, that brightness made a quick fade.

THE ANNOUNCEMENT

In October 2002, every newspaper in Central New York ran a headline that, though many had expected it, still hit like a crushing defeat: Nestlé Corporate was closing its Fulton plant. The papers reported that a team of twenty company-led technicians, engineers, supply specialists and financial planners had spent years analyzing the factory and had considered several options for its future, including completely revamping the plant or selling it intact, with a new company continuing Fulton's chocolate production. A third option, moving all production lines to other Nestlé plants and closing Fulton, ultimately became corporate's

plan, with officials stating their decision was heavily influenced by one critical factor: the central location of Nestlé's Midwest plants.

To explain the geographic gap between Fulton and Nestlé's other plants, newspaper reports included a review of all the company's U.S. factories in 2002. Aside from Fulton, there was Burlington, Wisconsin, which opened in 1966 and employed 508 workers; St. Louis, Missouri, with three plants that opened in 1955, '69 and '93 and had a combined total of 521 employees; and three Illinois plants: Bloomington, operating since 1967 with a current roster of 516 workers; Franklin Park, opened in 1966 and employing 735; and Itasca, also known as the Willy Wonka factory, which opened in 1974 and had 321 workers.

You could see Nestlé Corporate's logic about location by looking at a U.S. map, but after reviewing each plant's stats, I noticed a convincing second reason for the decision to close down Fulton: the first U.S. factory was more than fifty years older than Nestlé's other plants.

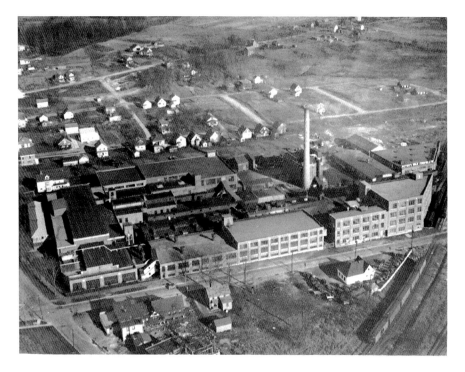

When Nestlé Corporate officials made the decision to close their Fulton plant, many of the buildings on the twenty-four-acre campus were nearly a century old. *Fulton Nestlé archives.*

Dennis Collins has no problem remembering the day the company announced it would be closing. It fell on the twenty-ninth anniversary of his working for Nestlé: "October 22, 2002," Dennis stated. "They called everyone into the cafeteria and made the announcement that they'd be closing in the spring of 2003." Dennis also remembered seeing a clue of the impending announcement when he showed up for work on the twenty-second. Outside the entryway of the main doors, the Nestlé flag was flying upside down.

The shockwave reverberated through the city of Fulton. It wasn't the first time the once thriving industrial town had been dealt such news. In 1952, one of Fulton's most successful factories, the Woolen Mill, closed its doors, leaving 1,500 out of work. Other smaller companies followed. Then, in December 1993, Fultonians learned that Miller Brewery, just outside the city limits, would be moving production elsewhere. Still, as devastating as that loss was, people didn't feel it like they felt the demise of Nestlé. Miller had been a newcomer to Fulton, having been in operation just seventeen years when it closed, and a good percentage of its workforce lived in the Syracuse area. But not Nestlé.

According to its union records, more than 80 percent of Nestlé employees called Fulton home. Many who'd lived their whole life with the factory in operation thought of its closing in this way: Nestlé *was* Fulton. One city resident underscored that belief with a poignant analogy: "If you were a Fultonian, it was like having your arm cut off." At the companywide meeting in the plant's cafeteria to announce the closing, Nestlé employees watched longtime coworkers put their heads down and weep.

In the months following the announcement, there were passionate discussions about the right and wrong of Nestlé Corporate's decision. An October 24, 2002 editorial in the *Post-Standard* placed the blame directly on the company: "It was a business decision…an all-purpose excuse to devastate the lives of 467 workers and their families. It was a decision made by executives 3,000 miles away in [the company's headquarters in] Glendale, California." But those familiar with the realities of executive business decisions found another way to look at the factory's closing. Nestlé plant manager Charles Cieszeski's son noted that his father and their family "grieved the loss as did every other family. There was a lot of real bitterness toward Nestlé in town, but Dad didn't share it. He said that Nestlé had provided great jobs and a living for people here for over one hundred years."

As the actual closing of the plant neared, the *Post-Standard* published a series of articles that featured people affected by the shutdown. Lois Groat, a

thirty-year Nestlé employee, told the reporter that she defined herself by her job: "When you meet somebody, you say the first thing that comes to your mind: 'I work at Nestlé. I make chocolate.' You become the job. I tell you, when these jobs end, some people will walk out that door and not know who they are, because for all these years they've been Nestlé employees."

Darci Dorval-Bowering, who works in the Fulton schools, commented on the impact this had on children of Nestlé workers:

A lot of people working there were husband-and-wife teams, and it was devastating. The kids didn't know what was going on for their parents. They couldn't automatically do everything they wanted to do anymore. If you were into sports, it was down to, if you were lucky, choosing one sport to participate in.

While workers were figuring out what life would be like beyond Nestlé, a ripple effect was taking place in the surrounding communities. Christopher Sherwood's father drove for Cloverleaf Transportation, a local trucking company that contracted with Nestlé. "Cloverleaf endured the Miller Brewery closing and a few others," Christopher explained. "But the closing of Nestlé was the kiss of death. Cloverleaf went out of business shortly after the chocolate plant closed."

Retail businesses felt the impact of fewer payroll checks being cashed at local banks. Not only were people shopping and purchasing less, but they also noticed something missing in local stores. During the decades that chocolate was made in Fulton, plenty of shelf space had been devoted to Nestlé products. However, after the company made the decision to close down its Fulton factory, many businesses refused to carry Nestlé products. For a lot of lifelong chocolate consumers, Nestlé was no longer welcome in their homes.

Remarkably, the bitterness felt by many did not affect the factory's final months of production. As Dave Miner noted, "Even after they told us we were closing, we manufactured product for eight more months. And everybody worked hard during that time. We all did our jobs and nobody gave them any problems." Nestlé Corporate acknowledged that commendable work ethic in a newspaper article covering the closing. Corporate spokesperson Tricia Bowles mentioned how employees had "proven their dedication by working all-out," putting in lots of overtime (some workers accumulated eighty-hour weeks) in the final months. "The heightened production," Bowles pointed out, "was to build inventory while Fulton production moved to other, newer plants."

While toiling through overtime shifts in their final months, Nestlé employees found time to stop in at the plant's favorite destination, the Company Store. Workers remembered how, in the closing months, items flew off the store's shelves—and then the shelves themselves were up for sale, along with file cabinets and other office equipment. Workers were offered a two-gallon paper sack stuffed with chocolate candy for a dollar. Denise Borek-Morganti remembered that her mom made several trips to the Company Store "so we had morsels in our refrigerator for months after they officially closed. It was a sad day when I took that last bag of morsels out of the fridge."

ONE FINAL BATCH OF CHOCOLATE

On the evening of Thursday, April 24, 2003, after one hundred years of Nestlé's operation in Fulton, the smell of chocolate rose one last time from the plant's Roasting Department. A final 13,200-pound shot of raw cocoa beans was sent from the Bean Room to Roasting, and the familiar aroma traveled through the city. People stopped a moment and took notice. Longtime Nestlé employee Karen Stafford commented to a reporter: "I said to the girls I was working with, 'Breathe deeply, kids, because this is the last time we're going to smell this.'"

Friday, April 25, the last day of production, rain clouds had moved in, but the alluring smell of chocolate did not greet those who drove or walked through town. As the final mixture moved its way through the chocolate-making steps, one product had the distinction of being the last candy made at the Fulton plant: Toll House Morsels. The following week, employees cleaned out departments, wiped down machines that had worked around the clock for decades and swept the last chocolate shavings off the floor. Word spread throughout the plant that on their last day of employment, May 2, workers should show up dressed in black.

The final workday began with some mystery. As company managers handed out a memory book with employee pictures and a history of the Fulton plant, workers gossiped about what had happened to one of the factory's signs. The ten-foot-wide wooden structure, carved as a Nestlé chocolate bar, had drawn attention to the factory for almost twenty years. Late Thursday night, union officials noticed the sign was gone, its five-inch supports cut with what looked like a chainsaw. Just as mysteriously, the sign

showed up at the union office on Friday morning, with no one claiming responsibility for its disappearance.

Some workers planned to start their last workday eating breakfast together at nearby Muskie's Grill. Others gathered outside the revolving doors of the factory's main entrance; among them was Sandy Traficante. Sandy was working elsewhere at the time but wanted to be there with her Nestlé family: "I told my boss that I was going over to Nestlé, and he didn't have a problem with it. I couldn't go into the plant, but I was in the lobby, watching all the people coming down and saying goodbye."

One of those workers exiting the plant for the last time was Lee McMillen, a machine operator at the plant, who told a news reporter: "For 34 years, I've gotten up every Monday to come into work. I think [next Monday] is when it's going to hit me that the plant is really closed." With many of Lee's friends nodding in agreement, he predicted what the next few days were going to be like: "Today, I'm going to get drunk. I'm going to get drunk Saturday, too. On Sunday, I'll sober up, and on Monday I'll get a new start, I guess." Above the exiting workers' heads, ominous dark clouds produced rain; lightning and thunder added to the gloom. "It's a perfect day for a funeral," one worker said.

The next day, the Fulton Elks Club had planned a big party in association with its annual May Day celebration. Nestlé workers were calling it "The Last Hurrah," especially since more than half of the Elks Club members were Nestlé employees. But Fultonians didn't feel there was much to celebrate. Attendance was low, and many amusement rides spent the day spinning around with no one in their seats. "One boy won a box of thirty-six white-chocolate candy bars in a raffle," said Pam Cordone, lead knight of the Elks Club. "When he saw it was Nestlé candy, he gave it back."

LIFE AFTER NESTLÉ

Most of the 467 workers still employed at Nestlé on the last day went on to other jobs, unemployment lines or retirement. But a few people stayed on. There was a more thorough cleanup and fresh coats of paint in anticipation of the hoped-for sale of the plant. Two months after the site's closing, a *Post-Standard* article noted that "a skeleton crew will stay on to continue winding down systems and dismantle equipment, some of which will be shipped to the plant in Burlington, Wisconsin. The rest will be auctioned off in September."

Dave Miner showed me a copy of the auction's full-color brochure, which promoted its items as from a "Chocolate Bar Manufacturing Plant—300 Million Pounds Per Year Plant Capacity, Cocoa and Chocolate Processing Systems, and Packaging Machinery." The brochure actually looked more like a catalogue. Totaling 55 pages, the 1,845 items to be auctioned off were assigned code numbers to make bidding easy. Featured among the equipment for sale were 34 of the company's famous conches and 69 of its agitating Jumbo tanks. There were Caterpillar front-end loaders, forklifts, lathes and drill presses and kitchen equipment from refrigeration units to dicers. Some machinery, I noted, had been installed as recently as 2001.

On the first day of the two-day auction, two hundred chairs were set up in front of a six-by-eight-foot television monitor in the plant's warehouse. Those in attendance were executives and managers from chocolate-making and other food industries. Larger restaurants sent buyers to review the items. And sprinkled among the crowd were former Nestlé workers who wanted one more look at the machines that were so much a part of their careers.

The Nestlé employees who were asked to stay on at the closed plant worked a few more years. "Corporate wanted our presence there," said Brian Kitney, one of the final staff at the factory. Brian finished up his forty-three years with the company helping to completely shut the plant down. "The deal was anything that said Nestlé on it was to be removed. Next, we went through all the offices and cleaned them out. It was disheartening. I knew that plant probably as well as anyone else—especially Building 30, where I spent a lifetime." Brian described what he saw when he entered the once-busy Building 30:

When they first closed the plant down, they sealed off the building by welding the door shut to the overhead bridge. When we went to clean it out, we opened the door, and it was a disgrace. There were mop tanks with all their water gone and the mops still standing in them. There were places where chocolate was on the floor, with its cocoa butter raised up in white. The moulding room, foreman's office, and everything—papers pulled out of files, papers everywhere. It was like someone had yelled fire and everyone just ran out. It was hard for me to see, and I'm sure a lot of people who worked there would have felt the same. You gave so much of your life—more time than you spent at home, and then to have it shut down like that.

Denise Borek-Morganti recalled how her father reacted when he heard the news of the plant closing. "He didn't talk about it a lot, but we saw a change come over his face. He'd get upset about companies moving overseas. When all these factories shut down, he said that would be the end of Fulton. He wondered, 'What are people going to do now?'"

Indeed, every Nestlé worker was faced with an uncertain future. In the months between the announcement and the plant's closing, a few employees were fortunate to have reached retirement age with their benefits intact. But many others were in a different situation. At the plant's official shutdown date, the average age of a Nestlé worker was fifty-two—close, but not close enough to retire. Most of them had been making chocolate for over half their lives—some for a lot longer. Where would they be able to put those skills to work?

Unemployment benefits helped as hundreds of people looked for their next jobs. To assist in their search, the company's corporate offices offered financial support in the form of a severance package. In order to receive this compensation, which was based on the number of years worked and job position(s), Nestlé employees had to committ to remain on the job until the final day of the plant's operation.

Some workers were offered the chance to transfer to another Nestlé company. Angelo Caltabiano, age fifty-three when the plant closed, talked about the decision-making process when considering a move out of the Fulton area: "I was offered a transfer to the Burlington plant, and I evaluated all the considerations: finances, my age, etc. For a while, my wife thought I should go and do a few more years until I retired. Maybe if I was younger—but I decided not to go."

Once he chose to stay in the Fulton area, Angelo began searching for employment locally, using another assistance program Nestlé provided its former workers: the Central New York Worker Reemployment Center of Syracuse. "I got some help with their consultants," Angelo said. "They helped me write my résumé and evaluate the next steps." A second local program, the County of Oswego's Department of Employment and Training, also advised displaced workers. Among that office's staff was Cindy Tompkins, daughter of plant manager Charles Cieszeski, who noted: "When Nestlé closed, our office became eligible for federal and state grants. Nestlé kicked in money, too, and we were able to open an office in downtown Fulton with a staff of ten."

Longtime Nestlé workers eventually found paths to new careers. Mike Malash and Charles Grower, two employees who were in their mid-fifties

when Nestlé closed, ended up starting a computer business together. Dave Wolfersberger, fifty-two years old when the chocolate plant shut down, used his severance package and some unemployment benefits to tide his family over while he went back to school to train for and find a job in heating and cooling. Angelo Caltabiano started taking civil service tests, and shortly after the plant closed, he was hired by a local school district's payroll department. He admits that there was some luck involved: "The woman who interviewed me noticed I had worked at Nestlé, and she mentioned that her mother also worked there—and I knew who her mother was."

About a year after the plant closed, at age fifty-five, Dave Miner found a new career with the Fulton School District, starting as a job coach. "I would take students into the workforce and help them acclimate to places like car dealerships, supermarkets and hardware stores." Dave reported for work at the school district's main office, where he noticed there wasn't any formal security system in place. After years of being in charge of Nestlé's Service Department, he mentioned this omission to the school superintendent. "He asked me to design a plan for security, and we started hiring guards," Dave explained. Miner made one more contribution to Fulton youth when he started tutoring for the school district. "I really enjoyed working with students," he noted, "and that's how I ended my working career."

School played an important role for other workers post-Nestlé. Dennis Collins was forty-eight years old when he lost his job at the factory. "Too young to retire," he said, "so I decided to go back to school. Because my job went to Brazil, I got my first two years of education paid through the Trade Readjustment Assistance, which was part of the NAFTA Act." Dennis noted that of the 467 people left at the plant when it closed, "86 of them started school that fall at Fulton's Cayuga Community College." After receiving his associate's degree in accounting, Dennis went on to earn a bachelor's degree, also in accounting, and a master's in business administration.

As part of his master's thesis, Dennis was required to complete a research project, and he decided to focus on his former workplace, applying his new business skills to a theoretical plan for its future. "I approached the project as if I took over the Nestlé plant when it closed," he explained. "I would have turned that into a museum and had a restaurant." Dennis told me that he holds onto his thesis paperwork, in case there's ever a need for it.

NEW HOPE FOR AN OLD CHOCOLATE FACTORY

After Nestlé closed, Operation Oswego County, an industrial development agency that helps communities like Fulton create new employment opportunities, began trying to sell the plant. According to a fact sheet created to promote the factory's selling points, the asking price for its entire campus was $3.5 million. The information was sent to over one thousand companies in the world that employed at least one hundred people and made chocolate as its primary or secondary product. Response was poor, with a major factor attributed to what Nestlé was well aware of: it was trying to sell a one-hundred-year-old facility that had been reconfigured numerous times in order to remain competitive in a rapidly changing food industry.

Still, less than seven months after the plant closed, the *Palladium-Times* reported a "significant development toward putting the plant and many of its employees back to work. The Oswego Industrial Development Agency (IDA) [a division of Operation Oswego County] is working out details, but so far Nestlé has agreed to extend the deadline for the IDA to complete a comprehensive environmental evaluation of the 38-acre Fulton plant."

The deadline extension was to accommodate two companies that had shown interest in the Nestlé campus. First was New York Chocolate & Confections, a company backed by a consortium of cocoa suppliers from the Ivory Coast. The group represented hundreds of cocoa bean growers (some that Nestlé had done business with in the past), much like Dairylea represented Central New York dairy farmers who provided milk for the Fulton plant. The second group interested called themselves the Fulton Chocolate Company. This was a smaller organization that planned to rent the plant's Building 95 from the Ivory Coast group and focus on creating a carbohydrate-free chocolate snack bar it was calling "Z-Carb." The two companies projected that they would be employing "up to 400 people," according to the *Palladium-Times*. A third company, a label manufacturer, had also signed on to create jobs related to the factory's reopening, though not at the Nestlé campus. All total, 600 people were projected to be back to work. The State of New York agreed to invest $1.7 million in capital grant money and as much as $31 million in Empire Zone tax breaks. Enthusiasm for renewed chocolate production was high.

The new company's candy making got off to a good start. Dave Miner was invited in for a pre-production tour and a taste of the new chocolate. Dave's thirty-plus years with Nestlé would influence his opinion: "They'd brought in some new equipment, and what they made wasn't a bad-tasting chocolate. It was nothing like Nestlé, but it was chocolate and I was impressed."

By May 2005, the Ivory Coast–based company was up and running, and chocolate was in the air again. But as wonderful as it was to have that sweet smell return, things soon turned sour. A year later, the company had fired several managers, and its workforce, which had reached seventy people, was down to less than a dozen. Dennis Collins has a theory why things didn't go well for the Ivory Coast group:

> *They tried to jump right in and compete with Nestlé and Hershey to make candy bars. Instead, they could have entered the market as a supplier of the processed cocoa beans or liquor to other companies already making chocolate. There was plenty of trained help in Fulton who knew how to do that. Then, over time, they could have slowly worked their way into the chocolate-making business.*

Making poor production decisions turned out to be the least of the Ivory Coast group's troubles. In October 2007, the *Post-Standard* reported that several of the group's investors accused its managers of misusing millions of dollars. Though the managers denied it, they couldn't ignore the fact that the new company's utility bills weren't being paid. Former Nestlé worker Wendell Howard was one of many in Fulton who had a hard time swallowing what was happening to their beloved chocolate factory: "The Ivory Coast people pulled the wool over our eyes. They had wonderful words of what they were going to do, but they took that money and misused it. It was just a cover for their money-laundering prank and it went on for more than two years."

In 2008, twenty-three people associated with the Ivory Coast consortium were facing charges of alleged embezzlement and fraud, and Fulton and its chocolate factory cut all ties to the group. A February 2009 *Post-Standard* article stated the harsh reality: "Court cases, financial troubles and foreign intrigue have kept the city's chocolate-making industry in limbo for several years." Though Fulton had not given up hope for its Nestlé property, the city was back at square one, looking for a new owner.

By 2010, those hopes were gone. There was a new plan to level the old brick buildings and clean the slate for what Fulton's future might hold. Edward Palmer, from the nearby village of Phoenix, stepped up to purchase Nestlé's main campus in a bankruptcy sale.[*] Palmer's plan was to demolish the buildings and replace them with new businesses and retail stores. People

[*] The remainder of the plant, Building 30, sold for $100,000 to Liverpool-based Spring Storage Park Inc., which planned to use it as a storage facility and U-Haul dealership.

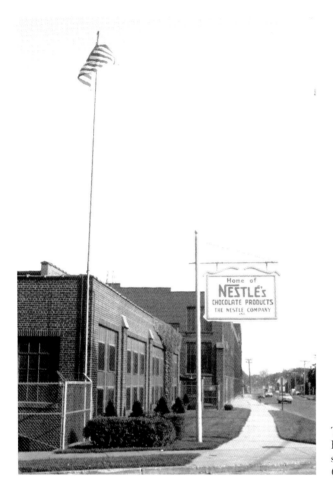

The portion of Nestlé's Fulton plant where a new supermarket now stands. *Courtesy of Lynn Ricketts.*

liked his idea, and he managed to topple some of the factory before finding himself in hot water. In 2013, a federal court convicted Palmer of violating the Clean Air Act for improperly removing asbestos insulation from old piping. With no other options, the City of Fulton regained control of the plant, and though financially strapped after decades of industrial slowdown, it vowed to complete the clearing of the site.

In November 2015, a dozen years after Nestlé closed its plant, Fulton finally got some good news. Its Common Council authorized the sale of a portion of the factory's property for an Aldi grocery store to be built at the corner of South Fourth Street and Fay Street. In early 2016, Infinity Enterprises continued the demolition of the Nestlé buildings, agreeing to do so at no charge to the city. (The company intended to make money by selling scrap steel and other building materials.) The deal was going to save

Fulton about $3 million, according to city officials, but several obstacles slowed Infinity's progress, including the removal of asbestos and creation of a suitable foundation for the Aldi store. When it determined that it would end up losing money in the plan, Infinity abandoned the project. Rowlee Construction, a Fulton-based company, took over the demolition and kept its promise to have the area ready for Aldi's start date.

During the drawn-out ending of the Nestlé plant, Fultonians were thinking about the chocolate-making legacy that would be left behind. Something should be done, people were saying, to preserve the memory of Nestlé's brightest years in our city. Mayor Ron Woodward announced a plan with this in mind. He and others proposed leaving one of the factory's original buildings in order to create a museum honoring Nestlé's time in Fulton and the workers who made the factory so successful. The city already had one item to put on display. The *Palladium-Times* mentioned it in their coverage of the demolition:

> *In late 2003, a small piece of* [Nestlé] *history had been saved. A plaque that was mounted on a wall of the now vacant plant was rescued from being thrown out for good. "Somebody called from Nestlé," said George Sprague, commander of the Oswego County Veterans of Foreign Wars. "That person said, 'We got this plaque over here and we have to get rid of it by 3:00pm.' A little piece of history would have been lost if someone hadn't been there to get it."*

For certain, it *was* an important piece of Nestlé history. The plaque that Sprague and his fellow veterans saved listed the thirty-two PCK/Nestlé workers who died while serving their country during World War II. For decades, it had hung in the factory, a poignant reminder of the strong connection between the chocolate plant and our country's efforts to win the war. Now, as the buildings began disappearing from sight, creating a permanent home for the plaque was an equally powerful reminder that the people of Fulton still deeply cared about their chocolate factory.

13

WATCHING THE BUILDINGS COME DOWN

I n April 2016, the Nestlé factory demolition took a dramatic turn. Its towering row of buildings alongside the main thoroughfare in and out of Fulton started coming down. Whether you mourned the loss of our chocolate factory or looked forward to new businesses located there, it was shocking to see. The equipment accomplishing this task—bulldozers, steam shovels, refuse trucks—looked like kid's toys among the mountains of brick, mortar and other building debris. When I took my first drive by it felt like I was looking at news footage of an inner-city neighborhood after a devastating riot.

But most surprising of all, once those front row buildings were leveled, was this unexpected sight: the eastern skyline. Suddenly, people passing the former plant as they began their day could see the morning sun rising over the city of Fulton, something no one in our lifetime had ever seen. After that first drive-by, I wrote this poem:

For years we sped by,
heading to the mall
and all points south,

until today,
when they caught our eye:
bricks heaped in piles

How Sweet It Was

After a century of driving by Fulton's Nestlé buildings, commuters found themselves with a very different view. *Syracuse.com.*

like chunks of chocolate,
breaking up something
once so sweetly whole,

crumbled mortar releasing
the sweat and dust
from generations of workers

now returned to earth,
while those of us still here
slow down our hurried lives,

noticing
an opening to the east,
the sun shining anew.

My polarized emotions about the demolished site puzzled me. At first glance, I was grieving over an urban war zone; a moment later, I felt the sun's rays warm my spirit. And I had never even spent time in the Nestlé factory. What about the people who'd spent a lifetime there? What did this new view of the eastern horizon mean to them? As I concluded each interview with former Nestlé workers, I asked this question: What was it like watching those buildings come down?

Dave Miner, who had spent over thirty years working in nearly every Nestlé department, admitted:

> *I tried to stay away as much as I could, but I was curious what they were doing. When they first started, it didn't look like much was happening, but they were tearing it down from the inside out and gutting a lot of the buildings. I knew every part of that plant, so I knew what areas are being taken down and what we just lost when they fell.*

One section of the factory familiar to city residents was the walkway over Fay Street that connected Building 30 to the rest of the plant. People had been driving underneath it for more than half a century, and when the announcement was made that it was to be torn down, they wanted to watch the sky above the Fay Street walkway reappear. Thirty-two-year employee Don Nihoff was among those who had gathered: "I pulled across the street and parked, thinking about all those nights pushing big steel tanks of broken chocolate through that catwalk."

Those witnessing the demolition who had ties to the plant's early history were reminded of their ancestors. Kathy Dann, great-granddaughter of Gustave Dentan, one of the first Swiss workers to make chocolate in Fulton, recalled the many years she and her parents lived on South First Street, just a block from the factory. Kathy had other family members who were employed at the plant, including her mom, who worked in the Cocoa Department. The building where that department operated was one of the last structures taken down, and "right up to the end," Kathy commented, "I could still look in its windows to where my mother worked."

Another family member of a Swiss founder, Ernest Fivaz's grandson Bill, hasn't lived in Fulton for years, but he called the demolition "devastating." "I have great compassion for all the families of those who worked at the Chocolate Works," Bill shared, "and I feel that a tremendous and historic tradition was taken away from this proud city."

For many, the grief of watching those buildings tumble was deeply connected to the loss of our city's distinctive chocolate smell. It wasn't just the pleasurable bonus from one of our hometown factories that was missed. People told me that being able to breathe in cocoa beans roasting gave them a sense of security. If the city of Fulton was our home, they said, Nestlé was our kitchen, and when chocolate air drifted by, we felt safe.

Generations of Fultonians associate that chocolate smell with being children and waiting for Mom or Dad to get home after a shift at Nestlé. "He would smell of chocolate," Charlie Terranova remembered about his father. "While Dad wasn't the warmest with us kids, I have a memory of when I was very young wrestling around with him and sniffing his chocolate-ness." Tanya Crowning expressed it like this: "I loved when Mom came home from work. I'd snuggle up to her and just breathe her in."

To some of those children, there wasn't anything better than that chocolate smell on their parents, and they made sure their opinion was known. Judy Hosey remembered once saying something to her mother *before* she headed off to work: "Mom would spray a dab of perfume behind her ears, and I'd

say, 'Mommy, I don't really think you need that. By the time you come home, you'll smell so sweet—like chocolate!'"

Loving that chocolate smell could sometimes get a kid in trouble—or almost in trouble. Jo Ann Butler remembered talking about Fulton's chocolate atmospheric conditions with a substitute teacher at her school:

> *She was not from the Fulton area and we were talking about the science of weather. She asked how we knew signs of weather, and I said "When it's going to rain, you can smell chocolate." The teacher didn't know what I meant, so she had to ask another teacher in the room next door. She came back and added, "…when you're in Fulton."*

In fact, if you grew up in Fulton and didn't travel a lot as a kid, you might have had a misconception about Fulton's chocolate smell, as Amy Tompkins Johnston recalled:

> *I was in college before I realized we were the only city that smelled like chocolate. It was so ingrained in me that I didn't think about it. I remember bringing college friends home with me and them saying, "It smells like chocolate," and I'd say, "Yeah, it's gonna rain." "What do you mean?" they'd ask. And then a light bulb went off: Oh, it doesn't smell like chocolate everywhere!*

It wasn't just kids who had to adjust to the idea that Fulton's air was sweetly different from other cities. Imagine moving to Fulton and not yet knowing about its aromatic conditions. When Bill and Pauline Rasbeck came to Fulton in 1981 for his job as superintendent of the city's schools, Pauline learned about the traveling Nestlé chocolate smell all on her own. A few months before they were due to move, on a muggy July day, Bill was at the school district's office and Pauline was getting their new home ready for their family. "I had the windows open," Pauline remembered, "and the most delicious smell of chocolate drifted in. I wasn't exactly sure what was going on, but after smelling it for a few hours, I called Bill at work. 'On your way home,' I told him, 'pick me up a hot fudge sundae.'"

It's unclear if losing the chocolate smell was harder on former Fultonians who'd relocated and adopted a new hometown or on those still living near the former factory site. "Being brought up in Fulton, we always had the Chocolate Works," recalled forty-three-year Nestlé employee Brian Kitney, who now lives in Binghamton, New York. "And we always smelled it. So to

come into town and not have that smell and see it torn down was rather sad." Lifelong Fulton resident, ninety-five-year-old John Procopio, feels the loss this way: "I hated to see the plant leave. After that, you never knew when it was going to rain."

WHEN A CHOCOLATE FACTORY WAS YOUR NEIGHBOR

By the time I'd finished a first draft of this book, much of the Nestlé rubble had been trucked off-site or pushed into piles. With most of the buildings down, the immensity of what once was the factory's campus became quite apparent. In a tiny portion of the northeast corner of the property, metal spikes had been driven into the ground, marking the borders for the new Aldi store. While the next chapter of Fulton's history was being constructed, people continued to share their memories of the Nestlé chapter, including what it was like to grow up in the shadow of a mammoth chocolate factory.

Steve Phillips, whose mother, Betty Phillips Mirabito, worked at Nestlé, remembered "driving with my dad to pick her up at the end of her shift. We would park our car right in front of the almost-block-long glassed-in area where everyone exited the building. We sat in anticipation, waiting for her to appear and then waving like crazy as she walked all the way down to the exit and over to our car."

When Sherry Burdick was a child, driving by Nestlé felt a little bit like magic to her: "I used to sit in the back seat of our car with my grandfather. On our trips through Fulton, he would ask my grandmother to drive by the chocolate factory so he could slap a big Nestlé candy bar on the car seat, telling me a worker must have thrown it out the window to us."

As someone who grew up in the Nestlé neighborhood, Denise Borek-Morganti has plenty of happy memories associated with the plant:

Dad worked at the loading docks of Building 30, and when he was working the 6:00 a.m. to 2:00 p.m. shift, I walked the three blocks from my house to the dock doors to bring him his lunch. He'd sit on the loading dock, which was six feet off the ground, with his legs dangling. I'd reach up and Dad would reach down and I'd hand him his lunch. I'd sit on the ground next to the dock, and we'd talk while he ate.

If Denise's dad was working the evening shift, she'd take that three-block walk to meet him at 10:00 p.m. "On my way," Denise explained, "all the men walking home would say hello and tell me Dad was on his way. Today, no one would let a little girl do that, but back then it was perfectly fine. Everyone looked out for everyone else. Those men would have protected me if I needed anything."

Jo Ann Natoli remembered many evenings that her mother drove to the plant to pick up her father, Phil Pappalardo:

> *Most families only had one car back when I was a child, so on summer days, my mom kept the car and we'd pick Dad up at 11:00 p.m. I remember all the men and women coming out of the building and going to their cars. Dad worked more than thirty-five years in the Cocoa Department, and the crew he worked with got so familiar with the cocoa-packing machine they named it Big Bertha. When Dad got in the car after work, we'd never know what kind of candy he was bringing home. It was always something different. In all my years of growing up, there was never a time when we didn't have chocolate in the house.*

Paul Cardinali lived most of his life on South Seventh Street, right off Fay Street, and recalled:

> *Nestlé was a backdrop to all my hometown memories. I have images of helping my grandfather in his garden that later was purchased and became part of a new warehouse. I remember seeing men carrying their black lunch pails on the way to work as they walked by my home. I also remember hearing a cheer from across the street as the factory noise wound down announcing the annual two-week July shutdown. And I used to have to stop playing and come home from lunch when I heard the noon whistle.*

Daryl Hayden not only has memories of the Nestlé noon whistle, but he also has it in his possession. When demolition workers were tearing buildings down, they found the whistle and knew who to contact regarding it. Since Daryl has always had a strong interest in the company's history, it made sense that he make sure nothing happened to such an important symbol of the factory. "It was a steam whistle mounded on top of the boilers," Daryl explained. "The boiler operator would pull the lever to have the whistle go off, and every Saturday at noon, from my earliest recollections, it did. You could hear that whistle all over the city."

Neighborhood kids not only had a whistle to help them tell time and an occasional chocolate bar tossed to them from a factory window, but they also learned some life lessons. Greg Meeks grew up four houses down from the plant, and he and his friends used to hang around the Building 30 trucking area, jumping off the dock. "One time, when I was about ten years old, we were playing and noticed a large box full of candy bars. I figured out that someone must have put that aside to pick up after work. My friends and I turned the box over to Nestlé, and they were very grateful. They even put an article in the newspaper about it and gave each of us candy bars for our valiant efforts."

FINAL MEMORIES FOR THE FINAL BUILDINGS

In September 2017, it was announced that the last two Nestlé buildings along the city's main street were slated to come down. The highly visible structures—Bob MacMartin noted that they were the first Nestlé buildings he'd see each morning coming into work from the south—were built in the 1930s, which meant that people had been driving just a few feet from all that history for over eighty years. Weeks before their teardown was to take place, media began warning motorists that the street alongside those buildings would be closed. Over twenty thousand cars and trucks pass the site each day, and the city felt it was too risky to keep the street open while excavation crews toppled the structures. The buzz around town was that people would gather as close to the action as possible to watch yet another part of Nestlé fall. I decided to be one of the viewers.

On a summerlike September day, I pulled into the parking lot of the medical center kitty-corner to the Nestlé campus. Already, a crowd had started to gather. The mild temperatures meant people could leave their vehicles and sit in a grassy area. I imagined that some who'd come to watch the day's demolition were former workers, and I considered politely introducing myself to ask if they wanted to share their chocolate-making memories. But I thought better of it. This was a private moment for many. Better to sit with them quietly and watch.

Four cranes got right to work, each attacking the structures from a different angle, their long-armed buckets clawing at the buildings' top floors. From the barricaded street, workers had fire hoses aimed at the buildings, spraying water to keep dust from drifting to nearby neighborhoods and debris from

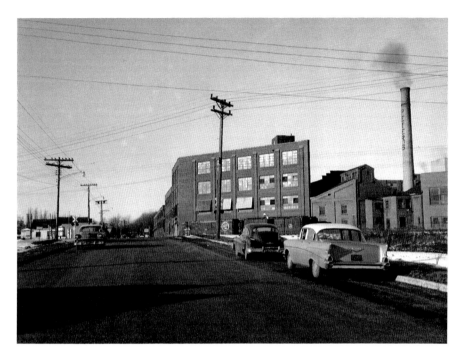

Among the last buildings demolished at the Fulton plant were those seen for decades by people driving into the city from the south. *Fulton Nestlé archives.*

rolling into people's yards and business parking lots. Trucks were hauling away what was quickly piling up. For hours, the work continued.

The next day, I returned to watch part two of the demolition. I decided to station myself at a different location, hoping to gain some new perspective on this momentous occasion. An abandoned parking lot on the corner of Fay and Seventh Streets looked like a good spot. I was the only person to pick that vantage point, and with the sound of tumbling buildings far enough away, I could hear crickets chirping, reminding me that we were at the end of one season, with another soon on its way. Most of the two buildings had been leveled by this point, and I could look through window casings of the one remaining wall to see trees starting to turn their autumn colors. The next time those trees bud, I thought, those of us driving by will see Fulton's future, not Nestlé's past.

The final memories I heard from former employees who'd witnessed the buildings' teardown focused on the coworkers of their Nestlé family. Above all else, people wanted to make sure I knew about the care and concern that was offered no matter what job you held at the factory. There was no division

between management and workers when it came to a person's well-being. I heard about the company's supportive policies when a worker's family was going through tough times. Coworkers rallied for one another; they were there for the joyful moments and for the struggles. Succinctly said, I was hearing about friendship.

Colleen O'Brien reflected:

> It wasn't the buildings that retained the history of the first Nestlé plant in the United States; it was the people of Fulton. Although the factory closed many years ago, it is still common to meet someone and, at the mention that I worked in the lab, hear: "My uncle worked in Roasting" or "Aunt Barb worked in the Company Store" or "my cousin worked in Moulding."

Dave Wolfersberger thinks of the buildings' demolition as "part of its history. It's been fifteen years [since the plant closed], and I still miss it. The biggest reason is that I worked with super people."

Sandy Traficante got to know almost every person Colleen, Dave and others remember from their era of Nestlé. Sandy's work in the Personnel Office and all the volunteer programs she helped coordinate means that today she comes in contact with many former Nestlé employees. She explained why this is sometimes difficult:

> It hurts me now if I run into somebody and I can't remember their name. But I remember the person and what we did together. In fact, last week, one of my key volunteers died, and I went to his calling hours. I sat there for an hour and a half, talking with every single person from Nestlé who came to pay their respects. We talked about the buildings being torn down and how much we missed the family feeling.

Vern Bickford mentioned the importance of his Nestlé family when he explained why seeing the buildings come down was so hard to watch: "I had a lifetime there. It wasn't the factory itself, it was the people I worked with, and that's what I miss the most. I was the oldest in my department, and the younger ones were like my kids."

Betty Hendricks noted how Nestlé "fed my family and paid the rent. When I started there, I was a single mom so I was thankful for my job and insurance. I also made a lot of friends, not to mention I had a lot of fun. Not many people can say they had fun at their job. It was hard work, but I laughed every day."

Sally Parkhurst echoed Betty's thoughts about what it meant to work at Nestlé: "I was hired as a young girl and was so excited to be working there. I had been employed before Nestlé, but they were low-paying jobs. I wasn't actually living in poverty back then, but after I started at Nestlé, I no longer had to live paycheck to paycheck."

Many people talked about the pride they had by being associated with the Nestlé family of workers. Here's one of the things Gary Frost remembered about his thirty-eight years with the factory: "Fulton Nestlé used to be the 'Can Do plant.' If the company couldn't make something work at any of their other plants, they sent the project to Fulton."

One of the families who also mentioned that pride was the Cieszeskis, who had so many memories of Charles Cieszeski's time as plant manager. Here's how Charles's daughter, Cindy, reacted to those buildings coming down: "I think my father would have been spinning in his grave. I went and got two bricks from the piles of rubble and put them on his gravestone. I thought he needed to have them."

Dick Atkins, who worked in management and was involved in the final years of the plant's closing, spoke from a global perspective concerning the buildings being leveled: "The history of the Fulton plant is fascinating; how it grew and the fact that Nestlé is still the largest food company in the world. But we always referred to Fulton as the Mother Plant. This is where it started."

Cindy McCormick, like so many others who gave all those years to the Nestlé plant, knows that the buildings coming down does not end the legacy of the chocolate factory. "The plant was more than brick and mortar," Cindy noted. "It was a beating heart that sustained the Fulton community and so many employees and their families. I loved it and all it stood for."

THROUGHOUT MY INTERVIEWS, THE word *Nestlé* was said thousands of time by those telling me about their experiences at the factory. Sometimes people would mention that they weren't sure if they were pronouncing the name of their company correctly. Was it Nestlé, with the first E a short vowel and the second a long vowel? Or should it be Nestle, with two short vowels? We usually ended up deciding it didn't make a difference, but I think Terry Terranova came up with the perfect answer when he was telling me about his father Charlie's work at Nestlé: "I prefer to pronounce it with the two short vowels, like you would say the word *nestled*. Because that was how people felt about the factory. The company took care of its people; it provided them a nest."

As the new Aldi grocery store was being built, behind it, towering above, was the still-solid brick exterior of the last Nestlé structure to stand, Building 58.* It looked as if the older, wiser Nestlé building was watching over the new kid in town, advising the youngster how to find success in Fulton. One of the suggestions that mature building might have offered is this:

Trust the power of a group of like-minded people, whether they be investing in a grocery store, a neighborhood or a newly incorporated city. In the years after Nestlé closed, many were hoping for something big to come and pull Fulton out of its financial slump. But history has shown us that's not really how it works. Just look back a century or so, when a group of forward-thinking Fultonians scrapped together $2,700, purchased a plot of land and invited a new company to set up business here, forever changing our city for the better.

* The Condensery, a smaller building behind Building 58, also remained, hidden from view.

TIMELINE OF NESTLÉ'S CENTURY IN FULTON

1898	Fulton newspaper reports Swiss Nestlé officials looking for suitable manufacturing site for its milk products.
1899	Fulton area residents raise $2,700 to buy a seven-and-a-half-acre plot of land for the Nestlé factory. Construction begins.
1900	Ernest Fivaz and other Swiss Nestlé entrepreneurs arrive in Fulton to open the infant formula and condensed milk plant.
1902	The City of Fulton is incorporated.
1907	The Fulton plant expands, and the Peter-Kohler Company begins making milk chocolate with the help of Swiss chocolatiers.
1909	Peter, Cailler and Kohler (PCK) merge as one company.
1914	World War I breaks out, and Nestlé provides soldiers much-needed milk products and chocolate.
1924	The manufacture of baby formula is discontinued at the Fulton plant, making room for more chocolate production.
1929	PCK and Nestlé merge, calling themselves the Nestlé Anglo-Swiss Corporation.
1938	Nestlé's Crunch Bar is developed and begins production in Fulton. The Toll House chocolate chip cookie is invented by Ruth Wakefield in Massachusetts, and Fulton Nestlé begins producing Semi-Sweet Chocolate in morsel form.
1941–45	A variety of chocolate and chocolate products are sent overseas in massive numbers for American soldiers fighting during World War II.

1948 Nestlé Quik is introduced and begins production in Fulton. By 1954, it is the top-selling chocolate-flavored drink.

1949 PCK joins the worldwide Swiss Nestlé group.

1950 Building 30, which focuses on chocolate moulding and wrapping, is added to the Nestlé plant.

1955 Nestlé in Fulton is producing one thousand tons of chocolate products per week.

1960s Employment at Nestlé reaches 1,500.

1960 A new Milk Condensery is built in Fulton.

1970 Fulton Nestlé employment reaches its peak of 1,700. A 124,000-square-foot warehouse is added.

1972 Nestlé's workers go on a twenty-two-week strike.

1987 The first Chocolate Festival is held in Fulton.

1989 A seven-thousand-pound Nestlé Crunch Bar made in Fulton appears in *The Guinness Book of World Records* as the world's largest chocolate bar.

1990 The Quik and Hot Cocoa Mix products made in Fulton are relocated to other Nestlé factories.

1991 A cogeneration plant adjacent to the Nestlé site is built.

1995 Building 95 opens, modernizing Fulton chocolate production. Several older sections of the factory are demolished.

2000 The one-hundred-year anniversary of the Fulton plant is noted with a new slogan: "100 Years of Making Life Just a Little Sweeter."

2002 On October 22, Nestlé announces it will close the Fulton plant.

2003 On April 25, production ends in Fulton. On May 2, the plant closes.

APPENDIX B

BUILDING BY BUILDING

Fulton Nestlé's Plant Expansion

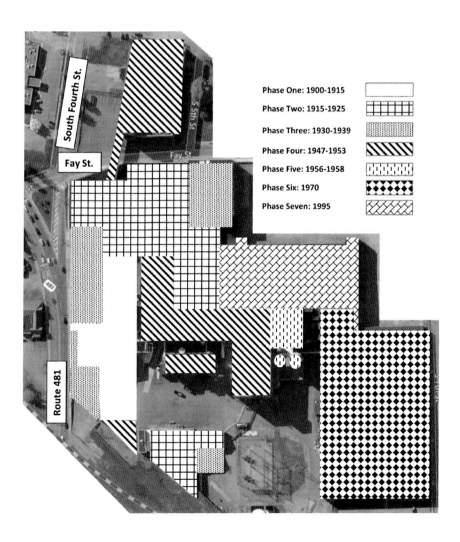

Phase One: 1900-1915
Phase Two: 1915-1925
Phase Three: 1930-1939
Phase Four: 1947-1953
Phase Five: 1956-1958
Phase Six: 1970
Phase Seven: 1995

South Fourth St.

S 5th St.

Fay St.

Fay St.

Route 481

A BASIC OVERVIEW OF NESTLÉ'S CHOCOLATE PRODUCTION

From Cocoa Bean to Chocolate Bar

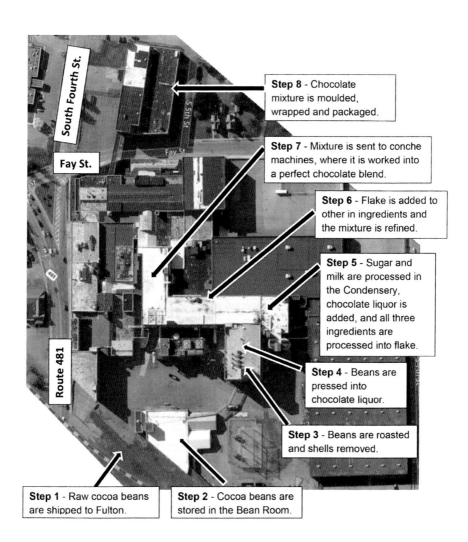

THE MANY NAMES OF FULTON'S CHOCOLATE FACTORY

O ne of the confusing aspects of Nestlé's history in Fulton is the various names the factory was known by over the years. Aside from the obvious "Nestlé," people also referred to the plant as "The Chocolate Works" or some version of its original chocolate company, such as "Peter's," "Peter-Cailler-Kohler" or just "PCK." Some people preferred generic terms like "the factory," "the plant" or even "the mill." There was a reason why the factory was known by many names. During its century in Fulton, its parent company refocused business strategies numerous times. New partnerships were formed, and those in charge wanted their busy Fulton plant to reflect those changes. Here's a chronological list of the names once associated with our city's chocolate factory.

1900 NESTLÉ MILK FOOD Swiss-based Nestlé opens its first American manufacturing plant in Fulton, New York, to meet a growing demand for its product in the United States.

1901 LAMONT, CORLISS & COMPANY An independent sales agent based out of New York City adds Nestlé milk brands to its product line.

1905 THE NESTLÉ FOOD COMPANY OF NEW YORK A sales agency is formed to include Nestlé products manufactured in the United States and Switzerland.

1905 THE NESTLÉ & ANGLO-SWISS MILK COMPANY Nestlé and its main condensed milk competitor merge.

Appendix D

1907 PETER-KOHLER COMPANY Chocolate manufacturing under the "Peter's Chocolate" brand name begins, with distribution by Lamont, Corliss & Company.

1909 PETER CAILLER KOHLER SWISS CHOCOLATES COMPANY INC. The three chocolate companies consolidate, with all products distributed by Lamont, Corliss & Company.

1911 PETER, CAILLER AND KOHLER COMPANY (PCK) The new company incorporates and begins manufacturing chocolates and cocoa under the PCK name.

1929 THE PETER CAILLER KOHLER COMPANY AND NESTLÉ The two companies officially merge but maintain their separate product names.

1948 THE NESTLÉ COMPANY INC. This reorganization of the two existing companies in Fulton reflects new marketing strategies, eventually phasing out the Peter's brand name for most of its commercial venues in the United States.

1950 SWISS NESTLÉ-UNILAC GROUP This company acquires the balance of Nestlé stock, in effect taking complete ownership of the Nestlé Company.

1951 THE NESTLÉ CHOCOLATE COMPANY INC. The business name now reflects its most famous product.

1960 THE VENDING AND INSTITUTIONAL MARKETING DIVISION (renamed THE FOOD SERVICE PRODUCTS DIVISION in 1972) Without mentioning the word *chocolate* in its name, the company is formed to market Nestlé products in hotels, restaurants, and mass feeding institutions, as well as to vending machine operations.

1966 NESTLÉ'S FOOD INGREDIENTS DIVISION (renamed FIDCO in 1976) Seeking to diversify its name brand, this company is formed to serve food, beverage, baked goods and confectionery manufacturers.

1982 FRANCHISE DIVISION The name reflects the company's new purpose: to license the use of Nestlé trademarks on various food products, such as Crunch ice cream bars, Nestlé ice cream products, Quik pure-pak chocolate milk and Nestea pure-pak iced tea mix.

1985 NESTLÉ FOODS CORPORATION Gone are words like *chocolate* and *Swiss*, emphasizing the company's move to expand its array of products and global influence.

1990 NESTLÉ U.S.A. The succinct name includes a much longer subtitle: THE NESTLÉ CHOCOLATE & CONFECTION COMPANY, A DIVISION OF NESTLÉ FOOD COMPANY.

1997 NESTLÉ USA—CHOCOLATE & CONFECTIONS DIVISION The company's final name change while the Fulton plant is in operation pays homage to its humble beginnings.

BIBLIOGRAPHY

Articles and Books

Allerton, Muriel. "Coming to Fulton Because of Nestlé." *Oswego County Business*, December 1999/January 2000.

Appelbaum, Stuart. "Class Warfare's Collateral Damage." *Los Angeles Times*, May 9, 2003.

"Automation Line at Nestlé Multiplies Manufacture of Filled Bars." *Candy Industry and Confectioners Journal* 123, no. 9, November 3, 1964.

Barbash, Tom. "Nestlé Confectioner Enjoying Sweet Success." *Syracuse Herald-American*, May 3, 1987.

Broekel, Ray. *The Chocolate Chronicles*. Lombard, IL: Wallace-Homestead Book Company, 1985.

The Chocolate Works through the Generations: The History of Nestlé Fulton. Fulton, NY: Nestle USA, 2003.

Dairylea, 100 Years of Service 1907–2007. Syracuse, NY: Dairylea Cooperative Inc., 2007.

Eaton, Leslie. "When the Chocolate Melted; Nestlé Factory Closing Leaves Town Reeling." *New York Times*, May 2, 2003.

Fulton, New York. N.p.: Morrill Press, 1901.

Heer, Jean. *Nestlé, 125 Years.* Vevey, CH: Nestlé S.A., 1991.

Hemphill, Douglas Hemphill, and Christopher Wood. *A Retrospective on the History and Processes of the Fulton Nestlé Site.* Creative Commons, 2016.

Holden, June R. *Fulton, NY (A Narrative History).* Fulton, NY: Friends of History in Fulton, 2001.

Kirst, Sean. "In Fulton, Quik's Inventor Made Magic." *Post-Standard*, October 21, 2002.

Landon, Harry F. *History of the North Country*. Indianapolis, IN: History Publishing Company, 1932.

Lubbock-Avalanche Journal. "Nestlé Closes Doors on Nation's Oldest Chocolate Plant in Central NY Town." May 3, 2003.

McRobert, T.B. "Milk Chocolate, the History of Its Invention and Development." *International Confectioner* 25, January 1916.

Nestlé Progress in Second Century, First Report to Employees 1966–1972. White Plains, NY: Nestlé Company Inc., 1973.

Nestlé's News. White Plains, New York: The Nestlé Company, Inc., various issues.

Oneonta (NY) Daily Star. "Wreck Left Candy Trail in 1955." August 18, 2008.

Valley News. "Who Can Resist?" May 7, 1987.

World Trade in Cocoa. Washington, D.C.: U.S. Department of Commerce Office of International Trade, 1947.

Newspapers

Palladium-Times (Oswego, NY)
Post-Standard (Syracuse, NY)
Syracuse (NY) Herald-Journal
Valley News (Oswego, NY)

Web

Aldrich, Mark. "History of Workplace Safety in the United States, 1880–1970." Economic History Association, edited by Robert Whaples. August 14, 2001.http://eh.net/encyclopedia/history-of-workplace-safety-in-the-united-states-1880-1970.

Big Walnut Area Historical Society. "Creamery to Baby Food to Coffee." Because You Asked, August 20, 2011. http://www.bigwalnuthistory.org/Local_History/Creameries/Nestles/Nestle.htm.

Chocolate Class. "Chocolate, Conching, and Consequences." March 23, 2015. https://chocolateclass.wordpress.com/2015/03/23/chocolate-conching-and-consequences.

González, Elaine. "History of Chocolate." www.peterschocolate.com.

Henderson, Amy. "How Chocolate and Valentine's Day Mated for Life." *Smithsonian*. February 12, 2015. https://www.smithsonianmag.com/smithsonian-institution/how-chocolate-and-valentines-day-mated-life-180954228.

James, Martin. "When Chocolate Filled the Air: The Story of Nestlé and Fulton." YouTube, November 6, 2013. https://www.youtube.com/watch?v=zq4OEZEFqYI.

Moriarty, Rick. "The Birthplace of the Nestlé Crunch Gets Crunched in Fulton." Syracuse.com, March 29, 2016. https://www.syracuse.com/business-news/index.ssf/2016/03/birthplace_of_the_nestle_crunch_gets_crunched_in_fulton.html.

nestlé.com

oswegocounty.org

oswegocountynewsnow.com

peterschocolate.com

Pitts, Ed. "Making Chocolate." Upstate Outpost. September 1, 2010. http://edpitts2.blogspot.com/2010/09/making-chocolate.html.

United States Department of Agriculture Census of Agriculture. agcensus.usda.gov.

whatscookingamerica.net

ABOUT THE AUTHOR

 im Farfaglia lives in and writes about the history and culture of Upstate New York. In 2011, after a fulfilling career in education and recreation, Farfaglia transitioned to focusing on his lifelong interest in writing. Through his business, Clearpath, Jim also enjoys helping others fulfill their dream of writing a book. Visit his website at www.jimfarfaglia.com.

Visit us at
www.historypress.com